IMAGES
of America

ROCKFORD &
INTERURBAN RAILWAY

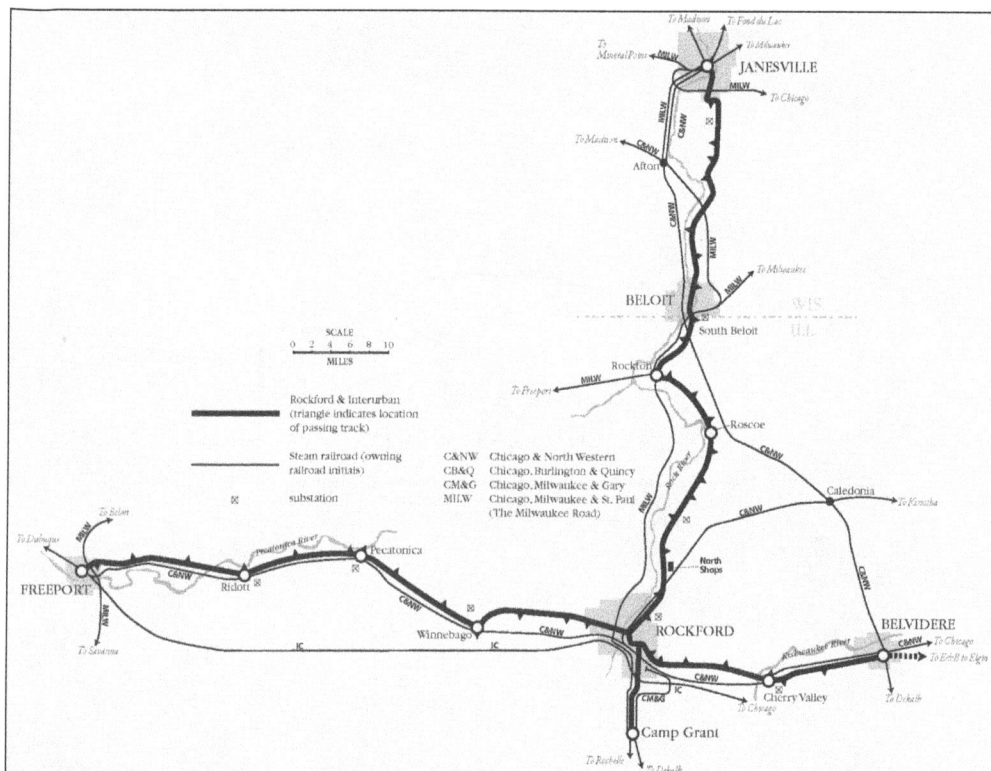

This map of the Rockford & Interurban (heavy line) shows the system at its zenith, around World War I. The principal "steam road" rail lines of the period are shown as the thinner lines. Not all individual tracks are shown; rather, the map depicts main routes. The steam railroads' initials show ownership of those lines during the interurban era. The triangular points on the R&I line indicate the location of passing tracks for trains to get around one another, while the small "X" boxes indicate substations, which fed boosted electric power to the interurban's overhead wire (catenary) distribution system. (White River Junction Productions: Tom Hooper, Mike Schafer.)

ON THE COVER: Rockford & Interurban employees—mostly conductors, but also a number of company officials—pose in front of and on an R&I car parked in the middle of Kishwaukee Street, in front of the carbarn at Rockford. Whether this was a special occasion is unknown, but the photograph was likely taken in the 1920s. The looming facade of the now gone Hess Brothers department store can be seen at right in the distance. The building at left still stands, however. In the late 1960s, it was home to Mid-West Studio, where coauthor Mike Schafer worked as a darkroom technician. (Brian Landis collection.)

IMAGES
of America

ROCKFORD &
INTERURBAN RAILWAY

Mike Schafer with Brian Landis

ARCADIA
PUBLISHING

Published by Arcadia Publishing
Charleston, South Carolina

Library of Congress Control Number: 2014952754

For all general information, please contact Arcadia Publishing:
Telephone 843-853-2070
Fax 843-853-0044
E-mail sales@arcadiapublishing.com ,
For customer service and orders:
Toll-Free 1-888-313-2665

Visit us on the Internet at www.arcadiapublishing.com

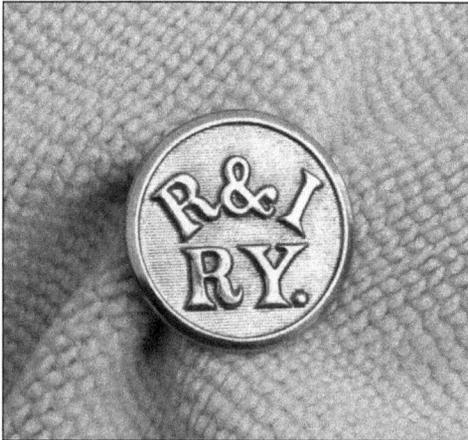

This is a Rockford & Interurban button from a trainman's uniform. (Mike Schafer collection.)

I would like to dedicate this book to my mother, Sandra Landis, who passed away on May 23, 2014, while I was working on this book; to grandparents Don and Bessie Landis, who lived in Rockford, Illinois, near much of the city's railroad activity; and to Fred and Maxine Germann.

—Brian Landis

CONTENTS

ACKNOWLEDGMENTS

Although this book lists two authors, Brian Landis and me, there were many more than two people behind the making of *Rockford & Interurban Railway*, and we need to shine a spotlight on them. But, I should start with applause for coauthor Brian Landis. Without his fortitude in being able to unearth R&I photographs and other illustrations, this book project would have derailed before we even got out of the station. The bulk of illustrations in this book can be credited to the Brian Landis collection (BLc.). Because of its early demise (1930), the R&I and its affiliate railways were not well documented photographically. But, through Brian's relentless searching on the Internet, on eBay, and at local museums and libraries, he located dozens of photographs of the R&I and Rockford's streetcar system, which for a time was operated by the R&I. He was also able to locate photographs of affiliate or subsidiary companies of the R&I. Unfortunately, local newspaper companies were not so accommodating.

For his generous time and very productive efforts, Brian and I must give extra thanks to Norman Carlson, president of the Chicago-based Shore Line Interurban Historical Society (SLIHS); managing editor of the SLIHS's splendid quarterly magazine, *First & Fastest*; and a board member of Metra, Chicago's commuter-rail system. Without the help of Norm and the SLIHS, there would be some very serious gaps in our coverage.

Also high in the ranks of folks generous with their time and resources in helping with this book is Gordon Geddes, another person well-versed in Midwest interurban history. I met Gordy at the Forest City Model Railroad Club in Rockford when I joined in 1963. Over the years—aside from being involved in the Rockford Mass Transit District—Gordy has amassed a large collection of interurban railway photographs, among them several we were able to use in this book. In fact, Gordy flew his photographs down to me from Rockford to Rochelle, Illinois, in his private plane. That's help and dedication!

In addition, I wish to thank brothers Rory and Cedric Peterson of Belvidere, Illinois, for the use of photographs taken by their father, the late Roy Peterson, another area pioneer railroad photographer. Additional thank-yous for help must go to George Kanary of the Electric Railway Historical Society, and to the folks at Beloit College, Boone County Historical Society, Stephenson County Historical Society, Rock County Historical Society, Rockford Public Library, Rockton Historical Society, Rockford Midway Village, Doug Cohen of Rockford Reminisce (rockfordreminisce.com), Art Peterson of the Krambles-Peterson Archive, Otto M. Vondrak, brothers Scott and Mike Landis, and Donald O. Ellison.

INTRODUCTION

Interurban railway systems played an important, if brief, role in the development of populated areas of the United States. The reign of the interurban as a critical facet of the nation's transportation system lasted only about a quarter century, roughly from 1900 to 1925, yet the trains remain a cultural icon of the early 20th century. Interurban railways were the link in the slow transition from the horse-and-buggy era to the automobile age.

To better enjoy and understand the history of the interurban that helped Rockford grow into one of the largest cities in Illinois, we first need to define "interurban."

An interurban was a sort of hybrid of a streetcar or trolley ("light rail" in today's parlance) system and a "steam railroad," which was the traditional, full-sized railroad that to this day remains a critical component of North America's freight and passenger transportation network. Generally, interurbans were designed to link larger cities with their satellite burgs and towns and rural areas. Nearly all interurbans took advantage of the new technology of electric power, specifically the traction motor, which supplied cheap and easy-to-generate electricity. This method powered railcars in a nonpolluting manner while allowing rapid acceleration and deceleration. For this reason, interurbans were often referred to as "the traction," and some lines had "traction" as part of their name, such as the Illinois Traction System. One of America's most successful interurbans, this line's 550-mile network linked St. Louis, Missouri, with several large central Illinois cities.

Interurbans focused on providing frequent, local service, mostly passenger but also express (package) traffic and a limited amount of freight. The steam railroads concentrated on longer-distance service requiring heavier trains and locomotives. In the early 20th century, the automobile was but a curiosity. Nearly all roads and city streets were of dirt, unpaved and badly rutted, and most people relied on horses and buggies or wagons for transport. So, the coming of the all-weather interurban was hailed as major step in civilizing towns and cities. The onset of the automobile era and publicly funded streets and highways—now paved, usually with brick and, later, macadam—doomed the privately owned interurban operations, with the Great Depression of the 1930s providing many nails in the coffins of the weakest interurbans. Today, although electric trolley/streetcar (light rail) systems have regained popularity and success throughout the United States—their virtues finally having been rediscovered—only two true interurbans survive—the South Shore Line between Chicago and South Bend, Indiana, and the Norristown High Speed Line of Philadelphia's Southeastern Pennsylvania Transportation Authority. Interestingly, both enjoy higher ridership now than during their reign in the interurban's limelight era. And both remain electric-powered.

Founded in 1834–1835, Rockford today is the most populous city in the state of Illinois outside of the Chicago metropolitan area, the reach of which extends nearly half the distance of the 85 miles that separate downtown Chicago from downtown Rockford. In the late 19th and early 20th centuries, with a large immigration of Swedes, Rockford became famous for its furniture industry and, later, manufacturing in general. Its city center astride the Rock River was a natural for a streetcar system, and in 1881, a mule-powered street railway system was born, the Rockford Street Railway Company. From this modest endeavor that wound from Fourth Avenue and Fourth Street on the east side of town, through downtown Rockford on the west side of the river to Montague Street, the 100-mile Rockford & Interurban Railway grew. It did so in the manner that was quite

typical of interurban companies of the era: through the formation of smaller companies that eventually were consolidated into the larger company.

The Rockford Street Railway added more lines, also mule- or horse-powered, during the next few years. Alas, it was not a success. Not everyone wanted to pay the outrageous fare of a nickel when he or she could walk for free and just as fast as the mules. Struggling to make ends meet, the company was sold (reportedly for 60¢ on the dollar) in 1889 to Judge R. Baylies of Chicago. Shortly after, the judge reorganized the company as the Rockford City Railway Company. Then, in 1890, came two turning points: first, the electrification of the system; and second, competition.

The first electric streetcar hit the streets in 1889 as an experiment. The experiment apparently proved successful, for in 1890, the Rockford City Railway took delivery of four new single-motor, four-wheel electric cars. They were of bidirectional design; in other words, they could be operated from a control platform at either end of the car.

As for competition, it came in the form of the new West End Street Railway, later known as the Rockford Traction Company (RTC), which began building its own set of lines in the city. But the RTC, like many other fledgling companies across the United States, failed in 1895 in the wake of the Panic of 1893. John Farson, another Chicagoan, acquired RTC's assets and kept the lines running until 1898 when he and Judge Baylies wisely consolidated the RTC and the Rockford City Railway into the Rockford Railway, Power & Light Company (RRP&L). Baylies became the president and Farson the vice president. At the turn of the 20th century, power and light companies were commonly intertwined with electric railway systems, with the railways being their own best customers until electric lighting spread throughout the communities they served.

In 1899, Baylies and Farson and their management team organized yet another rail company, the Rockford & Belvidere Electric Railway Company, and, through its auspices, built a 13-mile line between those namesake cities. In 1901, the Baylies/Farson team formed the Rockford & Freeport Electric Railway Company (R&FE) to connect those two cities with a 28-mile line that would run via Winnebago, Pecatonica, and Ridott. This line was completed in April 1904. Meanwhile, in 1902, the R&BE had merged with the RRP&L to form the Rockford & Interurban Railway Company (R&I). In September 1904, the R&FE was merged into the Rockford & Interurban.

The final segment of the R&I network was its Rockford–Janesville, Wisconsin, line, running via South Beloit, Illinois, and Beloit, Wisconsin. This 32-mile line—the Rockford, Beloit & Janesville Railway (RB&J)—had been built by a company that was considered by some as independent of the Baylies/Farson team and their booming rail network, although Baylies was thought to be connected with the RB&J in some manner. The RB&J used over two miles of R&I's streetcar trackage to reach downtown, paying the R&I 3¢ per passenger for trackage rights. The RB&J's planned branch to Lake Delavan, Wisconsin, was never built.

It was probably inevitable that the R&I would purchase the RB&J, and so it did on April 1, 1906. With that purchase, the R&I reached its zenith in terms of its overall reach to towns and cities in the region, save for a branch to Camp Grant on Rockford's south side, built in 1917 to address World War I issues. The only proposed R&I line that never got built was a nine-mile branch from Winnebago to Byron, Illinois, intended to connect there with the Chicago Great Western (CGW), a steam railroad linking Chicago with Kansas City, Omaha, and Minneapolis–St. Paul. The proposal was primarily aimed at increasing freight traffic through interchange with the CGW, but Rockford city fathers objected to the movement of freight trains on the city's streetcar trackage—a common conundrum faced by interurban companies throughout North America, most of which had considerable street trackage.

The use of existing street-railway trackage to access a city's downtown was a common practice among a majority of the nation's interurban railways. In the case of R&I's Belvidere line, for example, construction began in 1901 at the end of the Rockford Railway Power & Light Company's Fifth Avenue line near Eleventh Street (a half block from where coauthor Schafer grew up a half century later). In Rockford and Freeport, Illinois, and Beloit and Janesville, Wisconsin, R&I trains reached their downtown terminals by way of the city streetcar lines. In some cases, the R&I eventually acquired control or outright ownership of a city's streetcar system, with Rockford

itself being a prime example of the latter. Although Beloit's streetcar system was overseen by an R&I principal or two, it remained largely independent of the R&I, which had to pay for the use of Beloit's trackage. Janesville's street railway system was considered a cousin of the R&I, since both were owned by the same holding company, the Union Railway Gas & Electric Company. Freeport's street railway system, eventually purchased by Samuel Insull—one of the most famous of all magnates of interurban railways and their holding companies—was quite separate from the R&I, which had to lease trackage rights from the company.

Affiliated connecting interurban companies, however, extended the R&I's reach outside its ownership boundaries. The Elgin & Belvidere Electric Railway was a prime example, providing an interurban link between the R&I at Belvidere and Samuel Insull's Aurora Elgin & Chicago (later, the Chicago Aurora & Elgin) interurban line at Elgin. The R&I and the E&B became so closely associated that the two were in some ways operated as one. After 1912, the two carriers introduced through, "Limited" service (limited stops) between Rockford and Elgin, one of Chicago's principal satellite cities. R&I cars ran through to Elgin, while E&B cars ran through to Rockford. Passengers had to change at Elgin to the AE&C/CA&E to complete a trip to Chicago, and this transfer thwarted the success of Rockford-Chicago interurban service. Although fares on the interurban were cheaper, overall running time between the two cities was three hours and forty-five minutes; parallel steam railroads Chicago & North Western and Illinois Central did this in almost half the time.

In 1909, the R&I and its components were acquired by the Union Railway, Gas & Electric Company (URG&E), which was actually a holding company. In 1911, URG&E separated the R&I's streetcar operations into the Rockford City Traction Company (RCTC), making RCTC a subsidiary of the R&I. Ongoing corporate maneuvers such as this seemed to be a way of life for the R&I, just as they are in business today.

In 1917, the R&I built a short branch from the RCT's Seventh Street/Harrison Street loop to Camp Grant, destined to be a major marshaling point for troops headed overseas during World War I. Although the R&I had considerable steam-road competition at Camp Grant (the Chicago, Milwaukee & St. Paul; the Chicago, Burlington & Quincy; and the Chicago, Milwaukee & Gary), there were still enough troop movements to boost ridership on the railroads.

Into the Roaring Twenties, the R&I flourished, bringing on-line communities closer together through the sheer ease of traveling on the R&I. Since it was substantially cheaper and easier to operate an electric interurban car than a steam-powered passenger train, the R&I could provide hourly service on all its lines, all of which were paralleled by steam railroads. The R&I ran closely parallel to much of Chicago & North Western's Chicago–Elgin–Rockford–Freeport line west of Elgin; the R&I also paralleled, loosely, IC's Chicago–Rockford–Iowa main line between Rockford and Freeport. Between Rockford, Beloit, and Janesville, the R&I followed the Chicago, Milwaukee & St. Paul. All of these steam roads offered passenger service on those routes but simply could not match the frequency—a key to the success of almost any regional rail passenger operation, even today. Nor could they efficiently stop at every intermediate town and village, whereas nimble interurban cars would even make flag stops for rural residents at the lanes to their farm homes.

But all was not well, and one of the first signs of trouble was the paving of the Ulysses S. Grant Highway, later US Highway 20, in 1917. This was one of the first highways in the region to be paved. The Grant Highway, which ran from coast to coast, paralleled the R&I closely between Elgin, Belvidere, Rockford, and Freeport. In some cases, the R&I had trackage in the middle of the Grant Highway in downtown areas, as State Street served as US 20's routing through Rockford. Now, people fortunate enough to be able to afford an automobile could drive between those cities without having to tailor their travel plans to train schedules. To this day, this situation—rail passenger operations competing with the deep pockets of government subsidizing a highway and interstate system—remains the nemesis of nearly all rail passenger operations in North America.

R&I's passenger traffic peaked in 1919 and then began a slide that was unstoppable. Although the R&I had been drawing good dividends from its Rockford City Traction subsidiary, the railway had to be reorganized in 1922. By the end of 1925, the R&I was bankrupt. As the 1920s

wound down, there were some notable attempts at rescue, but, in the long run, none of them were successful. RCT was separated from the R&I, reorganized as the Rockford Public Service Company in 1926, and then sold to an outside company to which the R&I had to pay trackage rights for its remaining interurban trains. In October 1927, a new company, the Elgin, Belvidere & Rockford Railway, was formed to more firmly amalgamate the Elgin & Belvidere and the R&I, with the two now operating essentially as one company.

The last hurrah was the arrival of seven new lightweight, all-steel interurban cars from the American Car Company. They would go into service on all intercity routes, which by now had seen service cuts. But it was too late, and service cuts continued. Service north of Beloit to Janesville ended on July 29, 1929. By 1930, interurban passenger traffic had dropped by 90 percent. On March 9, 1930, Elgin-Belvidere-Rockford service ended; then, on September 30, 1930, Rockford-Freeport and Rockford-Beloit service ended. It was all over for the R&I.

At that point, the R&I's legacy was the Rockford Public Service's streetcar network, which soldiered on until the wee hours of July 4, 1936, when company officials operated the final streetcar. The day before, streetcar service had officially ended for the public. The streetcars were replaced by buses, both gasoline and electric trolley.

Ironies abound in this story. Today, electric streetcar systems are enjoying a resurgence, as people rediscover their virtues: clean, quiet, efficient transportation; greater comfort; and, interestingly, a perceived stability of operation. Recent studies show that people prefer streetcars to buses because of the perception of permanence. Where people see tracks, they know there is service, whereas bus routes can be changed overnight. Cities that once had streetcar systems and abandoned them long ago have revived them, while other cities that never had streetcar systems are building new ones. Interestingly, Rockford has recently mulled over proposals for a new streetcar line to promote growth of its downtown area. Cities like Portland, Oregon; Sacramento, California; Kenosha, Wisconsin; and Charlotte, North Carolina, have proven that streetcars bring renewed vigor to moribund central business districts.

There is another irony, too, in the R&I story. As this book went to press in 2015, the revival of intercity rail passenger service between Chicago and Rockford was in the works. The routing? Chicago, Elgin, Belvidere, and Rockford!

And the spirit of the R&I/E&B itself lives on in the world-famous Illinois Railway Museum, whose seven-mile main line—on which passengers can ride on vintage interurban cars (though none are R&I or E&B)—is built on the right-of-way of the Elgin, Belvidere & Rockford Railway.

What goes around, comes around.

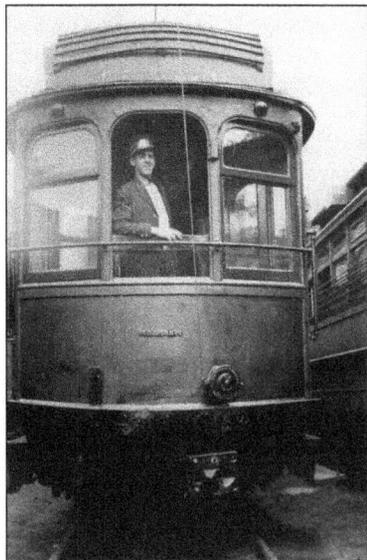

A young Rockford & Interurban trainman poses with an R&I interurban car at the Kishwaukee Street carbarn early in the 20th century. (BLc.)

One

From Equestrian Effort to Electrical Power

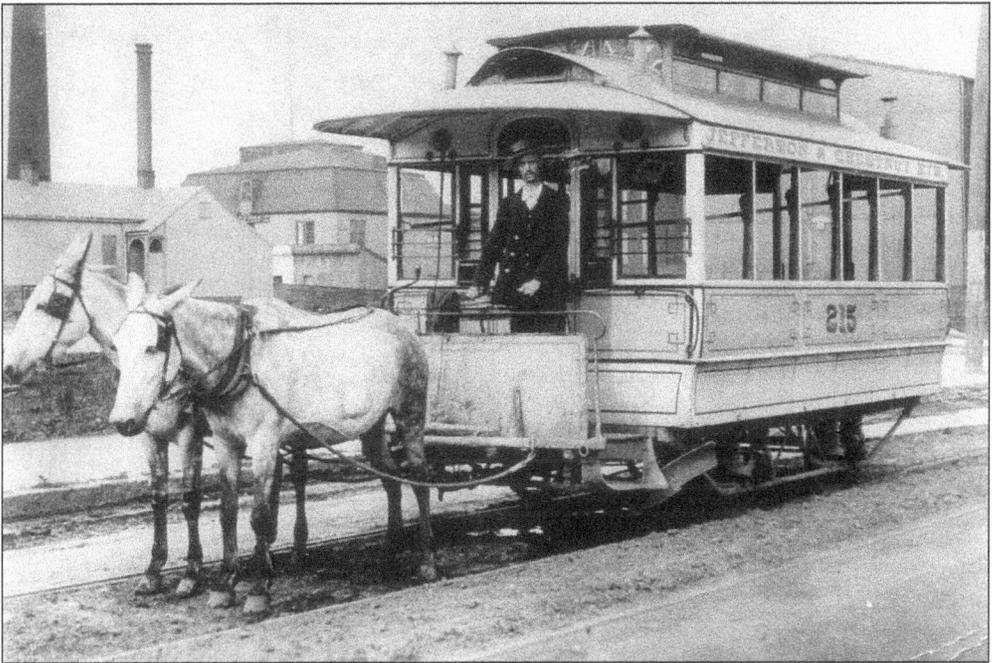

From acorns grow mighty oaks. In the case of the R&I, the acorn was the Rockford Street Railway Co. Propelled by real horsepower, car No. 215, assigned to the Chestnut Street line, is shown in 1889, only a few years before Frank Sprague's traction motor became a means of harnessing electric power to propel vehicles, particularly railcars. The wide and almost immediate acceptance of the traction motor ended the use of horses almost overnight. Horses (and mules) required constant attention in terms of food and water, and they polluted the urban environment. They were also limited as to how much and how fast they could pull a trolley car. (BLc.)

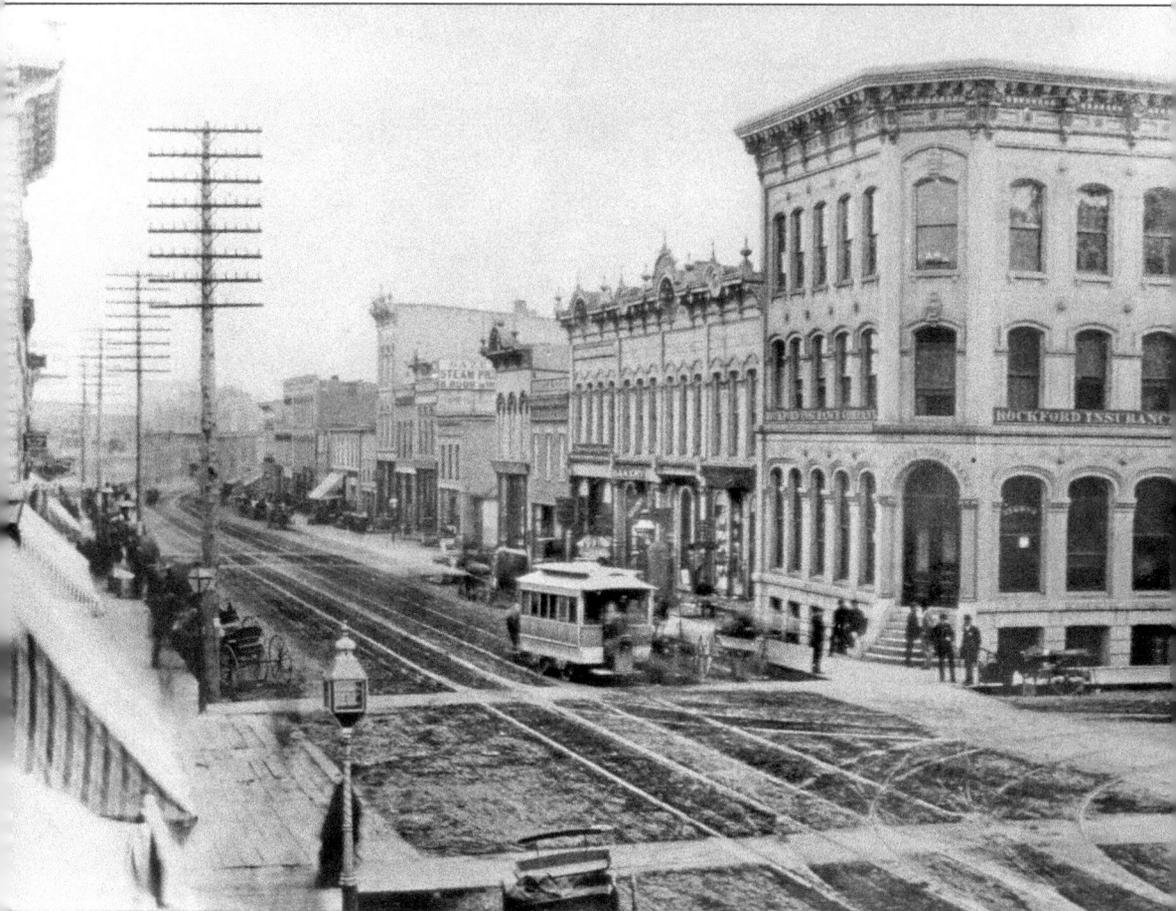

This remarkable view of downtown Rockford in 1889 looks east-southeast along State Street, toward the Rock River bridge at left in the distance. A horsecar has just turned off of Main Street and onto State Street, where it is pausing to take on passengers; the horse pulling the car is partially visible. The streets are largely still dirt (or mud, depending on the weather), and the sidewalks and crosswalks are wood planking and lined with gas lamps. Halfway between the horsecar and the river bridge, another set of crosswalk planking defines Wyman Street. In the not-too-distant future, the R&I's main downtown depot will be housed in the two-story brick building at the southeast corner of State and Wyman Streets (center left). (BLc.)

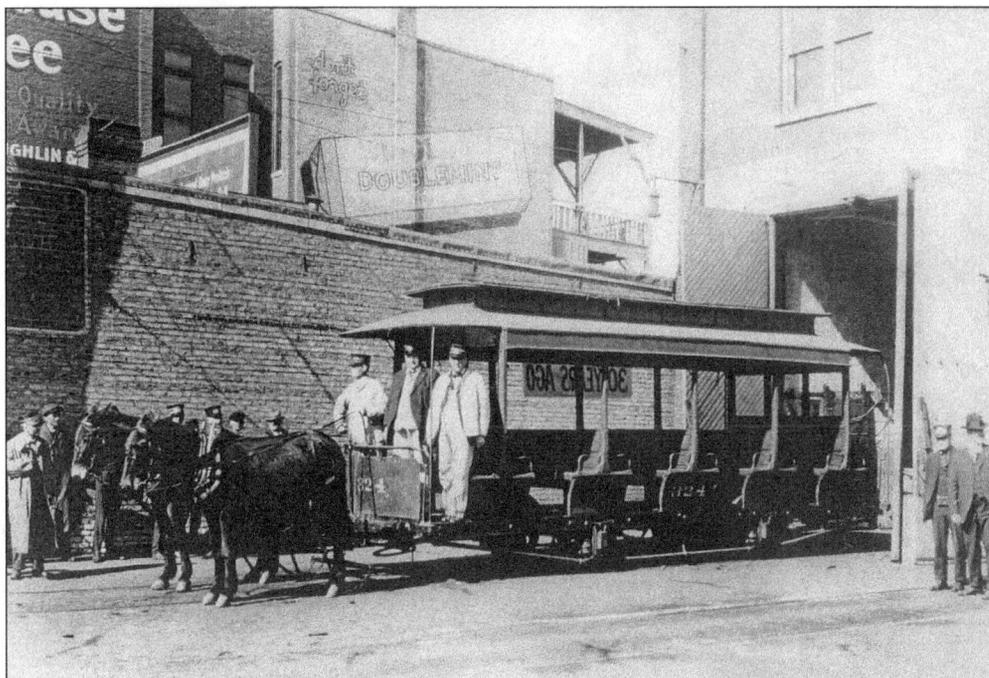

Horse-powered, open-air car No. 324 is in front of the Rockford & Interurban's Kishwaukee Street carbarn. The sign hanging on the other side of the car reads "30 years ago," so this is some sort of reenactment for the public, illustrating early streetcar travel in Rockford before mule- and horsepower gave way to electric traction motors in 1890. If the "30 years ago" sign refers to that date, then this photograph was taken around 1920. The brick carbarn was built in 1912 and still stands. (BLc.)

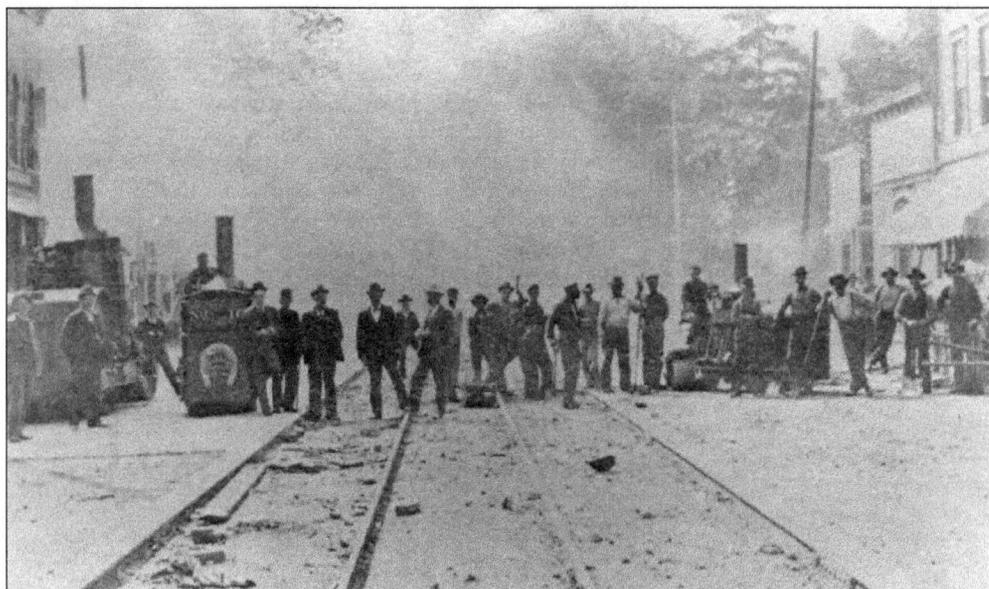

A construction team laying double track in the street at an unidentified location in Rockford has paused for the photographer. It appears that the street is being paved at the same time (probably the first time), with steam-powered paving equipment. (BLc.)

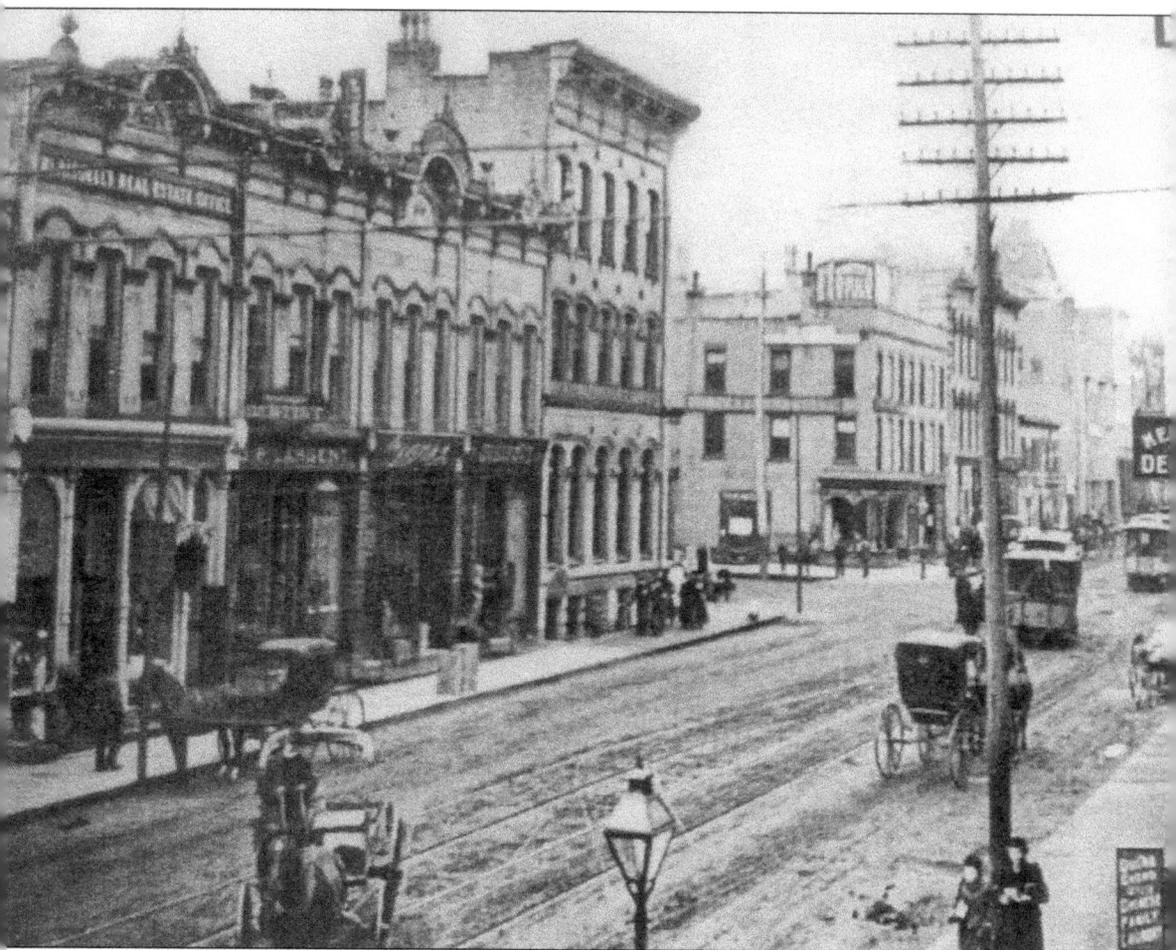

Rockford's downtown in the 1890s reveals dirt streets, horse-drawn carriages and wagons, and equestrian-powered streetcars The view looks west-southwest at the intersection of West State (foreground) and Main Street. The cupola of the ornate Winnebago County Courthouse can be seen at upper right, beyond the new electric pole line just below the cross arms. In 1880, organizers of the Rockford Street Railway argued whether the system should be powered by horses or mules, and a tie vote had to be broken by the president of the company, Anthony Haines. The first streetcar was placed in service on November 10, 1881, with horses as the mode of choice, although mules probably were still used on some lines. (BLc.)

No fewer than four trolleys are working their way west along State Street in this unusual view of downtown, looking east from a building on the corner of State and Court Streets in the early days of electrification. A portion of the front of the Winnebago County Courthouse can been seen at right. (Gordon H. Geddes collection.)

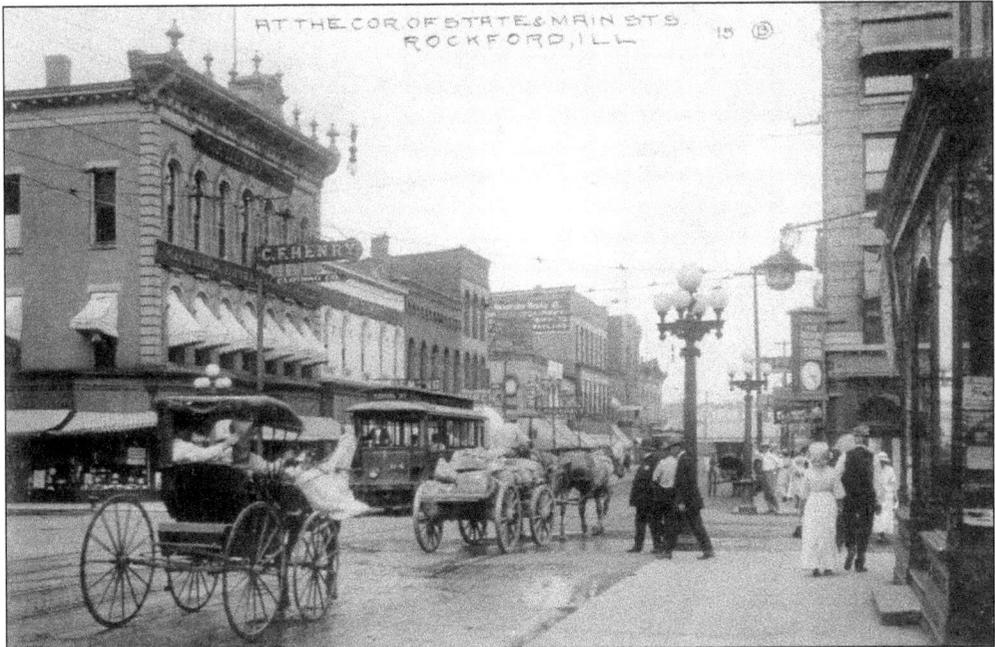

This c. 1910 downtown Rockford street scene shows some notable improvements. The view looks eastward along State Street from the corner of State and Main Streets. Clearly, electrification has come to the city's car lines, with an electric trolley heading west to cover the School Street route. Note that the streets are now paved and lighted by electricity, although horses are still used for moving most vehicular traffic. (BLc.)

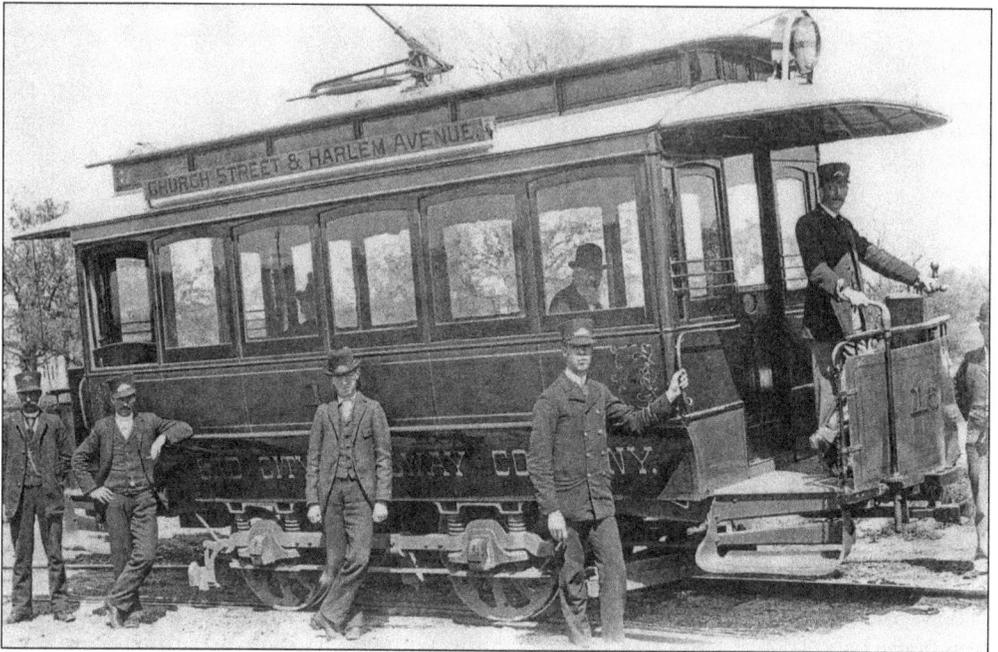

Several Rockford & Interurban employees pose with car No. 16, assigned to the Church Street/Harlem Avenue route. The car, painted and lettered for Rockford City Street Railway, a component of the R&I, is typical of early electric street railway vehicles, with a single truck (wheel assembly) and a single trolley pole that could be swiveled so the car could be operated in either direction. The photograph was taken in 1914, by which time the Rockford City Railway had gone through a name change and then merged into the Rockford Traction Company, an R&I subsidiary. (BLc.)

This is a rare image of the city car line that ran south along Main Street to serve the steam railroad stations along South Main Street. This c. 1915 view looks north along Main Street. The Chicago & North Western overpass is directly behind the approaching trolley car. The tall building in the distance is the Emerson-Brantingham Carriage Works. The photographer is standing close to the location of the Illinois Central station grounds at 815 South Main Street. (BLc.)

Rockford is somewhat unusual in that it has several subsidiary business districts. Best known is probably the Seventh Street business district, on the east side of the Rock River. The view in this 1912 photograph looks north along Seventh Street from between Sixth and Fifth Avenues. The interurban car in the distance has come up Fourth Avenue and will turn south on Seventh Street to Fifth Avenue, where it will turn east once again. Coauthor Schafer grew up in a neighborhood served by the Seventh Street business row. (BLc.)

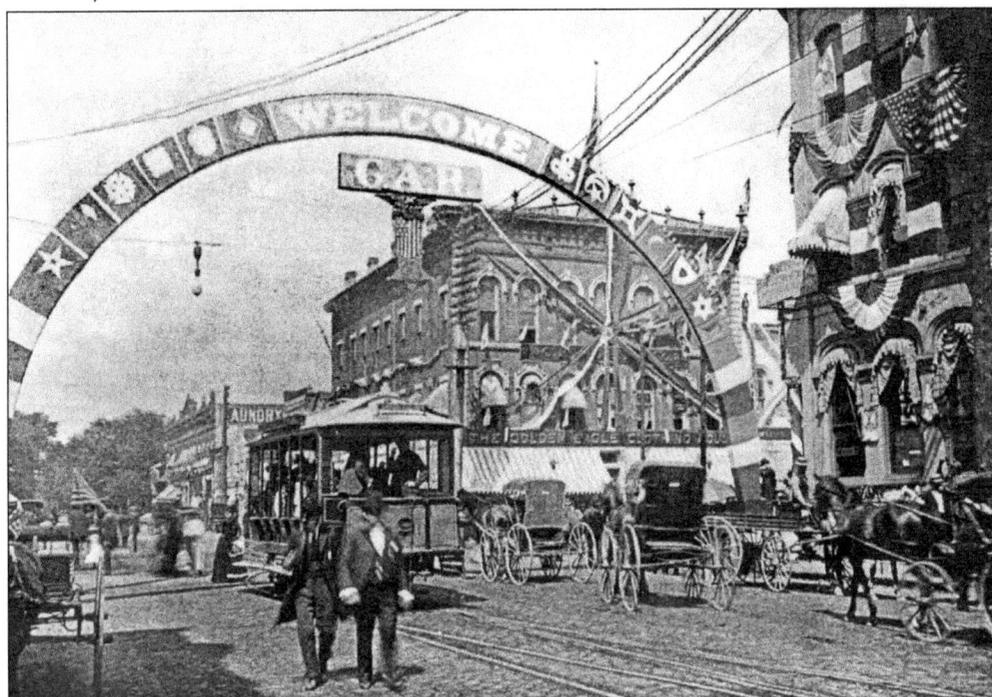

Rockford is apparently in the midst of preparing for a Grand Army of the Republic parade in this downtown scene from the late 1890s. The electrification of the city's streetcar system is in its infancy, and it appears the streets have recently seen their first paving. (BLc.)

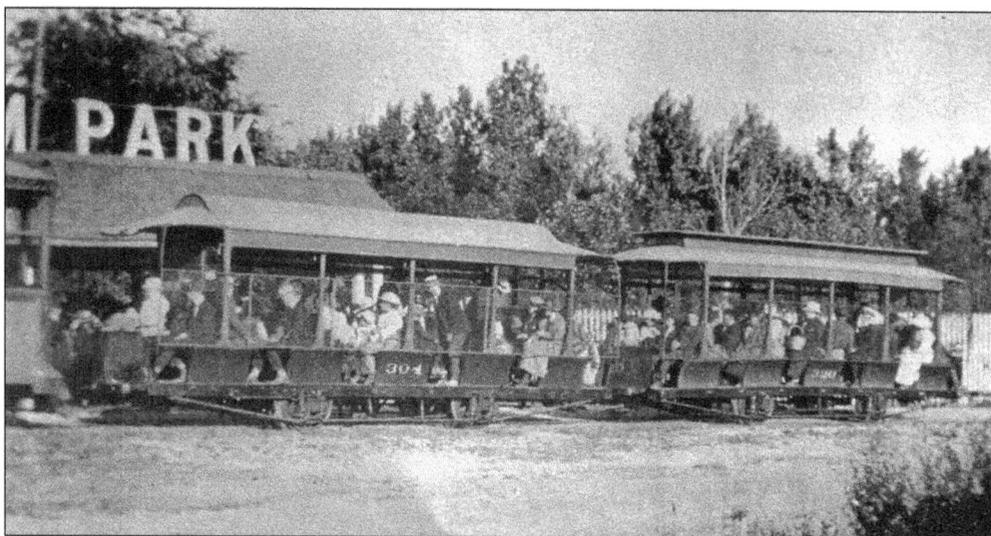

To handle the weekend crowds visiting Harlem Park, the R&I, which was an outgrowth of Rockford's street railway system, employed former Chicago cable car "trailers" (nonpowered cars) hauled behind one of the regular electric streetcars. Here, a train has just arrived at Harlem Park around 1915 behind car No. 837 (just visible at left). The trailers had been used on Chicago's short-lived cable-car system, which looped around the city's business district. Some historians insist that the "Loop" designation used to this day in Chicago comes from the cable-car system and not the 'L' (elevated) line that currently belts the business district. (Photograph by Fred Borchert, BLc.)

Harlem Park, along the west bank of the Rock River on Harlem Avenue between what is now Harper and Brown Avenues, opened in 1891. Judge R.N. Baylies, who bought the Rockford Street Railway in 1889, was the driving force behind the building of Harlem Park. It was common for fledgling street railways and interurban systems to build a pleasure park as a destination on evenings and weekends, when ridership was traditionally low. (BLc.)

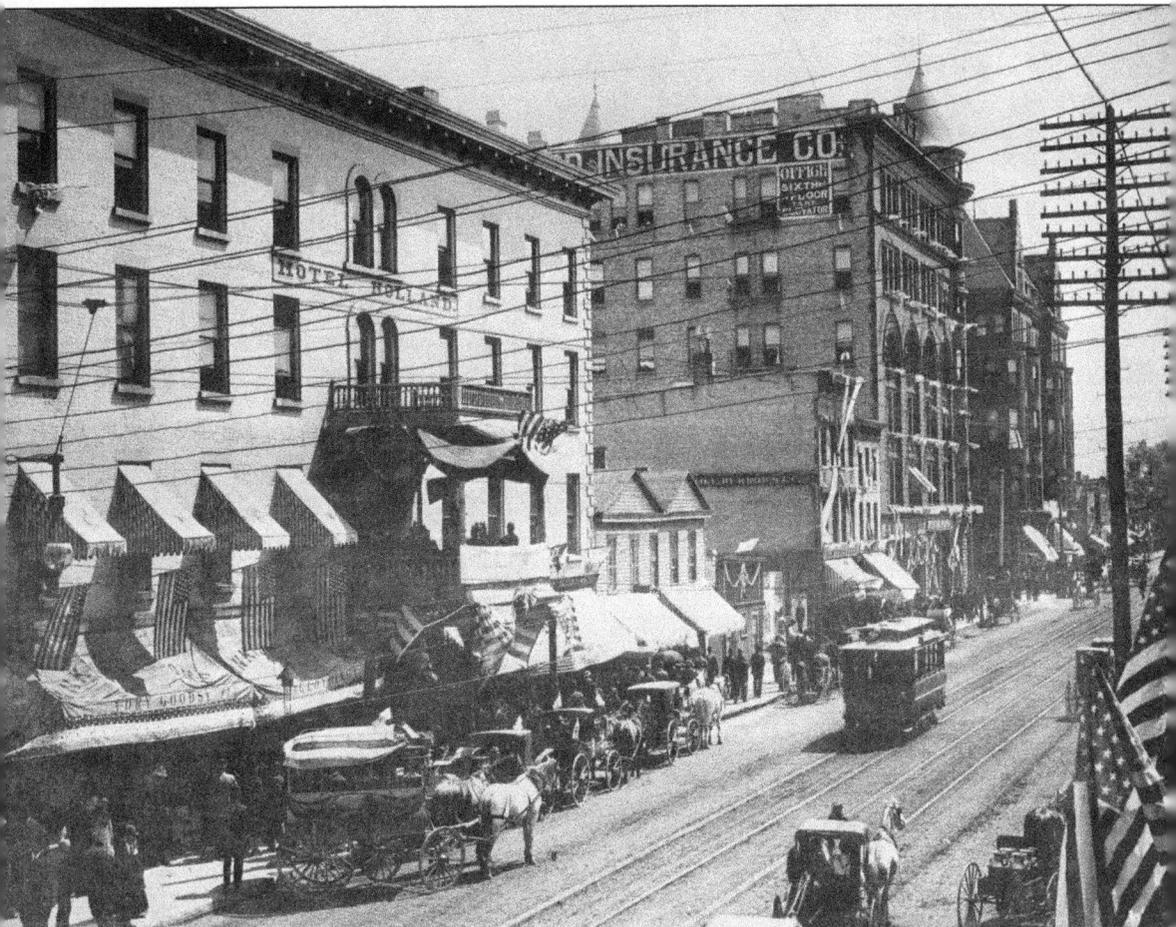

This is another downtown Rockford photograph from the early days of an electrified street railway system. The city is celebrating the Fourth of July in the 1890s. The view looks south-southwest along Main Street. A single-truck car ambles northward toward city center. A couple of ancient wooden structures from the mid-1800s still stood (center) when this photograph was taken; they are dominated by loftier and larger buildings on either side, including the Hotel Holland. (BLc.)

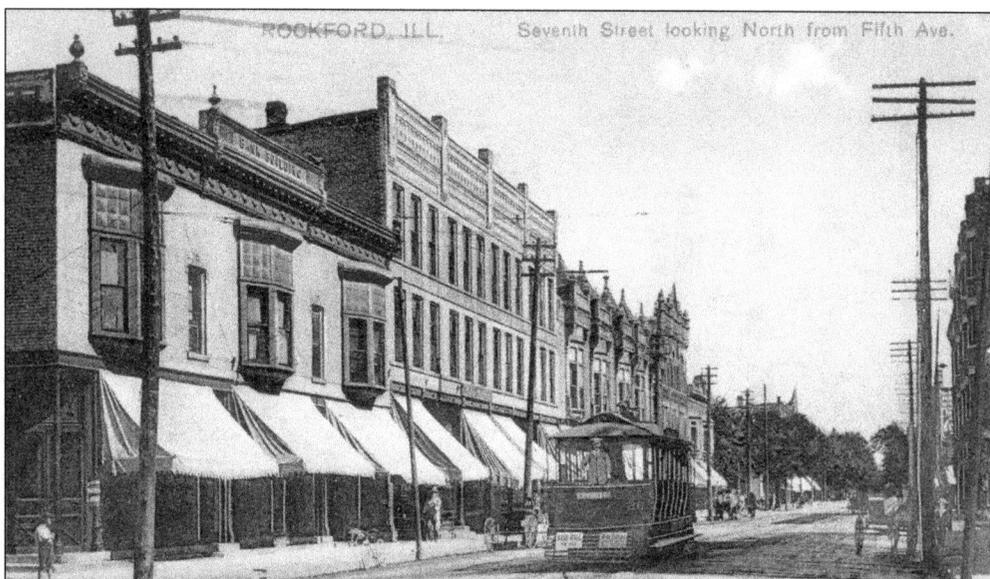

An open-air car rolls southward along the namesake street of the Seventh Street business district on Rockford's east side. The car is carded for Kishwaukee Street, which means it will proceed straight ahead. The line branching to the right (east) onto Fifth Avenue immediately in front of the car is the start of the Rockford & Interurban's main line to Belvidere via Fifth Avenue, Twelfth Street, and Woodruff Avenue out of the city. (BLc.)

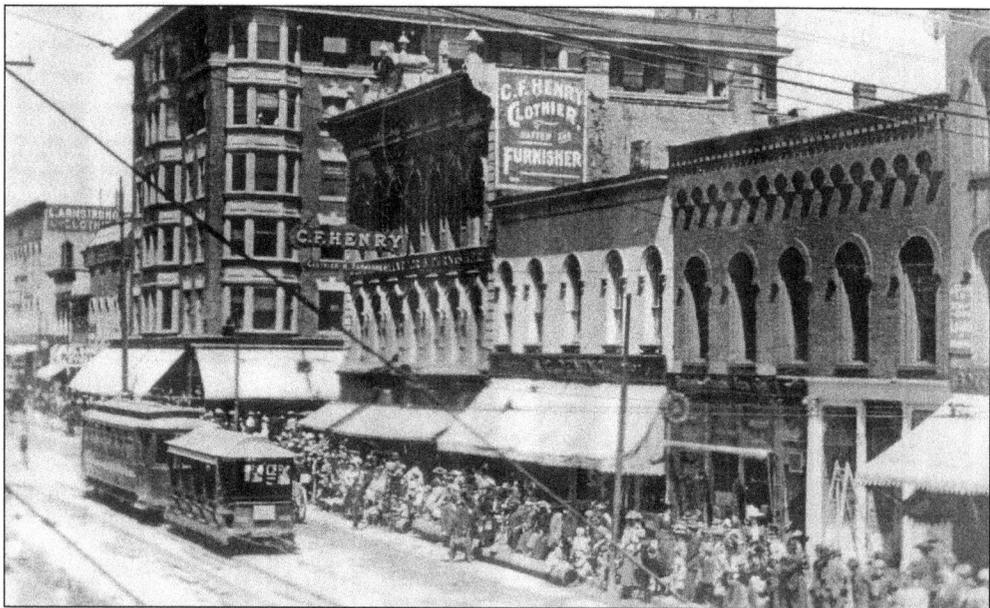

State Street just west of the Rock River crossing is shown around 1910 in a photograph apparently taken from the upper level of one of the buildings on the south side of the street. Throngs of Rockfordians are poised for a parade for some sort of event—parades being very popular in the late 19th and early 20th centuries. Meanwhile, a streetcar toting a "trailer" (nonpowered streetcar) heads west. The tall structure at the corner of State and Wyman Streets is the Ashton Building, erected in 1904. At a height of six stories, it was considered Rockford's first "skyscraper." Some people refused to go into it, thinking something that tall was unsafe and would eventually collapse. (BLc.)

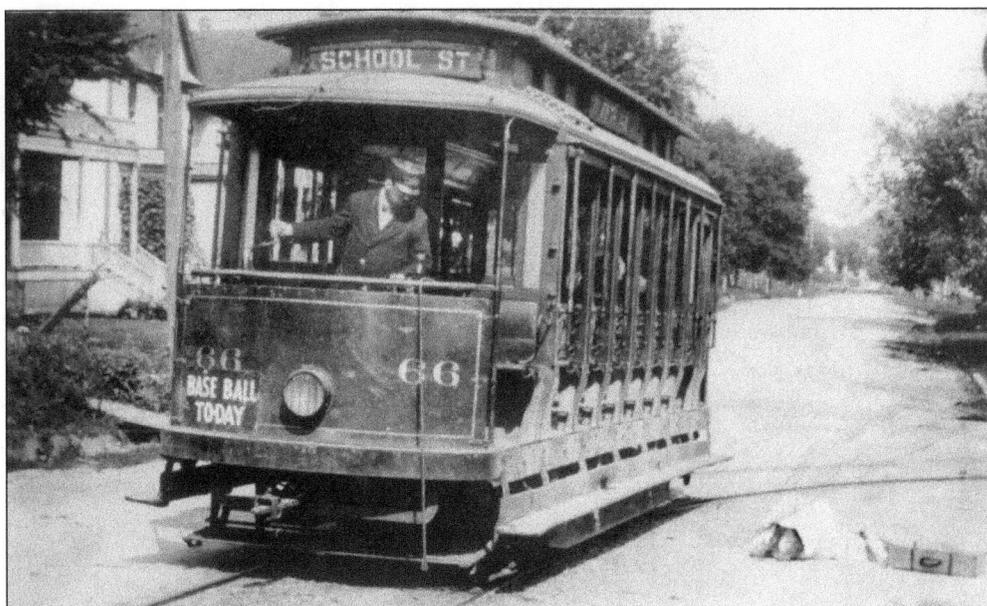

Open-air car No. 66 is on School Street at North Avon Street in an east-facing view taken around 1915. What is the motorman looking at? It appears to be the body of a young girl who had been carrying a bag of goods. It is speculated that this is a staged accident photograph for the company safety program, advising passengers and motormen not to scramble to assist the victim. Alas, the details of this scene are lost to history. (Gordon H. Geddes collection.)

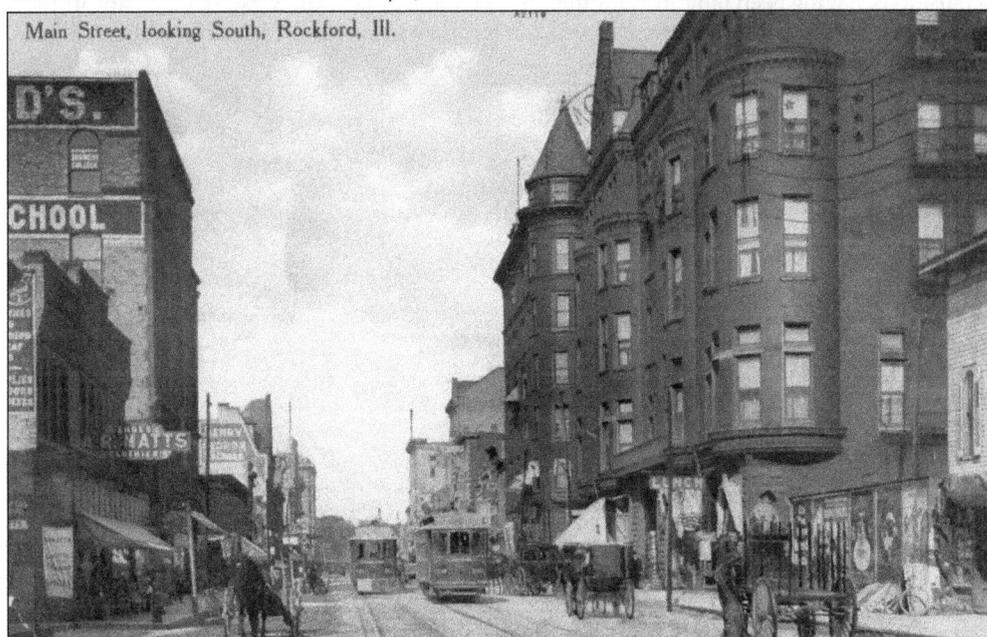

Rockford's leading hostelry, the grand Nelson Hotel, dominates this scene along South Main Street around 1910. The palatial landmark opened in 1892 and was the preferred quarters for visiting dignitaries, including US presidents Theodore Roosevelt and William Howard Taft. R&I cars No. 111 and No. 109—both Jackson & Sharp products from 1901—pass one another in front of the hotel. (BLc.)

21

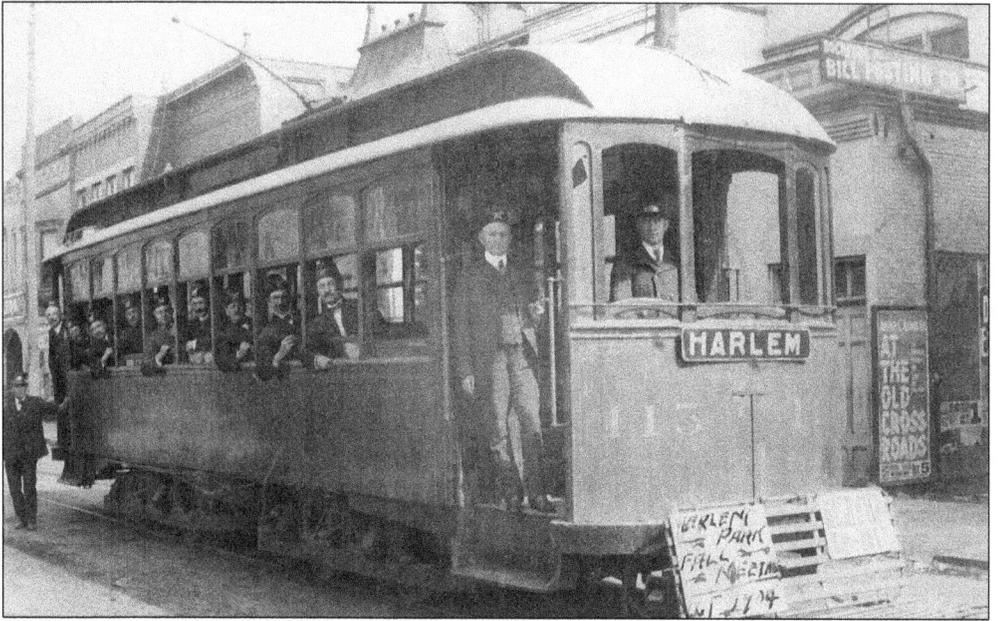

Shriners dominate the passenger loadings on this run on the Harlem line in 1904. The R&I motorman and conductor have kindly paused on North Wyman Street in front of the Grand Opera House in Rockford to record the group, which appears to be headed for Harlem Park (note the handmade sign on the car's pilot). Double-truck car No. 115 was one of the R&I's earliest acquisitions, having been built in Wilmington, Delaware, by Jackson & Sharp Company in 1901. The car was used in both city service as well as interurban runs to Belvidere and Freeport, Illinois, and Janesville, Wisconsin. (BLc.)

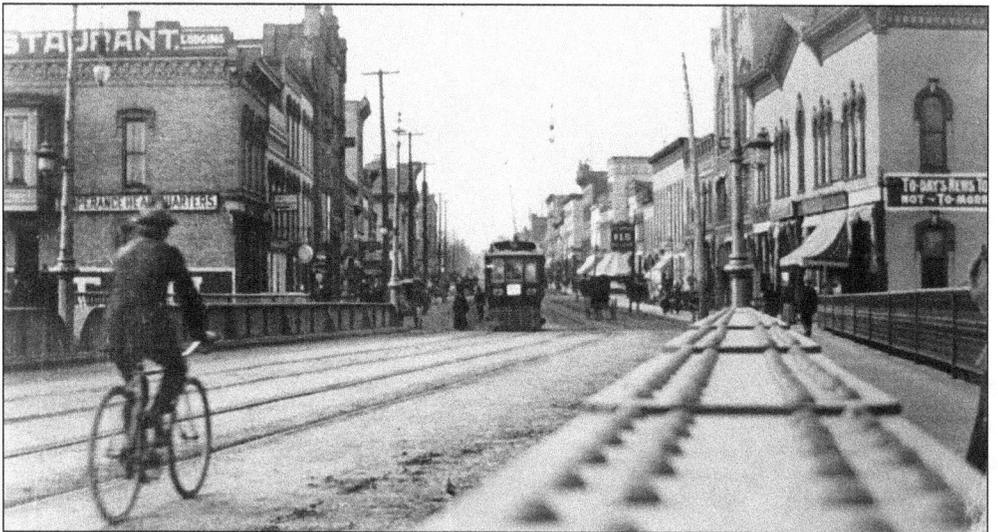

Using a girder of the new (1891) State Street bridge to steady his camera, a photographer captures an interesting scene around 1905. The view, to the west-northwest, looks along State Street into Rockford's central business district. A trolley sets out for the east-side business district leading up to the Midway Market. Note the Temperance movement headquarters building at left. The first building at right is the *Rockford Register-Gazette* building and Rockford Business College. Eventually, it would house the State Theater. (Gordon H. Geddes collection.)

Two

THE R&I COMES OF AGE

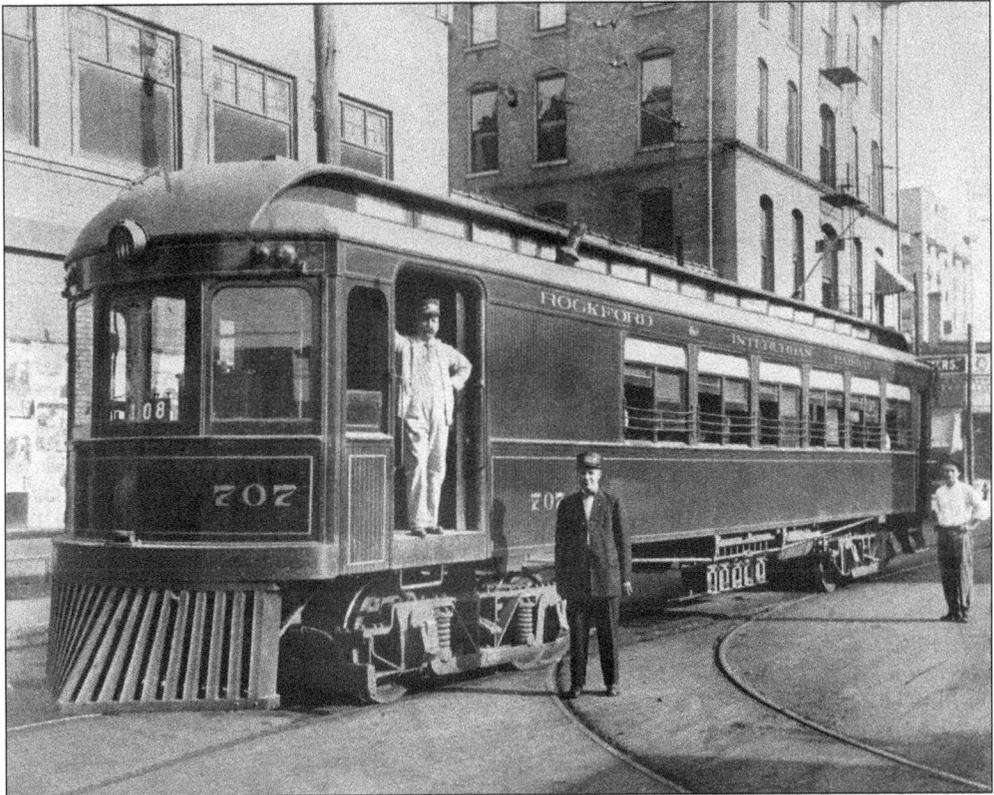

This scene at the Rockford & Interurban's main station at State and Wyman Streets in downtown Rockford shows the R&I at its zenith, with handsome, wooden interurban cars that were classics of their day. Car No. 707 was one of ten interurban cars built by the Niles Car Company and the Kuhlman Car Company in 1902–1903. The varnished cars wore Pullman green and had gold lettering and striping. The R&I's heyday, though, was relatively short-lived—28 years overall, from 1902 to 1930, with the peak of activity occurring around the time of World War 1. (BLc.)

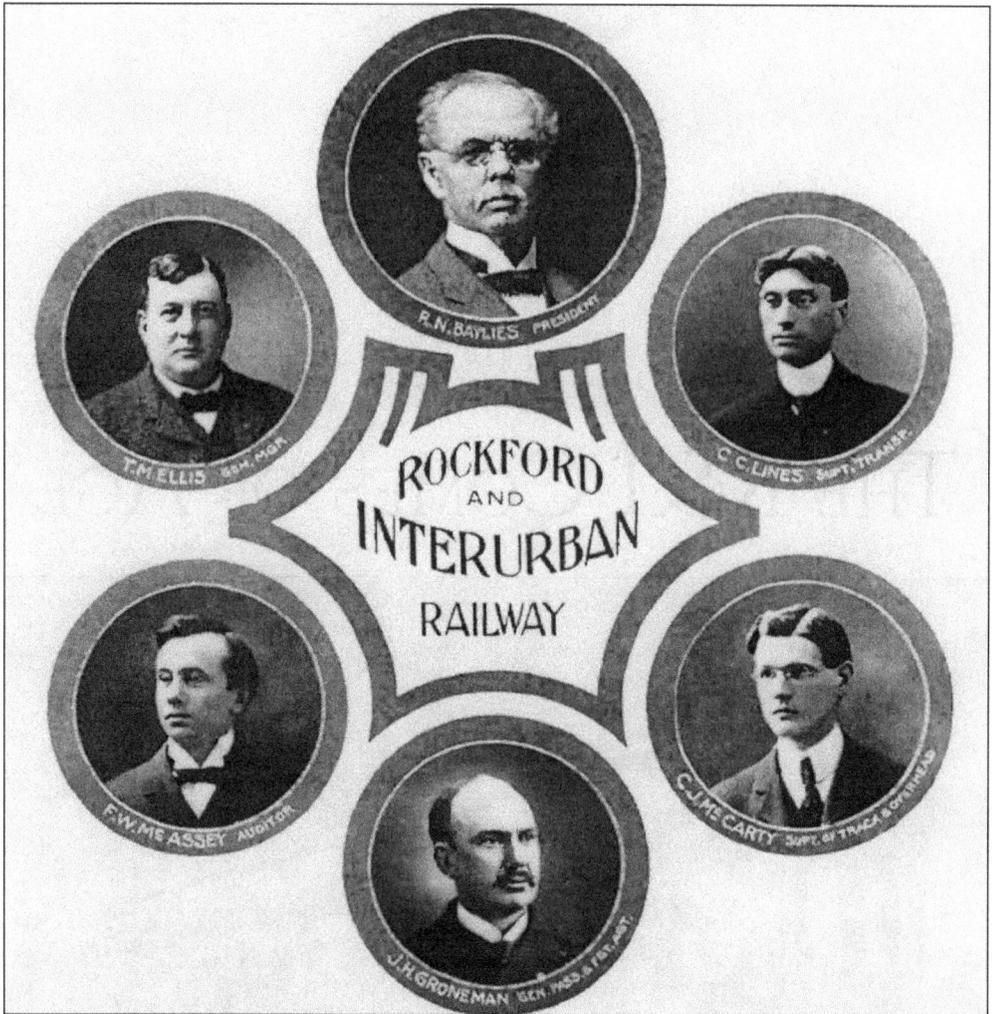

The men behind the founding of the Rockford & Interurban Railway are shown in this interesting composite image, which may have appeared in one of the traction news journals of the early 1900s that reported on the developments of the interurban and electric transit industry. The man most associated with the R&I was Judge R.N. Baylies (top). In 1889, he bought out the financially frail Rockford Street Railway. From there, other acquisitions led to the formation of the Rockford & Interurban Railway Company on September 16, 1902. The others shown here are, counterclockwise from top left, general manager T.M. Ellis, whose name surfaces a number of times in R&I history; auditor F.W. McAssey; J.H. Groneman, the general passenger and freight agent; C.J. McCarty, superintendent of track and overhead (the electric catenary system); and C.C. Lines, superintendent of transportation. (BLc.)

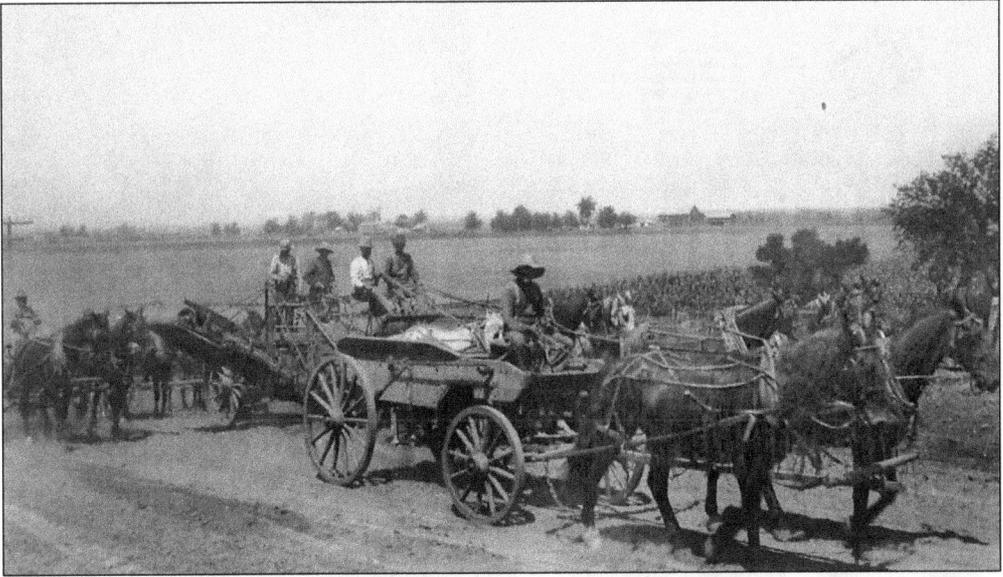

Early in the 20th century, no fancy construction equipment was available for building interurbans, which were usually created on a shoestring budget. This grading team, which may be the Kohler Brothers Construction Company from Chicago, is preparing the way for the pioneering Rockford & Interurban's first stretch of line beyond Rockford, to Belvidere, Illinois. This scene was recorded between the two cities. The line was built as the Rockford & Belvidere Electric Railway Company under the R&I's corporate umbrella. (BLc.)

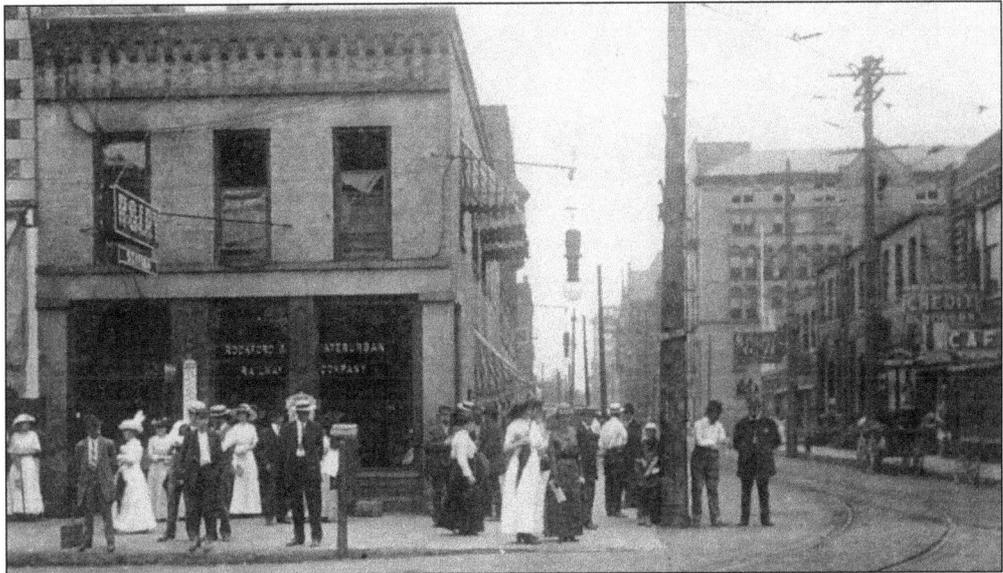

The Rockford & Interurban's main terminal in its namesake city was in this building at the corner of State and Wyman Streets. It is shown probably very shortly after the R&I opened for business on November 16, 1901. The building itself predated the R&I, and the railway likely leased it. This view looks south, with State Street in the foreground and Wyman Street at right. Interurban cars usually loaded or unloaded at the west side of the station on Wyman Street to stay out of the way of the flow of local streetcars. Electric lightbulbs spell out "R&I RY Station" in the sign above the main entrance on State Street. (BLc.)

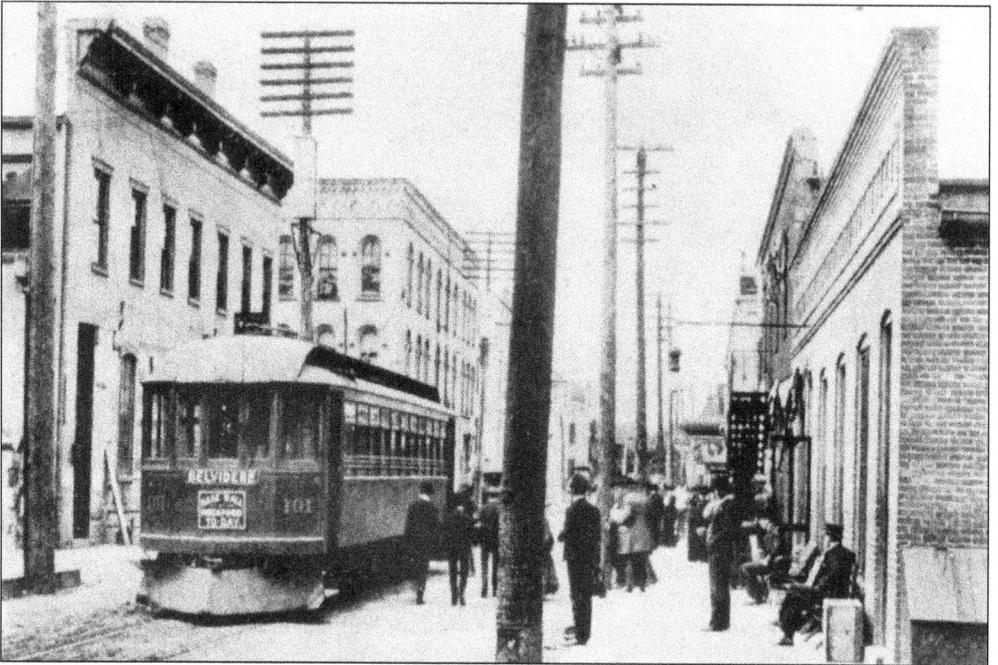

R&I interurban car No. 101, built by railcar manufacturer Barney & Smith of Dayton, Ohio, is at the R&I's main station (right) on Wyman Street at State Street in downtown Rockford around 1902. Upon departure, the No. 101 will leave the station heading south, looping around the block via Elm Street and South Main Street, then to head east on State Street for Belvidere. (SLIHS.)

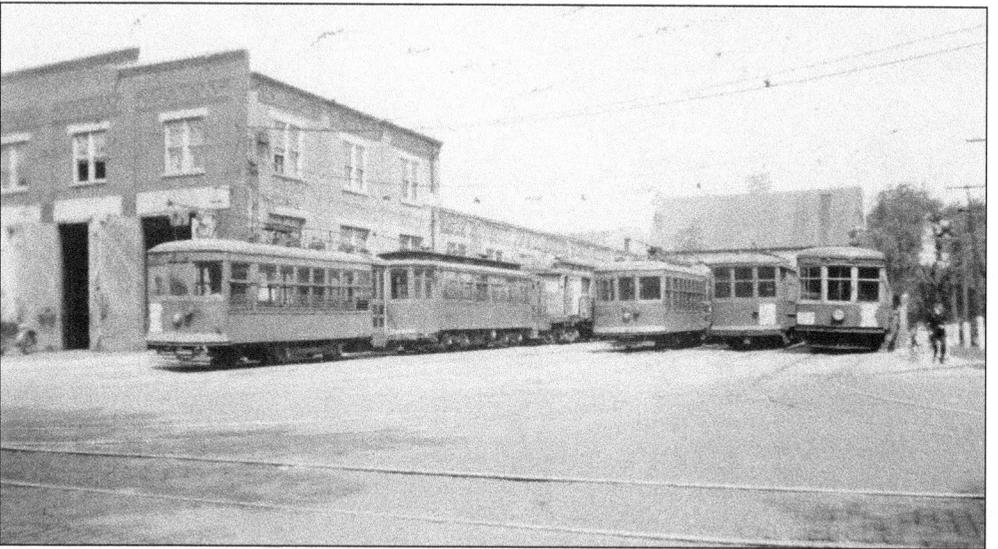

The heart of Rockford & Interurban operations was the Kishwaukee Street carbarn and yard at Kishwaukee Street (foreground) and First Avenue (right, beyond photograph). The building shown here is the third at this location constructed expressly for street railway and R&I operations since 1881. This brick facility was built in 1912 by the R&I and was still standing as of 2015, though it is almost unrecognizable because of its heavily modernized facade. The view in this 1930s photograph looks east. The R&I had an auxiliary facility called North Shops along North Second Street in what is today Loves Park. (Photograph by William C. Janssen.)

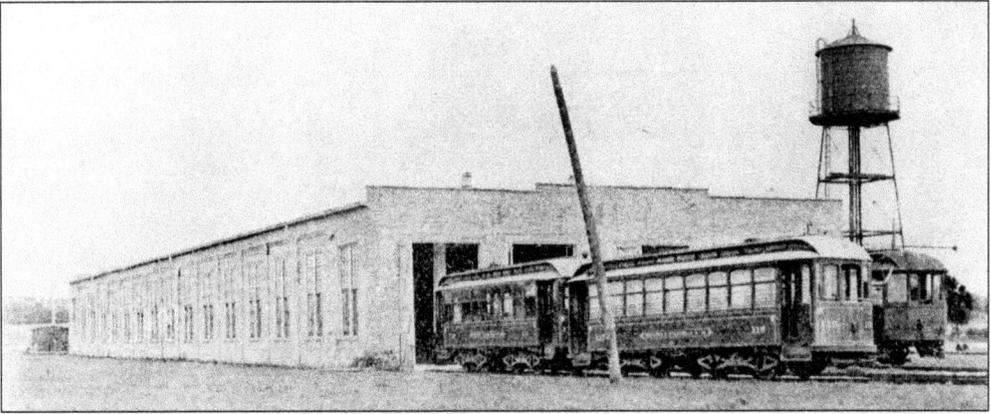

The Rockford & Interurban built North Shops in 1911 as an auxiliary facility to the Kishwaukee Street carbarns, destined for replacement in 1912. North Shops was 256 feet long and 75 feet wide. It had three servicing tracks, a carpenter shop, a paint bay, a blacksmith shop, and a machine shop. Major car work could be handled at the complex, located east of North Second Street in today's Loves Park on what is now the site of Woodward Governor. In fact, an apocryphal story suggests that the building still stands but that it has been integrated into newer buildings put up by Woodward Governor. (Gordon H. Geddes collection.)

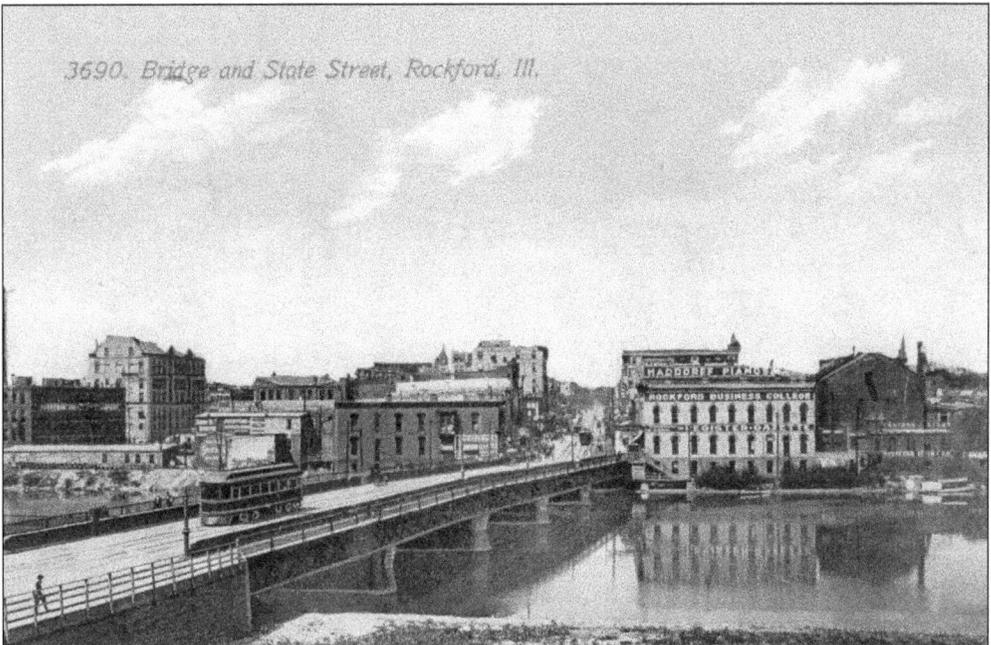

Though heavily retouched, this c. 1910 postcard shows an eastbound R&I 700-series interurban crossing the State Street "Girder Bridge" and heading into "Uptown," the Seventh Street business district, and then on to Cherry Valley and Belvidere. In the distance is what appears to be a local city car. This view looks west-northwest. Today, the area is nearly unrecognizable, in that many of these vintage buildings were replaced in the late 20th century by larger, modern structures of lesser aesthetic quality. (BLc.)

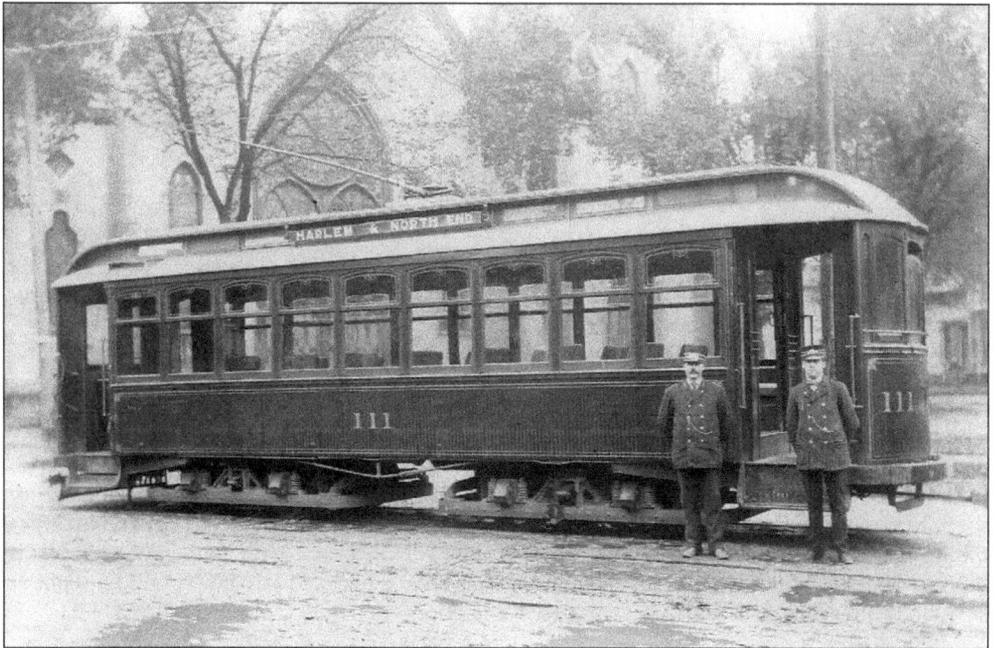

Here, two trainmen proudly stand with car No. 111, one of four cars built for the Rockford &
Interurban by Jackson & Sharp in 1901, the year the R&I was born. The car is in front of the
Rockford Masonic Cathedral at Kishwaukee and Walnut Streets. (BLc.)

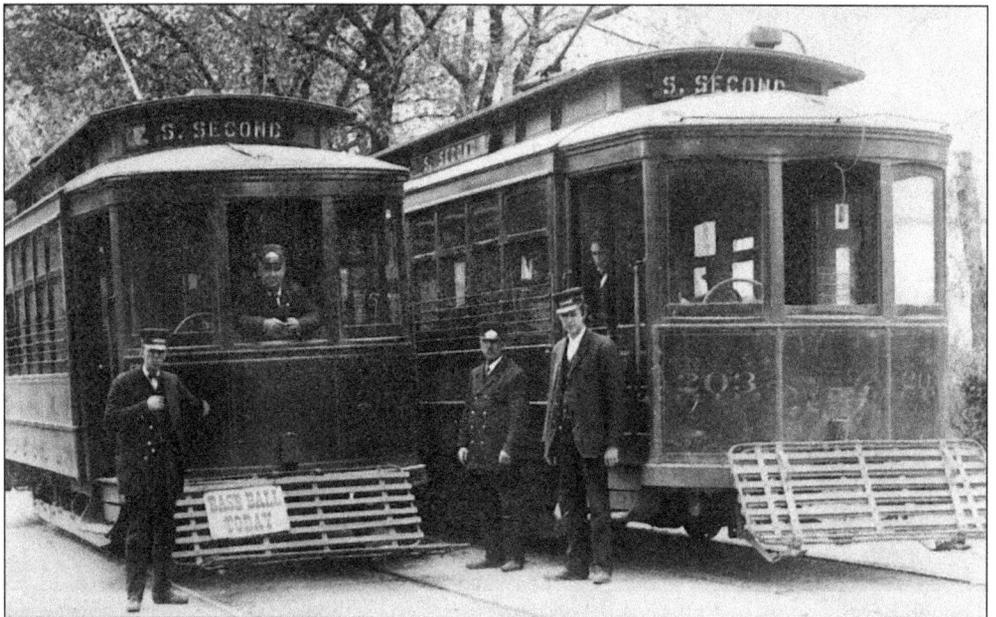

Although the R&I is thought of primarily as a city-to-city interurban carrier, the railway was, in
one way, closely tied to the operation of Rockford's city streetcar system, initially through outright
ownership and later through a subsidiary arrangement. City cars No. 209 and No. 203 pause as
they pass one another on the South Second Street route. Both cars were built around 1906 by
the St. Louis Car Company expressly for city service. (Photograph by Robert Wright, BLc.)

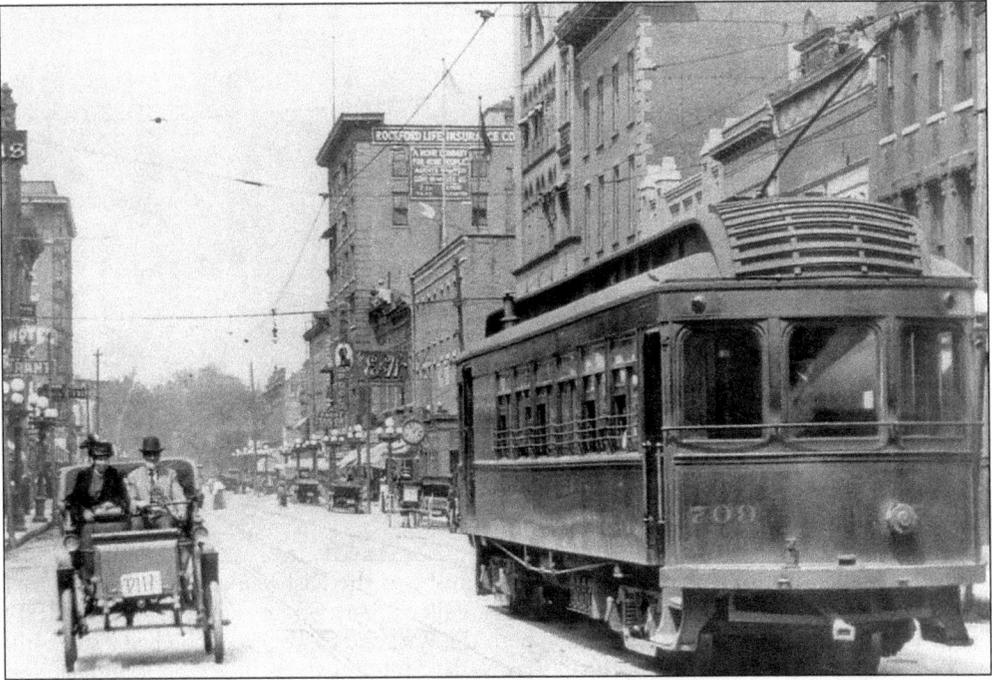

The view in this photograph looks north on Main Street, two blocks south of State Street, around the time of World War I. Rockford & Interurban car No. 709 travels away from the photographer, who, it is presumed, will get out of the way of the approaching, newfangled automobile. Car No. 709 has just looped out of the R&I station at Wyman and State Streets, then gone south to Chestnut Street, west to Main Street, and now north to State Street. From here, the car will turn east and head for Belvidere. (BLc.)

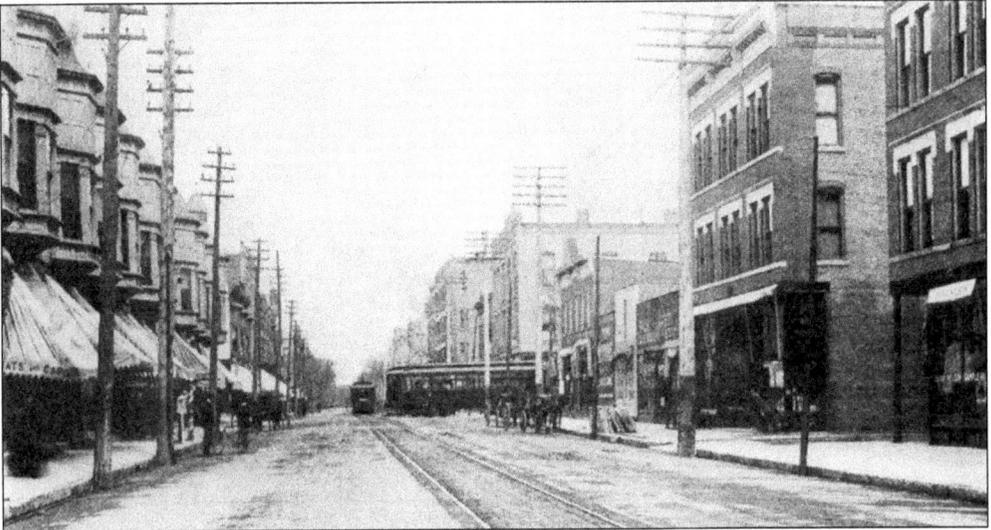

In this view looking north in the Seventh Street business district in 1914, a Belvidere-bound interurban car is in the process of turning east onto Fifth Avenue, as a city car follows. The city car will continue toward the photographer, who is standing at Sixth Avenue very near Chicago & North Western's East Rockford depot. Many of these buildings still stand, but the tracks are long gone. (BLc.)

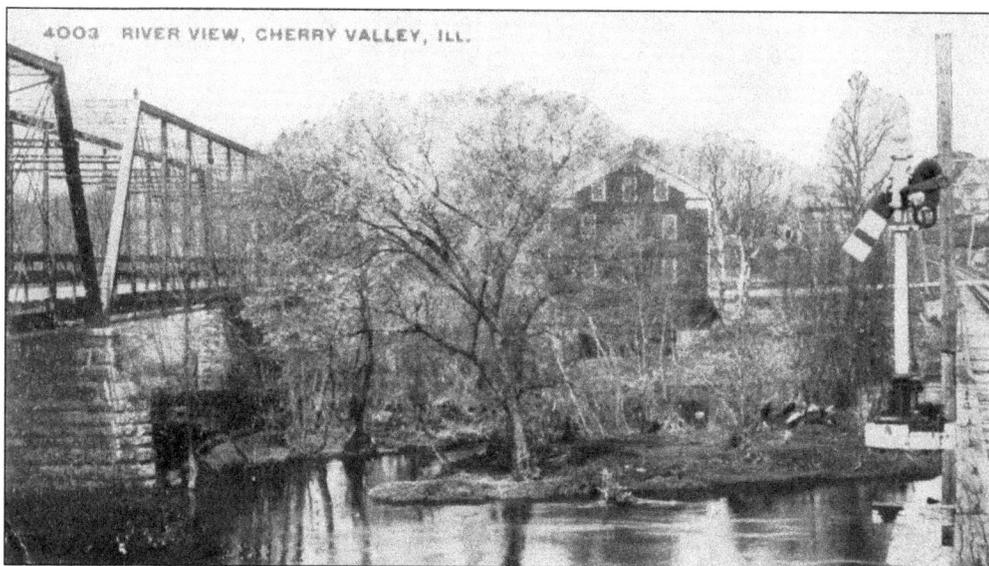

4003 RIVER VIEW, CHERRY VALLEY, ILL.

The west-facing view in this postcard photograph shows the Kishwaukee River just west of downtown Cherry Valley. The bridge for Cherry Valley's State Street is at left, and the R&I's bridge is at right. Beyond the river crossing, both the R&I and State Street climbed a steep hill out of the river valley. In Rockford, the Cherry Valley State Street became Charles Street, and the R&I continued to follow it closely, all the way to present-day Alpine Road before heading off into what is today the Rolling Green neighborhood of Rockford. The semaphore signal at right guarded the R&I's crossing of the C&NW. (BLc.)

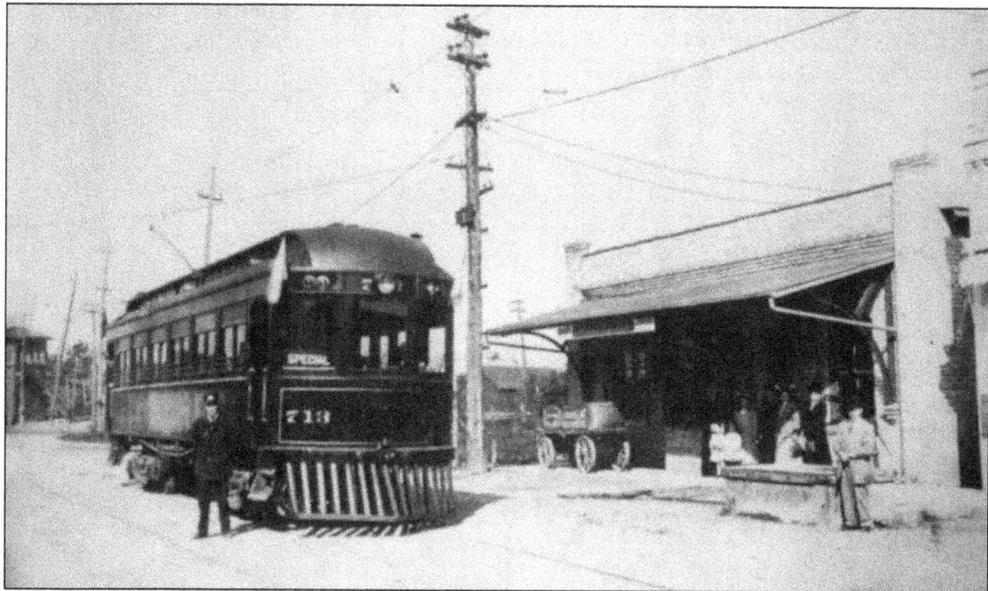

Running as a special train, not a regularly scheduled train, car No. 713 poses in front of the Cherry Valley station after arriving from Rockford. In the background is the tower controlling the intersection of the R&I and the Chicago & North Western's West Chicago–Elgin-Belvidere-Rockford-Freeport branch. A photograph taken today from this same spot will show a scene that has not changed all that much. The depot, nicely renovated, still stands, and the location of the R&I tracks can still be seen in Cherry Valley's wonderful brick streets. (Mike Patrick collection.)

This is the interurban station on the corner of Pleasant Street and McInnes Court in Belvidere in 1915. R&I car No. 713 boards passengers for a run to Rockford. The photographer is standing on or near the C&NW tracks, facing northeast along Pleasant Street. The car is loading on McInnes Court and will circle around to State Street as it departs for points west. (BLc.)

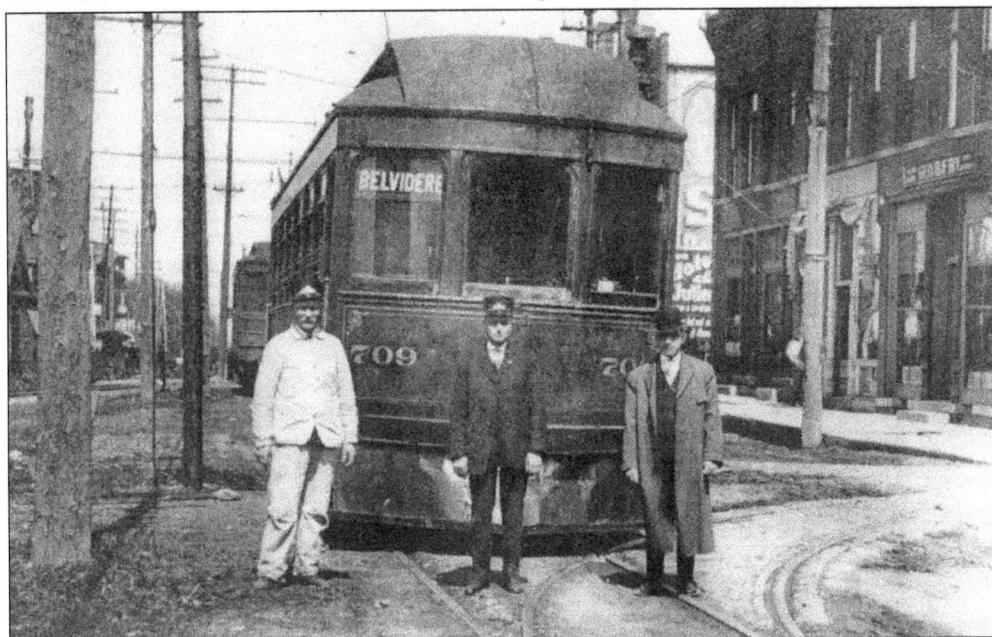

Rockford & Interurban car No. 709, a Niles Car Company product of 1902, is shown in front of the Belvidere station (beyond the photograph to the right). Behind is an Elgin & Belvidere car that will take connecting passengers east to Marengo, Union, and Elgin. The view in this c. 1910 photograph looks northeast on Pleasant Street, south of the Chicago & North Western main line off to the left. (Photograph by R. Wright, BLc.)

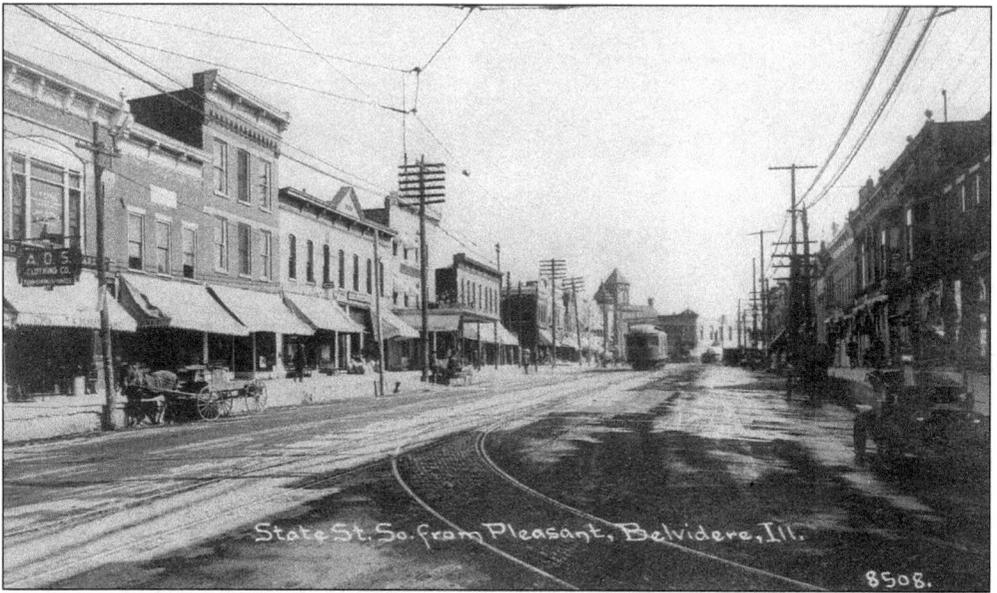

State St. So. from Pleasant, Belvidere, Ill.

8508.

Downtown Belvidere is shown about 1907, shortly after the Elgin & Belvidere began operation between its namesake cities. The view in this photograph looks southeast down State Street from its intersection at Pleasant Street. The track in the foreground diverging west onto Pleasant Street is one of the two "wye" tracks here—one from each direction—leading to the Belvidere station on McInnes Court. The approaching car from Elgin appears to be an express car for handling time-sensitive package shipments. (BLc.)

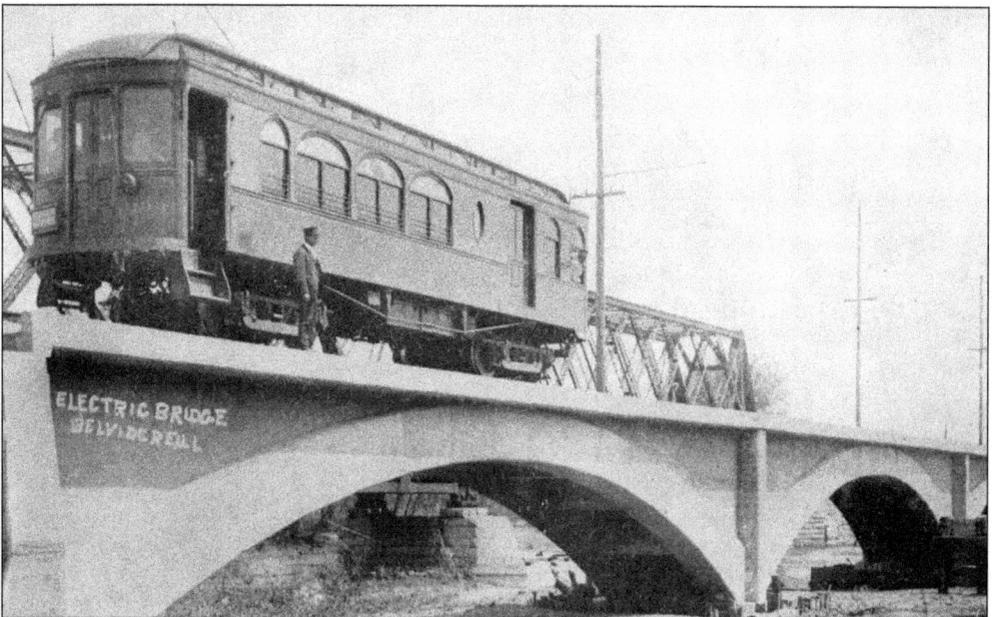

ELECTRIC BRIDGE
BELVIDERE ILL

An Elgin & Belvidere Electric interurban car stops on the graceful concrete arches of the new bridge spanning Coon Creek east of Belvidere. The photograph was probably taken shortly after the E&B opened for business in 1907. Immediately to the north is the parallel Chicago & North Western's West Chicago–Elgin-Belvidere-Rockford-Freeport line, a direct competitor for the E&B and R&I. (BLc.)

This is an Elgin & Belvidere Electric public timetable from 1909. Although not owned by the Rockford & Interurban, the E&B was a key player in R&I's bid for the Chicago-Rockford market, always a heavy corridor for travel. The timetable cover promotes the R&I as well as the Aurora Elgin & Chicago. In later years, the three lines would offer coordinated services for near-seamless travel between Chicago and Rockford and to intermediate stations such as Elgin, Marengo, and Union. (BLc.)

OFFICIAL TIME TABLES

In Effect September 15, 1909

ELGIN AND BELVIDERE Electric Co.

CONNECTING

ELGIN GILBERTS HUNTLEY UNION MARENGO GARDEN PRAIRIE BELVIDERE

Connecting at Belvidere with the Rockford and Interurban for

Rockford, Freeport, Beloit and Janesville

Connecting at Elgin with the A., E. & C. for

CHICAGO, AURORA AND JOLIET

GENERAL OFFICES

181 LaSalle Street, Chicago

OPERATING OFFICE AND CAR SHOPS

MARENGO, ILLINOIS

W. A. RUSSELL, Superintendent

C. R. PETTENGILL, Freight and Express Agent

Issued by ROCKFORD & INTERURBAN RY. CO.

ELGIN & BELVIDERE ELECTRIC CO.

BELVIDERE

—TO—

ELGIN

On conditions named in contract

C R 64 ONE PASSAGE NOT GOOD IF DETACHED

Via R&I, E&B, AE&C

27410

Rockford to Chicago AND RETURN

Joint-agency service among area interurbans is illustrated in part by this ticket for a ride on the Elgin & Belvidere Electric between its namesake cities. The ticket was issued by the R&I. (BLc.)

33

The Hess Brothers & Company "Big Store" sparkles in the late-morning sun as an R&I interurban rolls in on East State Street from Belvidere, catching up to a local car. The view looks north at the new P.A. Peterson Building, completed in 1911. Carl and Milton Hess's new department store, located in the building, was convenient to all who used R&I interurban cars as well as city cars.

This is a Rockford & Interurban city line ticket from 1921. The punches indicate that the ticket was issued for a late-night trip on January 25–26 between Eighteenth and Fourth Avenues. Inasmuch as the Eighteenth Avenue area of Rockford was a factory district, the person making the trip was probably coming home from work, home being in the vicinity of Fourth Avenue near Seventh Street. (BLc.)

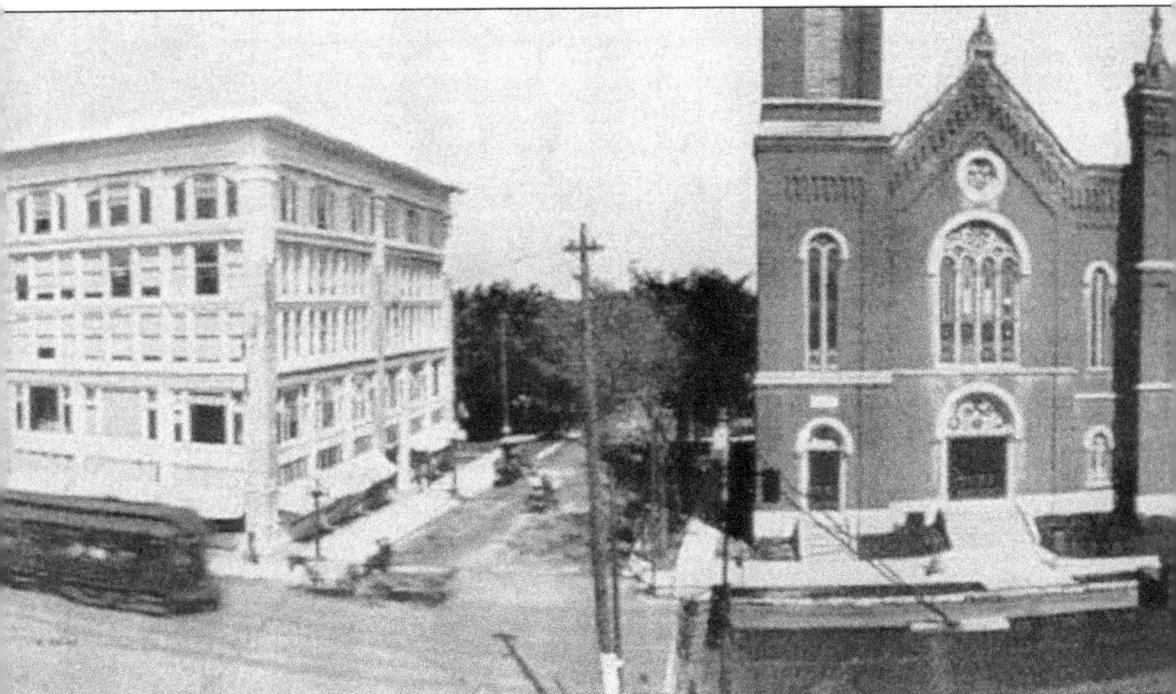

The photograph was apparently taken from the tower of the Midway Theater, which opened in 1918 at the Shumway Midway Market area along North Second and East State Streets. At right is the State Street Baptist Church. (BLc.)

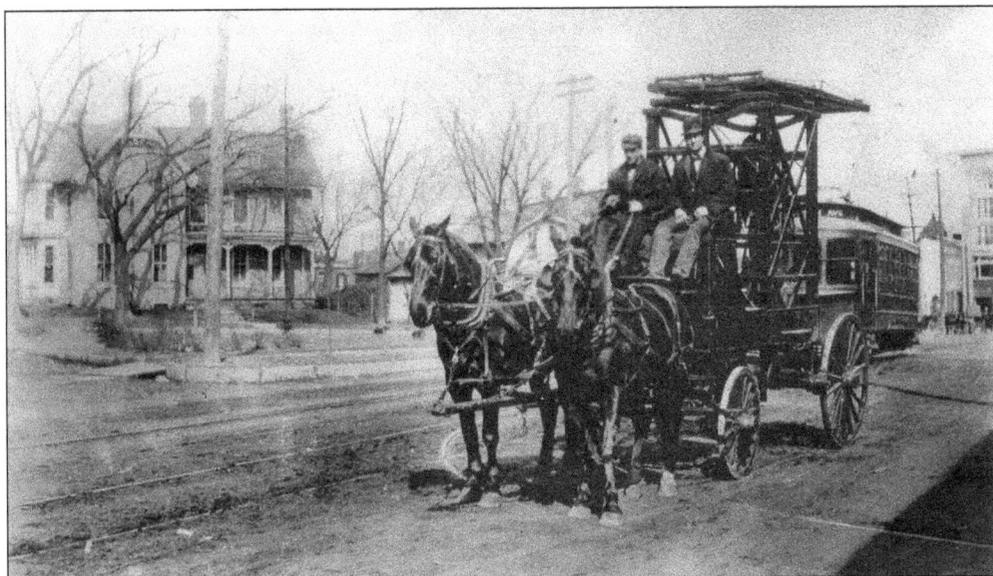

This extremely rare view of an R&L line car wagon was taken in front of the Kishwaukee Street carbarn (out of view at right). This was used to maintain the overhead catenary wire system. The platform on the wagon is of wood construction so workers can handle the overhead wires and not be electrocuted. At far right in the distance is the new Hess Brothers department store. (BLc.)

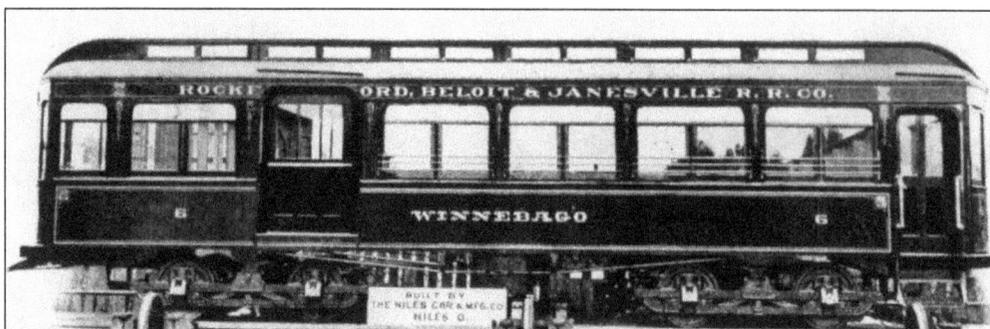

Rockford, Beloit & Janesville car No. 6, built by Niles Car Company in 1902, carried the name *Winnebago*, honoring the county of that name, for which Rockford is the county seat. This car was one of 11 built by Niles Car & Manufacturing Company of Niles, Ohio, and Kuhlman Car Company of Cleveland, Ohio, in 1902–1903 for the R&I subsidiary, which merged into the R&I in 1906. These cars were later rebuilt by the R&I. (Krambles-Peterson Archive.)

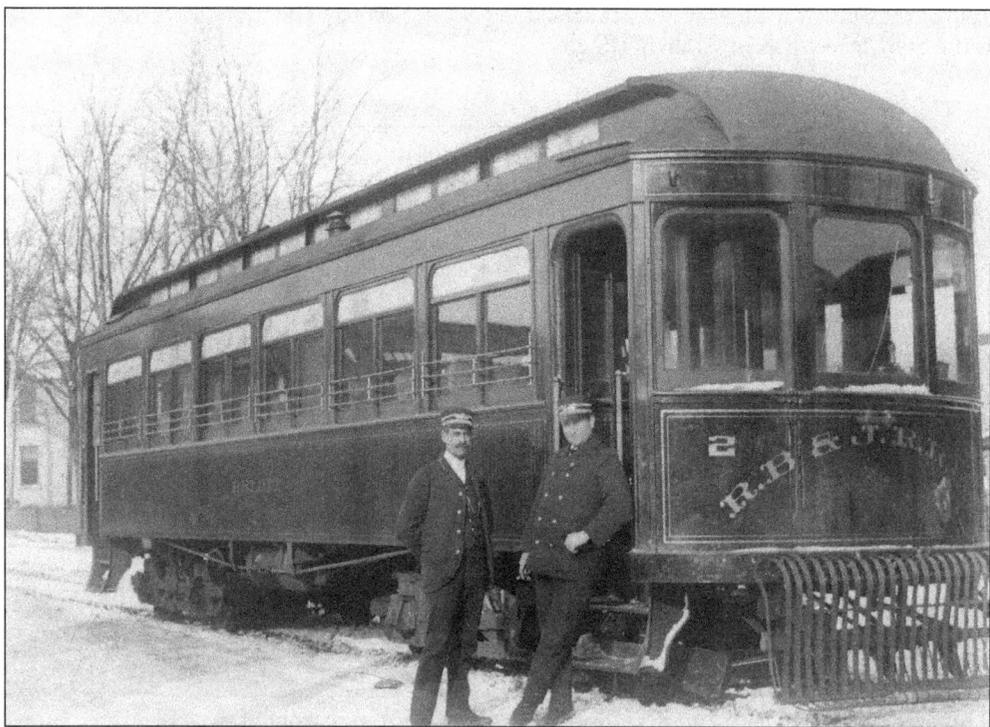

The first set of RB&J cars, Nos. 1–11, carried the railway's initials across the car noses. All of the cars were named. The No. 2, shown here in Janesville, was the *Beloit*. Conductor Joe Grell (left) poses with his unidentified motorman. (BLc.)

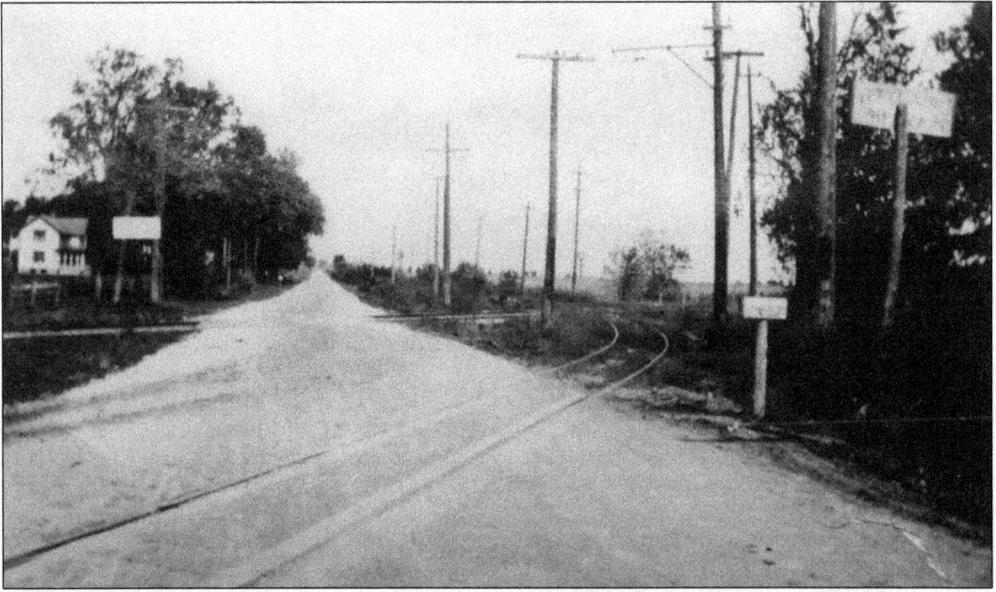

At Snow's Crossing, the R&I (RB&J) curved across Chicago & North Western's Kenosha Division line that ran between Rockford and Kenosha. The view looks north along the future North Second Street and Business US 51, which today is six lanes wide at this location and marks the south city limits of today's Loves Park. The former C&NW track, now owned by Union Pacific, is still in place. (BLc.)

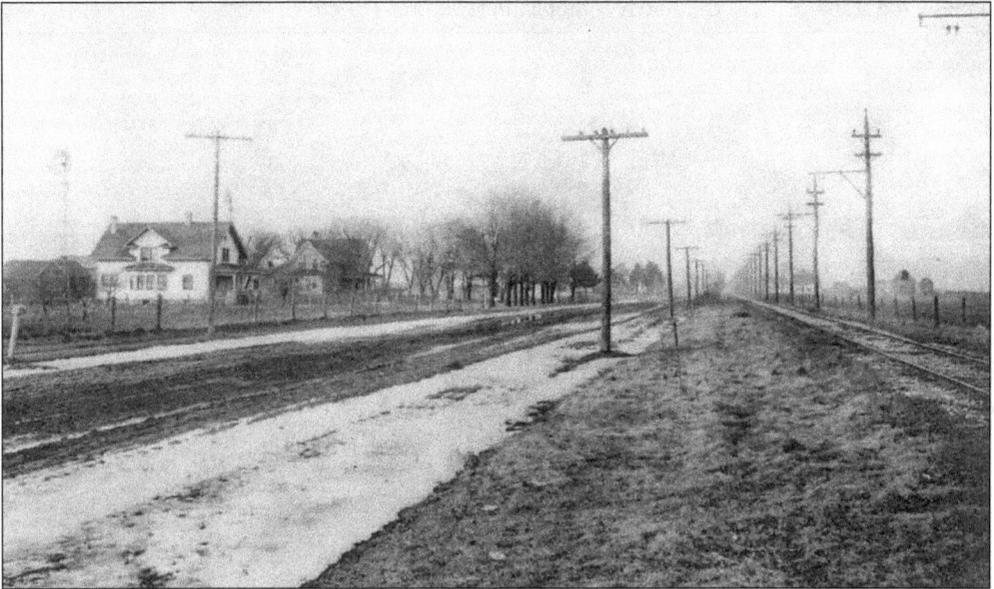

This scene along what is today North Second Street, Business Route US Highway 51, in Loves Park, typifies the look of early interurban properties. This photograph, with a north-facing view, was taken in 1915. North Second Street, a dirt road, became nearly impassable following heavy rain and snow. Such conditions made interurbans popular for the first 25 years or so of the 20th century. This rural scene is unrecognizable today, as North Second Street is now a four-lane, divided highway. The northbound lanes ride on the right-of-way of the R&I's RB&J line to Wisconsin. (BLc.)

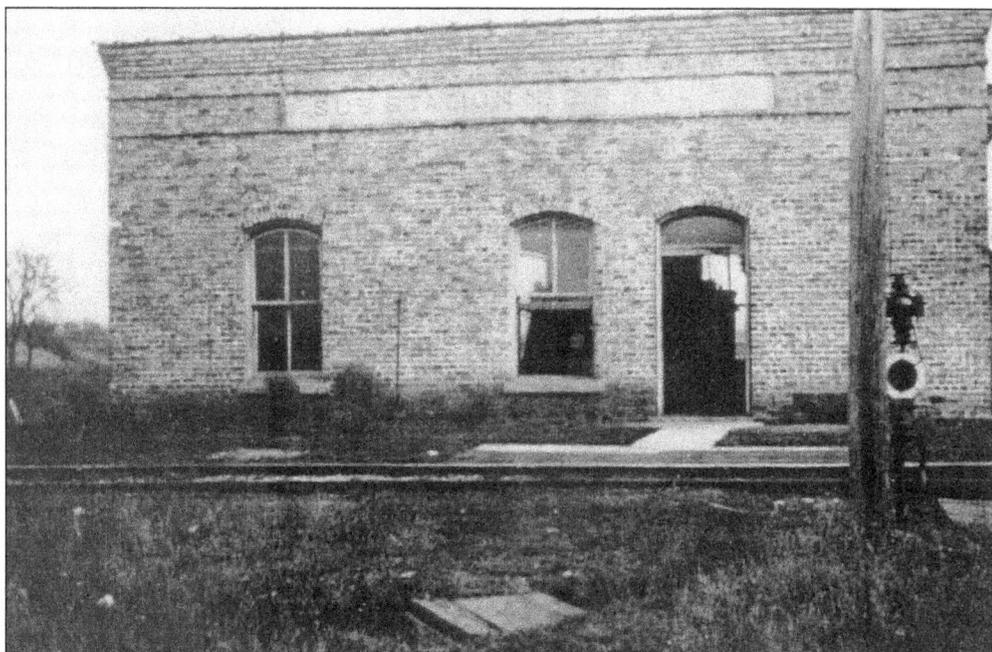

Substation No. 2 of the R&I's Rockford, Beloit & Janesville subsidiary was a sturdy brick structure located north of what is today the location of Machesney Mall. Substations were necessary to boost power in the catenary lost to resistance or the movement of a passenger car along the line. The switch stand denotes the north end of Miller's Siding. (BLc.)

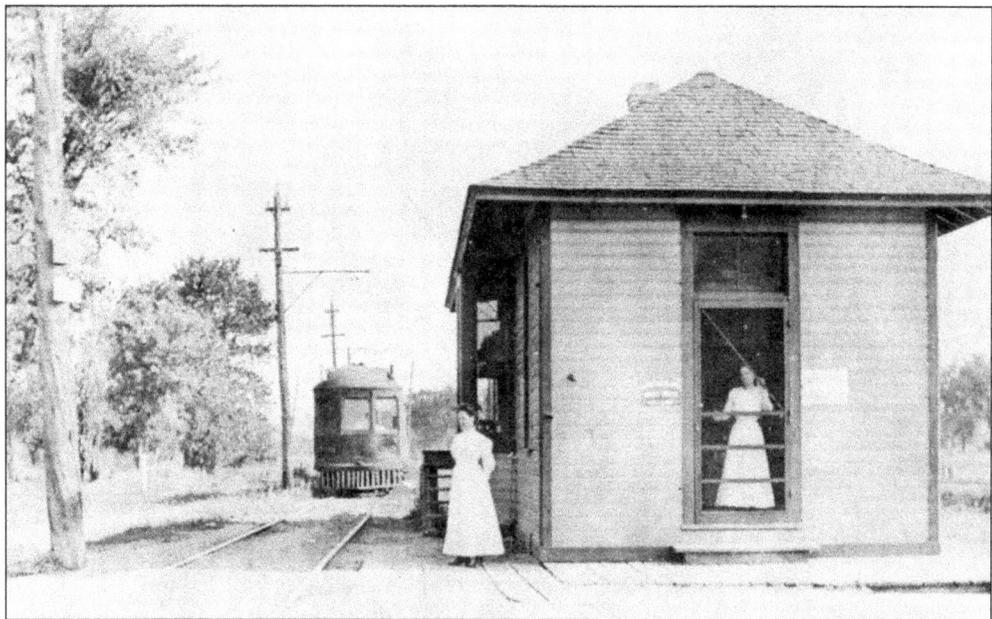

Rockton, Illinois, was still in its infancy when this photograph of car No. 703 was made as it arrived at the village's tidy frame depot. The agent at the time of this classic photograph was a woman, Margaret Comstock, standing on the platform. Interestingly, the Rockton station was a popular transfer point for travelers connecting to and from the nearby Chicago, Milwaukee & St. Paul. (Photograph by William H. Polk, BLc.)

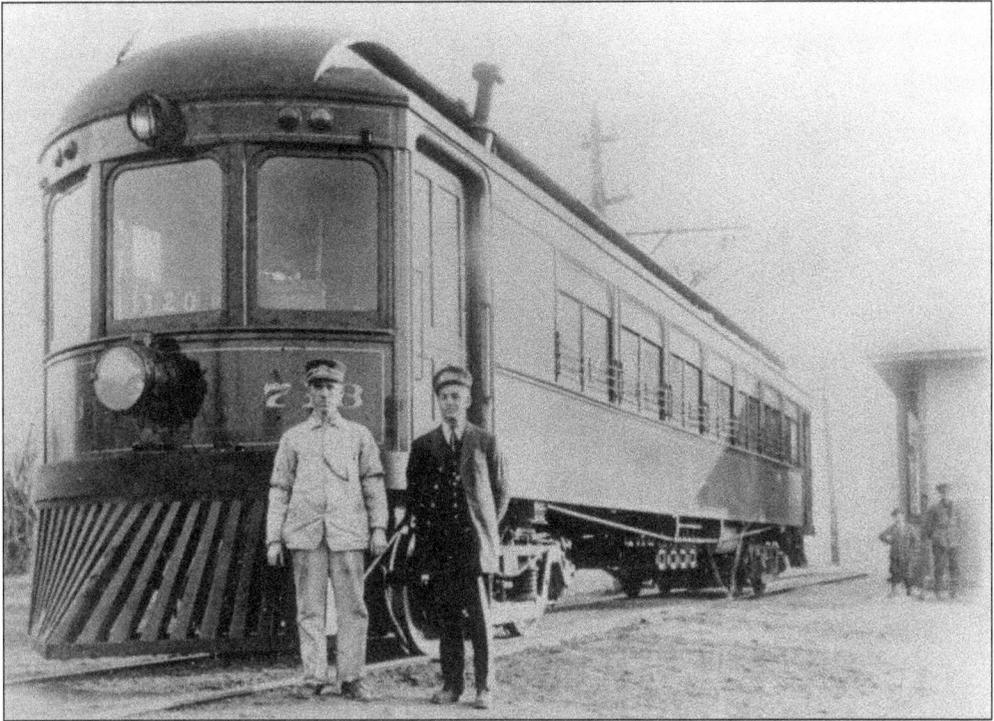

R&I crews apparently loved to pose with their electric steeds, as crew-with-car photographs abound in various collections. This unidentified crew stands with car No. 713 at Rockton, Illinois, around 1915. The small set of numbers visible through the front window indicates the run. All runs were numbered, as is done with steam roads and today's Amtrak. Train or run No. 120 was a Janesville-Rockford run. (Photograph by W.F. Michale, SLIHS.)

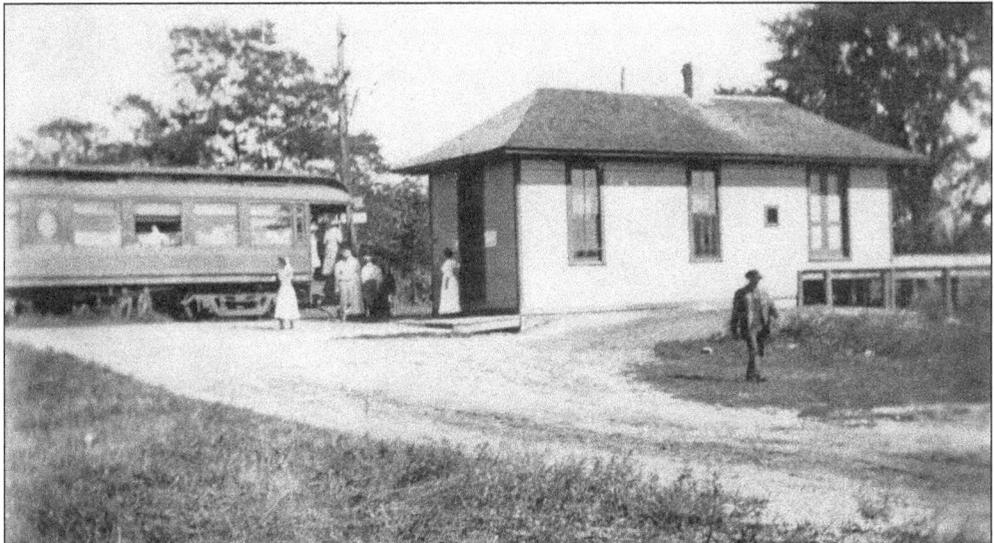

It is train time at the Rockton depot. What appears to be car No. 131, built for the Rockford & Freeport Electric by St. Louis Car Company in 1903, is being used on the RB&J line on this day in 1911. The R&FE had been merged into the R&I in 1904, after which R&FE cars could be found just about anywhere on the R&I system. (BLc.)

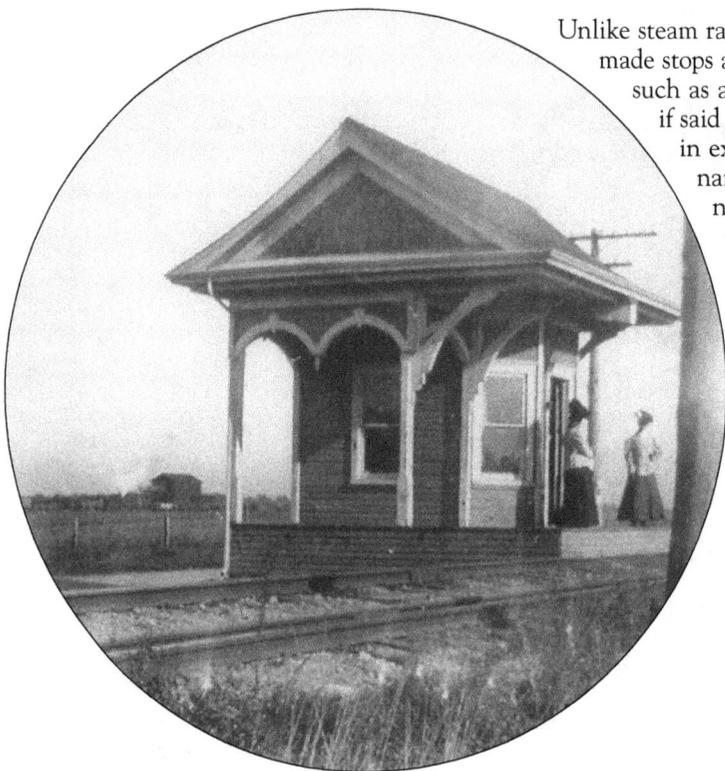

Unlike steam railroads, interurbans often made stops at isolated rural locations, such as a farmer's lane (especially if said farmer had provided land in exchange for a station stop named for his family). Liddle, north of Rockton, Illinois, on the R&I's RB&J line, was a good example. In this 1910 photograph, women await their train at what has to be one of the most attractive elfin depots on the entire Rockford & Interurban system. (BLc.)

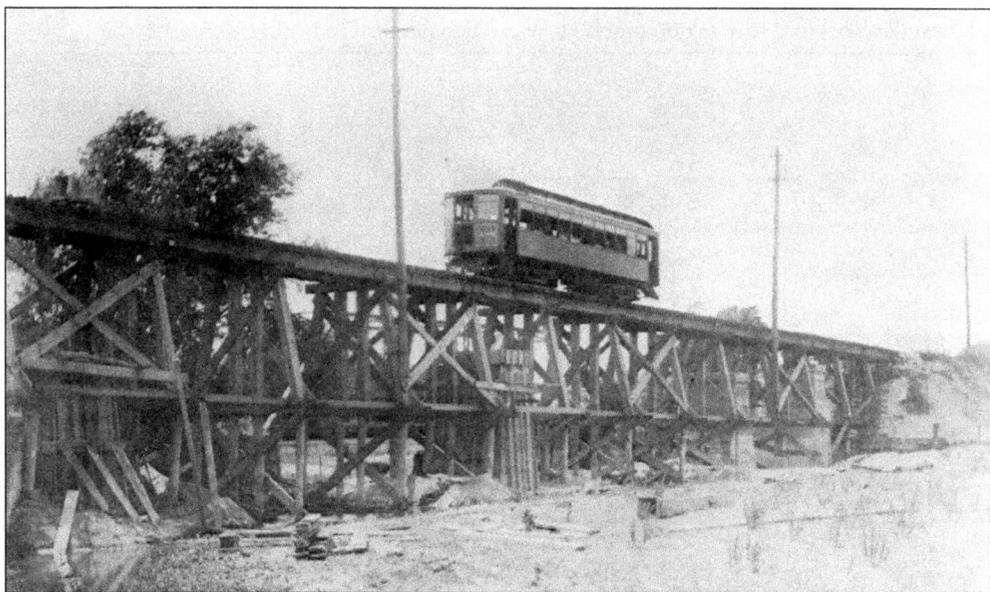

R&I car No. 105, one of the earliest built for the new carrier's interurban service, treads lightly over the original trestle near Rockton, Illinois. The car is on the Rockford, Beloit & Janesville extension. New concrete piers are being erected amid the trestle bents, which will be removed once all the piers and connecting girder spans are in place. (BLc.)

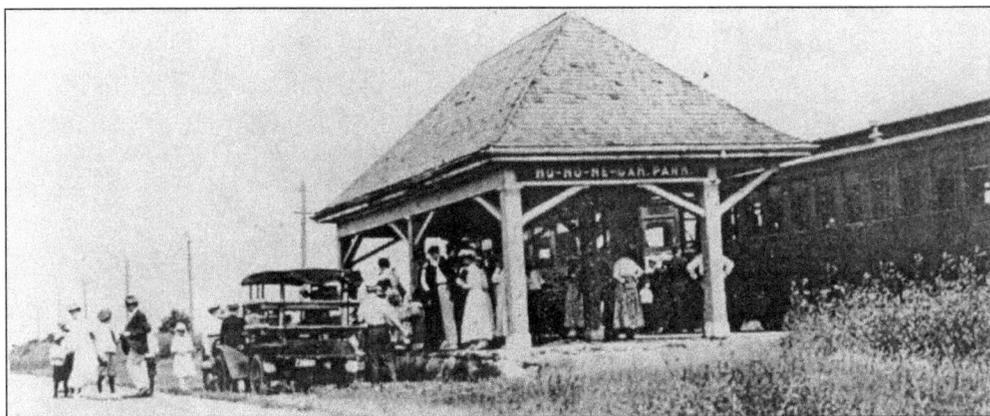

Hononegah Park—earlier spelled "Ho-No-Ne-Gah," a Winnebago name meaning "eldest daughter"—
was another popular destination for Sunday outings. The R&I had this extra-large shelter at the
stop, where a number of passengers have just detrained from an R&I train in 1916. (BLc.)

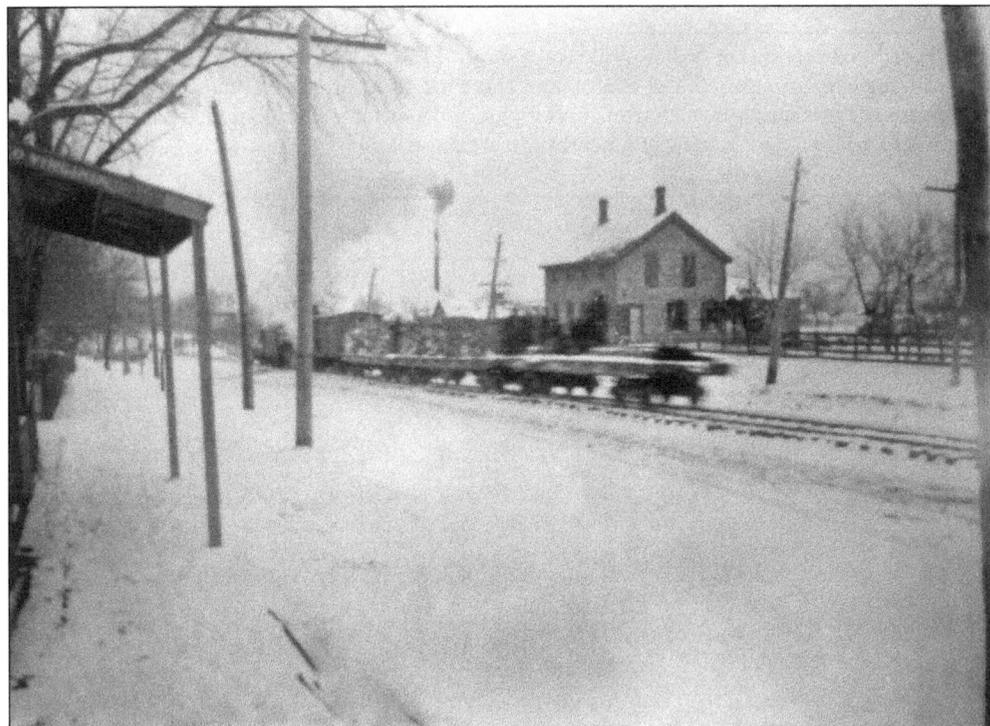

This very rare glimpse of the R&I's Rockford, Beloit & Janesville Railway under construction
shows a steam-powered work train passing through Roscoe along the future US Highway 51.
Today, residents would probably complain vociferously about a railway being built through their
neighborhood. Early in the 20th century, however, towns competed with one another to attract
a railroad to build through their community. (BLc.)

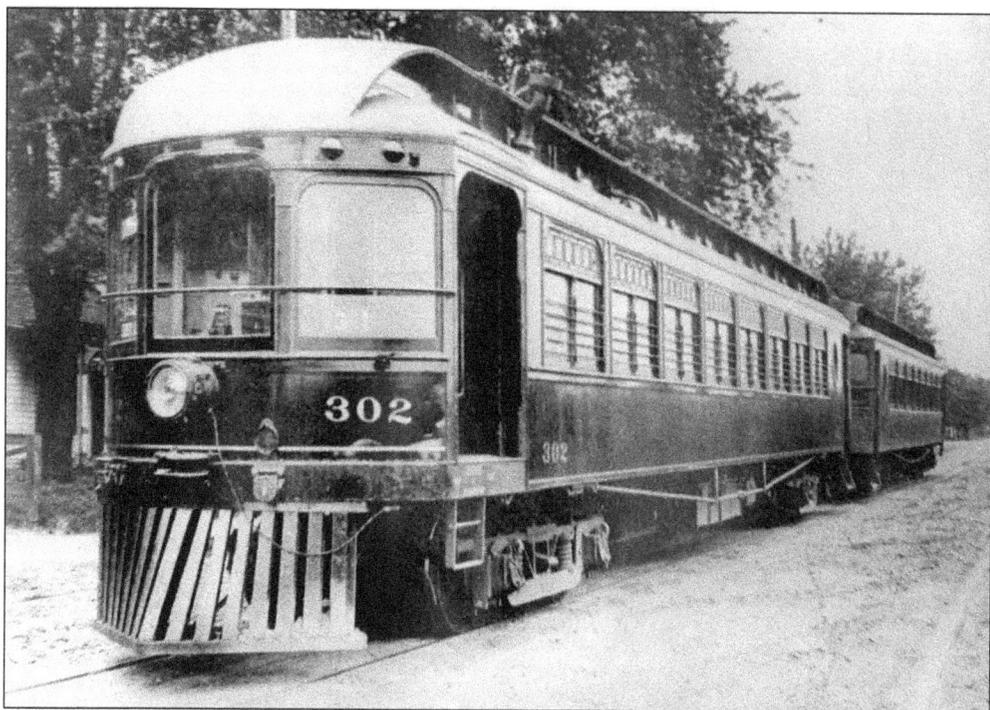

A two-car Rockford, Beloit & Janesville train stands at Roscoe, Illinois, on July 12, 1907. Since the train appears unmanned and empty, and there are two cars when one usually sufficed for regular traffic, this might be a charter run for picnickers or for a special group that has come up from Rockford for a day's outing at a nearby attraction. (BLc.)

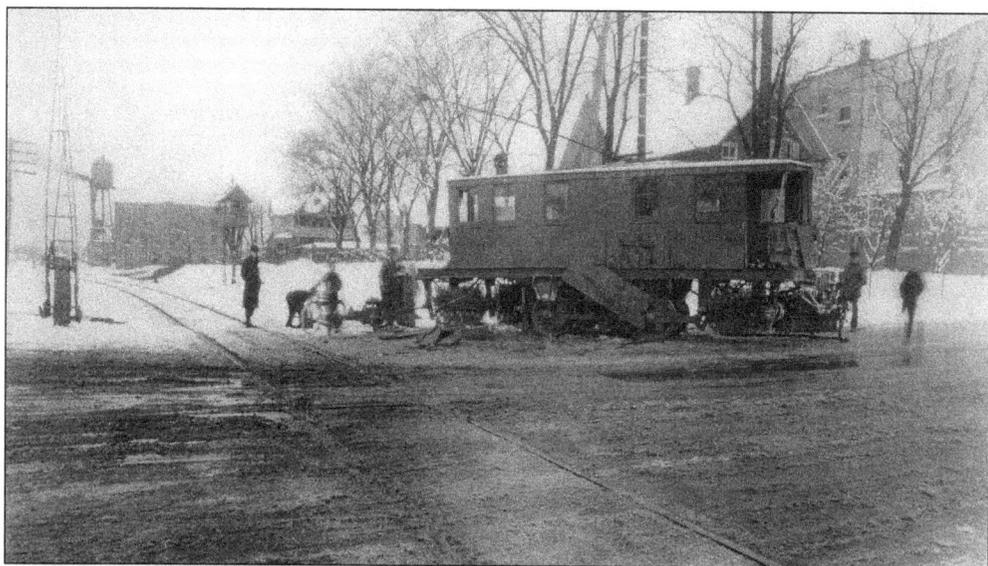

An R&I snow-sweeper working the Seventh Street line has somehow been knocked off the tracks where the line crosses the Illinois Central main line. One end of the car has been smashed, leading one to believe that the snow-sweeper may have had an unfortunate encounter with an IC train. The view looks westward toward Sixth Street. (BLc.)

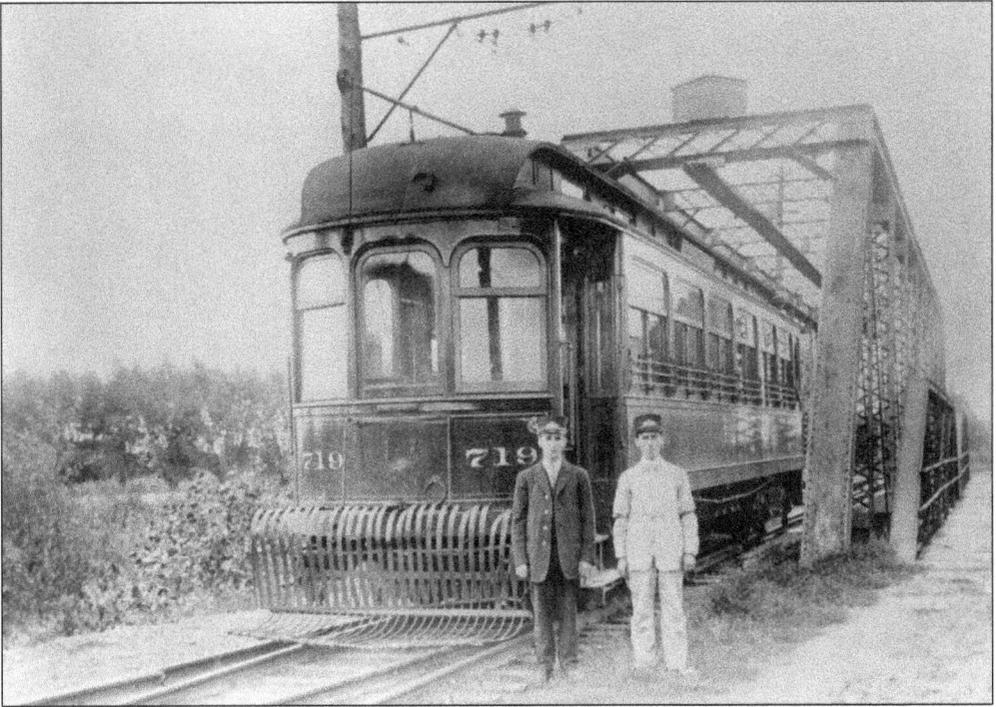

One of the Kuhlman-built 700s, No. 719, has exchanged its trademark pointed wooden pilot (an R&I trademark on the 700s) for an awkward-looking rake-type pilot. This is the north end of the R&I's bridge over Turtle Creek, with the Wisconsin state line behind the photographer. The switch ahead of the car led to the powerhouse and carbarn. The photograph was taken in South Beloit, Illinois. (SLIHS.)

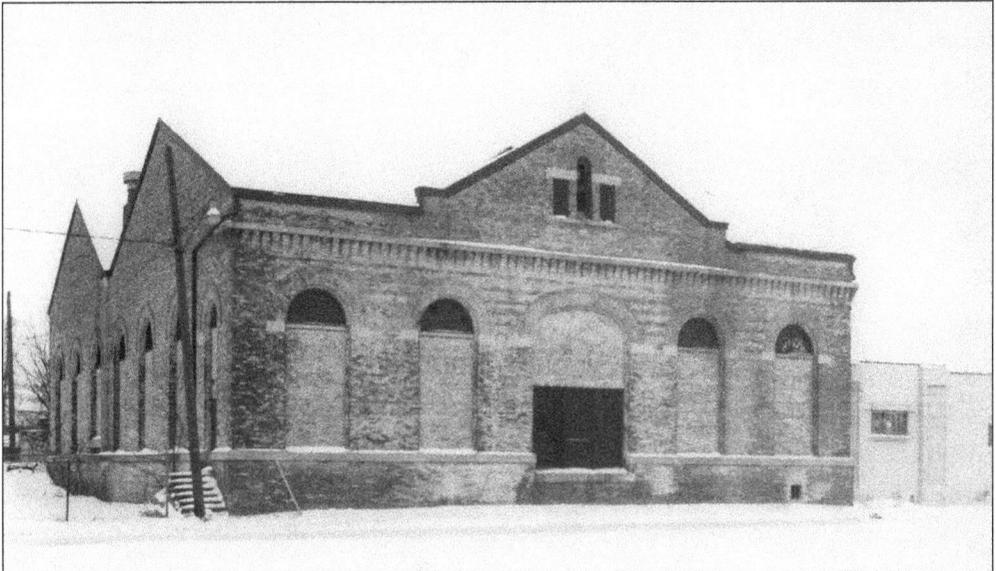

The Rockford, Beloit & Janesville Railway built this sturdy brick powerhouse at Beloit to power both the city streetcar system and the upper part of the Rockford-Janesville line. It was located south of the business district, near the Illinois state line. (BLc.)

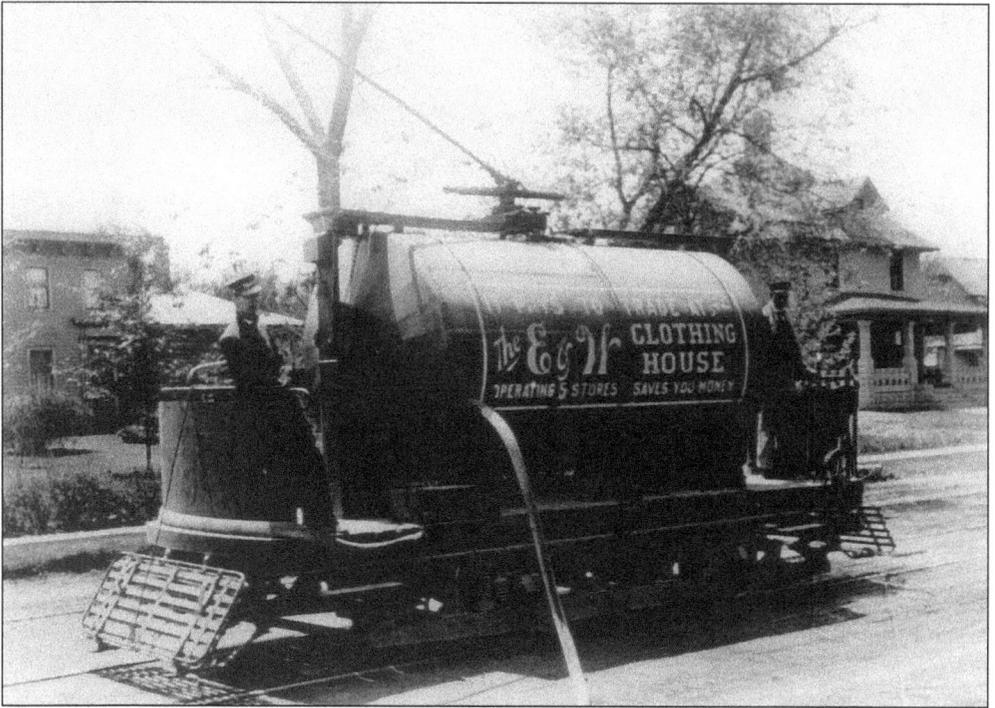

One of the more unusual pieces of R&I equipment was this water-sprinkling car, used to reduce the dustiness of dirt streets during dry weather and to help keep the rails clean for better grounding of electricity. The sprinkler car also doubled as a rolling billboard for local businesses. Charlie Fitch is the motorman on this day. (BLc.)

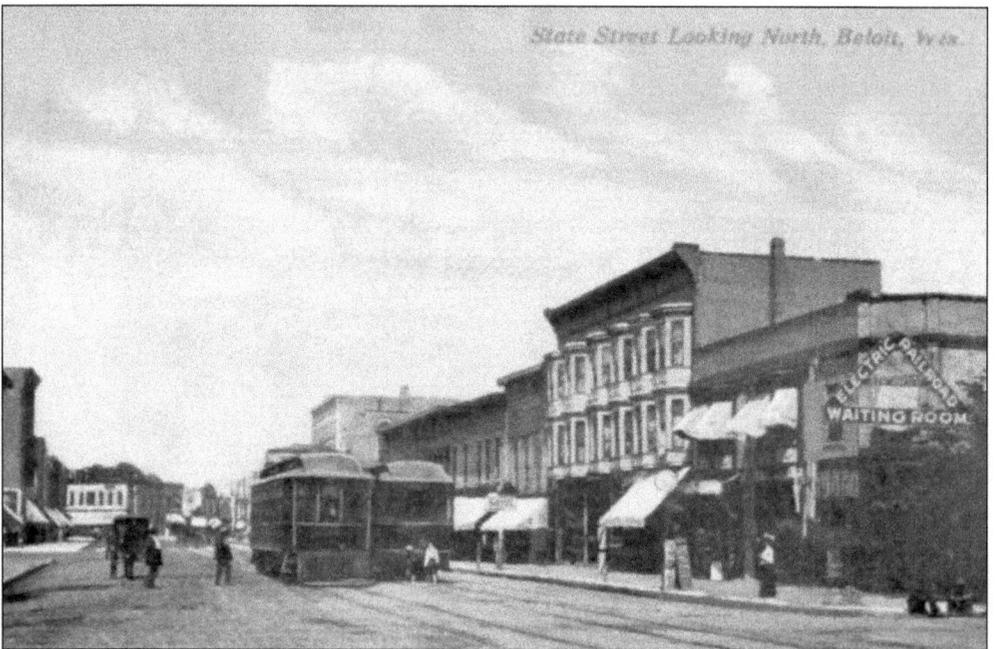

A pair of Rockford & Interurban trains meets at the station on State Street in downtown Beloit around 1910. Note the "Electric Railroad Waiting Room" sign at right. (Beloit College.)

This is Grand Avenue and State Street in Beloit, Wisconsin, around 1910. A Rockford & Interurban freight motor (left) on Grand Avenue approaches the intersection, and a Beloit Traction Company city car (right) turns north onto State Street. Although BTC was essentially a separate company from the R&I, at this time, the BTC was run by the same management group as the R&I. (BLc.)

One of the R&I's former Rockford, Beloit & Janesville cars built in 1902–1903 moves along Grand Avenue in Beloit, Wisconsin, around 1912. Automobiles, a couple of which share the street with the R&I train, had yet to take over city streets. Eventually, they would crowd out interurban cars altogether, becoming the default means of regional travel. (BLc.)

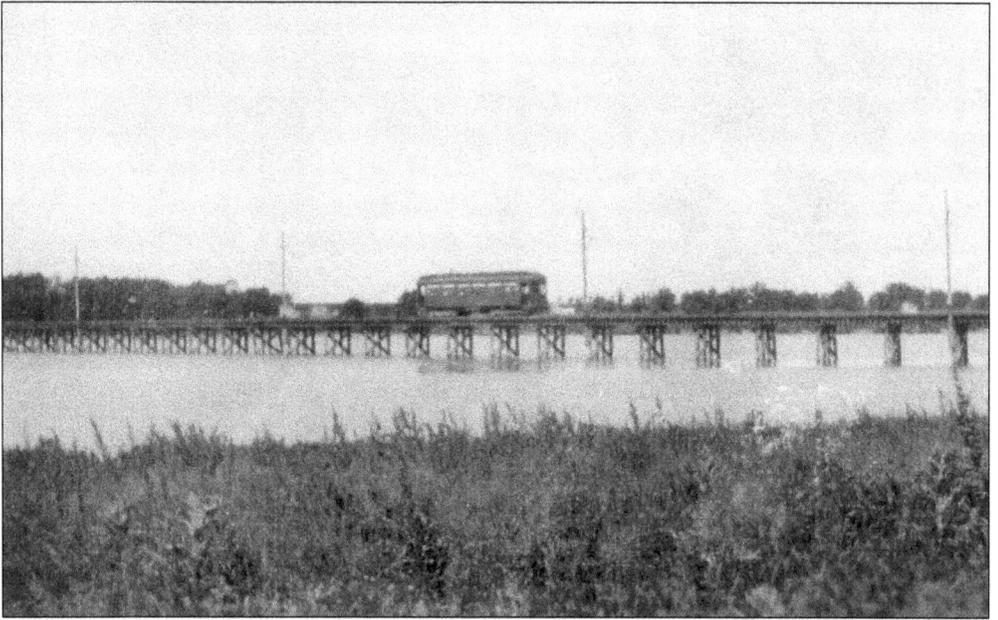

The Rockford, Beloit & Janesville Railway's route through Beloit required two crossings of the Rock River. The southern crossing was easy, as the RB&J shared Grand Avenue's relatively short bridge over the river. But the crossing north of downtown required a much longer bridge, as the river was wider because of a dam. This bridge was exclusive to the RB&J. The railway wanted to remain on the east side of the river to save on the costs of building the long trestle shown here, but political maneuvering determined otherwise. (BLc.)

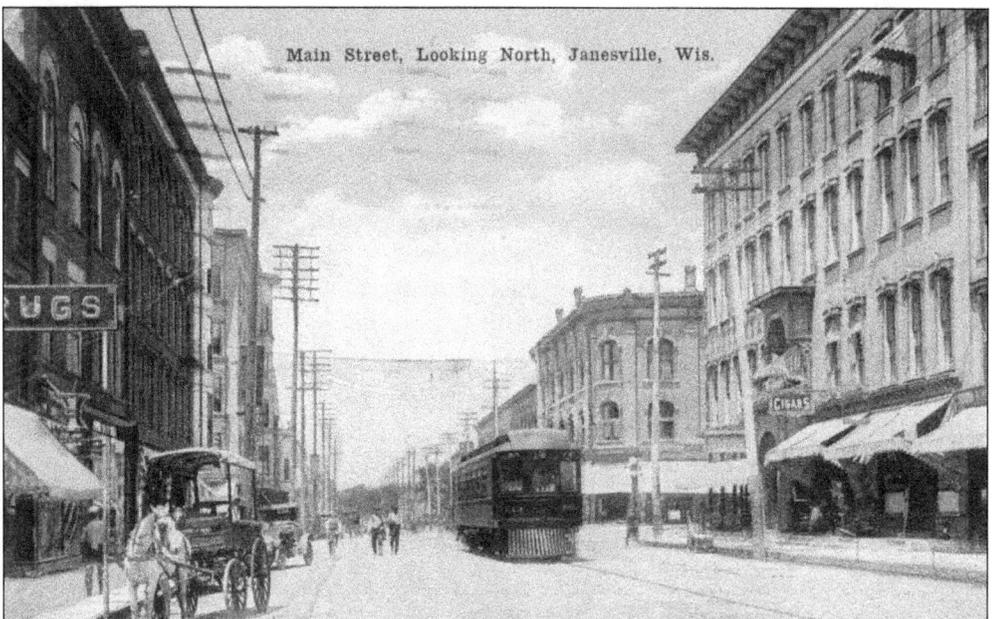

Rockford & Interurban car No. 713 cruises along Main Street in Janesville about 1910. The train has left its terminal northwest of this location and is headed for Beloit and Rockford. In another 10 or 15 years, the street will be congested with automobiles. (BLc.)

46

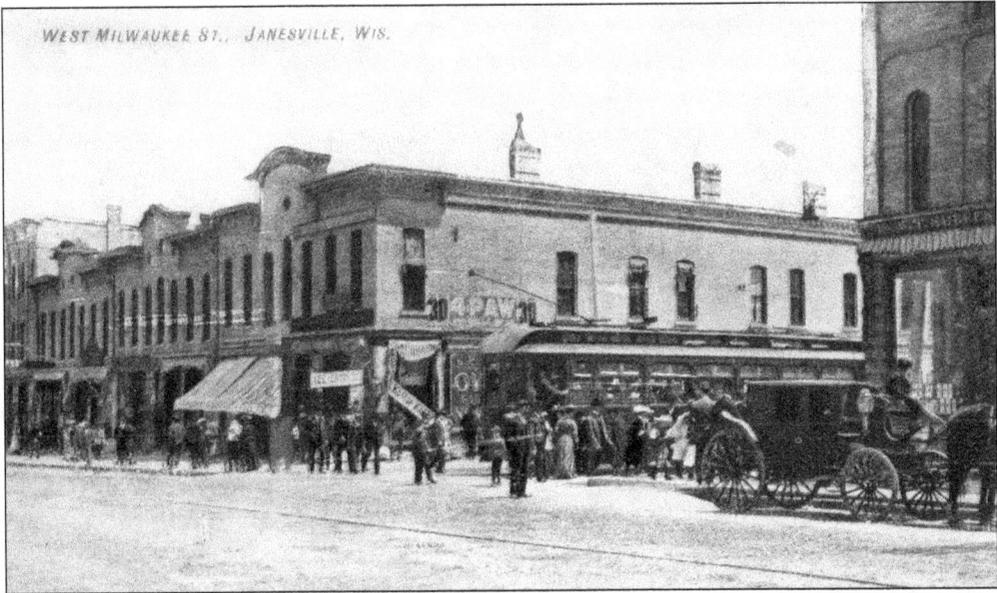

The northern terminus of the Rockford, Beloit & Janesville was at North Franklin and West Milwaukee Streets in downtown Janesville. Milwaukee Street was a major artery then, as it is today, though nearly all the buildings in this scene have been razed. Judging by the crowds in this postcard scene, this train may be among the first to operate into downtown in December 1902. (BLc.)

A Haven of Rest

A Quiet, Restful Home for the Restoration of Those Suffering from

Nervous and **Mental** **Diseases**

A l s o **D r u g** Addictions

FIFTEEN *YEARS'* *EXPERIENCE*

Delightfully located, one mile north of the city of Rockford, on the east bank of the Rock River. Five acres of Park. Pure spring water. All patients under the special personal care and direction of

P E N N W. R A N S O M , M . D . , R O C K F O R D , I L L I N O I S

The Kenosha Division of the Chicago and Northwestern R. R. passes within a few rods of house; all trains stop when requested from Rockford or Caledonia. Also the Rockford, Beloit and Janesville Interurban electric line passes the place, making easy access to Rockford or points north.

This c. 1905 advertisement for the "Haven of Rest" home for the mentally ill and anxiety-prone touted the facility's easy access by way of the Chicago & North Western as well as the Rockford, Beloit & Janesville Railway. This was an era when most people traveled by rail between cities. (BLc.)

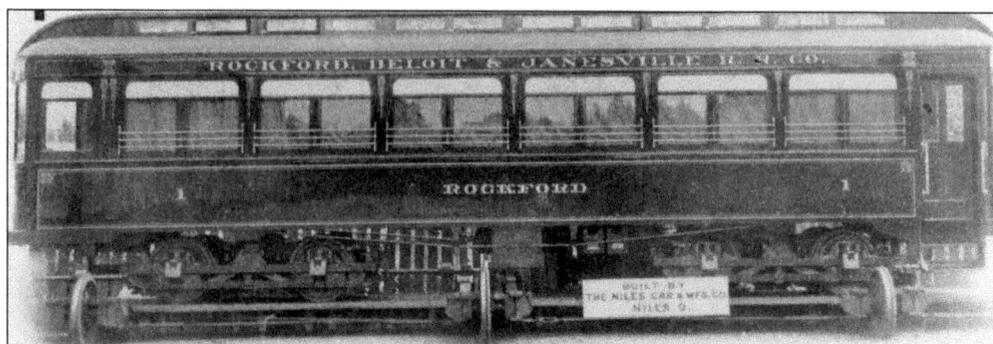

Rockford, Beloit & Janesville car No. 1, named the *Rockford*, is shown upon its release from the Niles Car Company in Niles, Ohio, in 1902. The car sits on a transfer table at the Niles facility and will be moved by a steam train to Rockford. There were 11 RB&J cars of this style (three were built by the Kuhlman Car Company), Nos. 1–11. Some were different in that they had baggage doors for handling express and milk. Later, all of the cars were transferred to Rockford & Interurban ownership, rebuilt, and renumbered in the 700 series. (Gordon H. Geddes collection.)

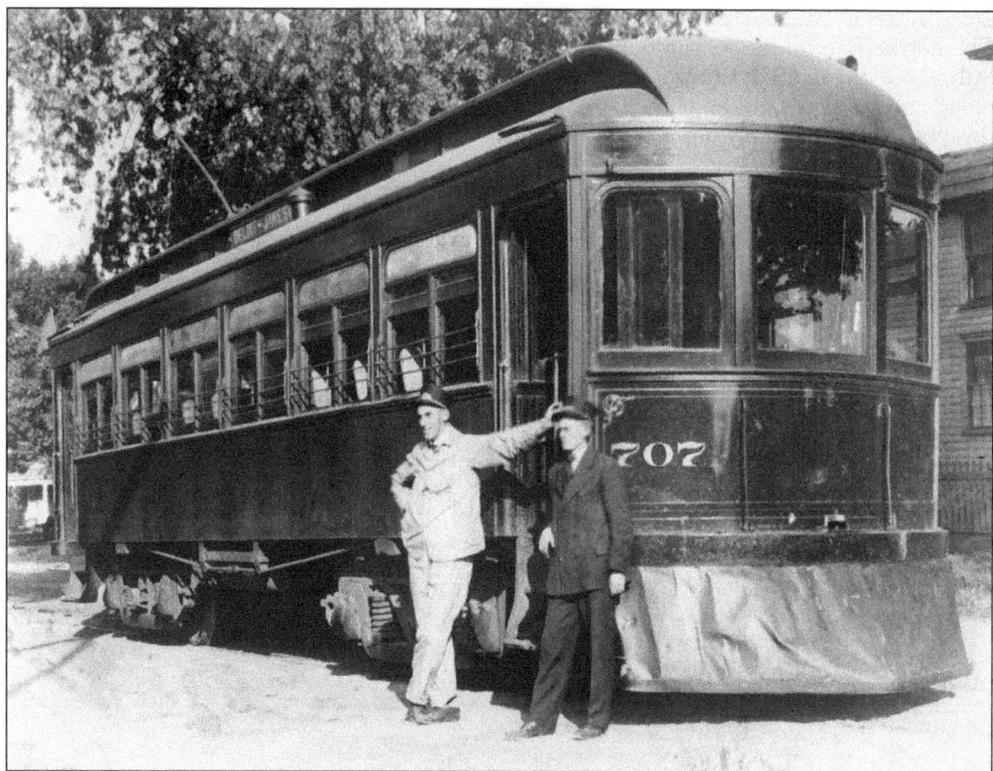

R&I car No. 707 and its six sister cars (701, 703, 705, 709, 711, and 713) all had traditional interurban car styling common in the early 20th century. All but three of the cars were built by the Niles Car Company of Niles, Ohio, in 1902. Cars 717, 719, and 721 were built to more or less the same specifications by Kuhlman Car Company of Cleveland, Ohio, in 1903. All were built for R&I subsidiary Rockford, Beloit & Janesville and initially assigned to Rockford-Beloit-Janesville service. Note the "Beloit-Janesville" destination plaque on the clerestory roof. (Photograph by William C. Janssen, SLIHS.)

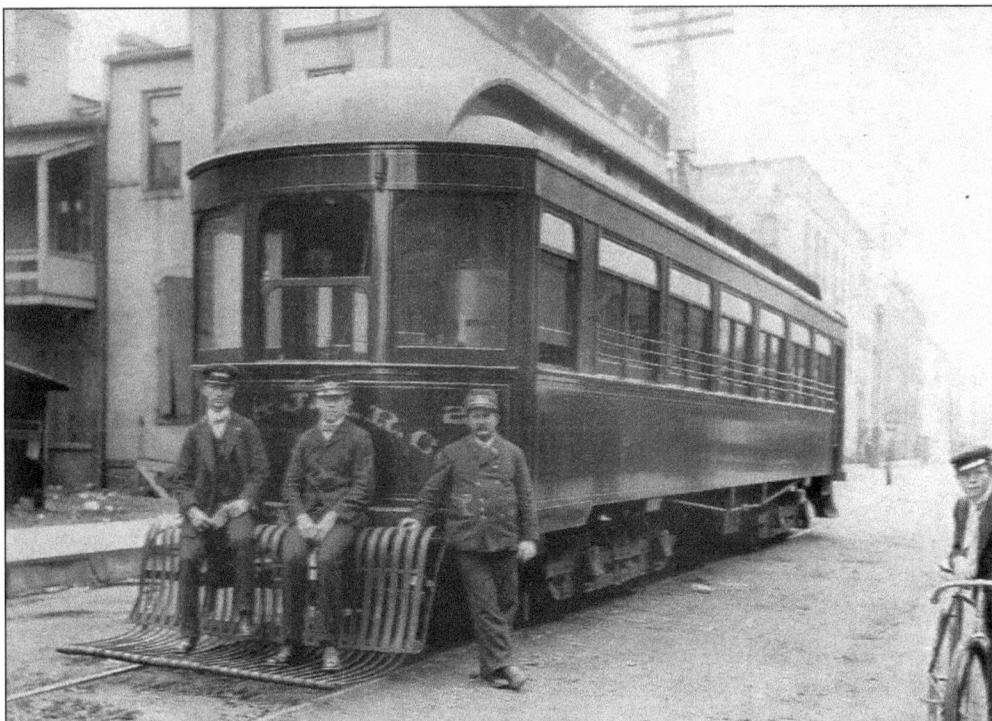

Rockford, Beloit & Janesville Railway car No. 2 and its crew are seen early in the car's career at the Rockford & Interurban station on Wyman Street just south of State Street in downtown Rockford. The RB&J was, for all practical purposes, merged into the R&I in a somewhat complex stock sale in 1911. The view in this photograph looks north on Wyman Street, which today has been widened considerably at this location. These buildings have long since been razed. (BLc.)

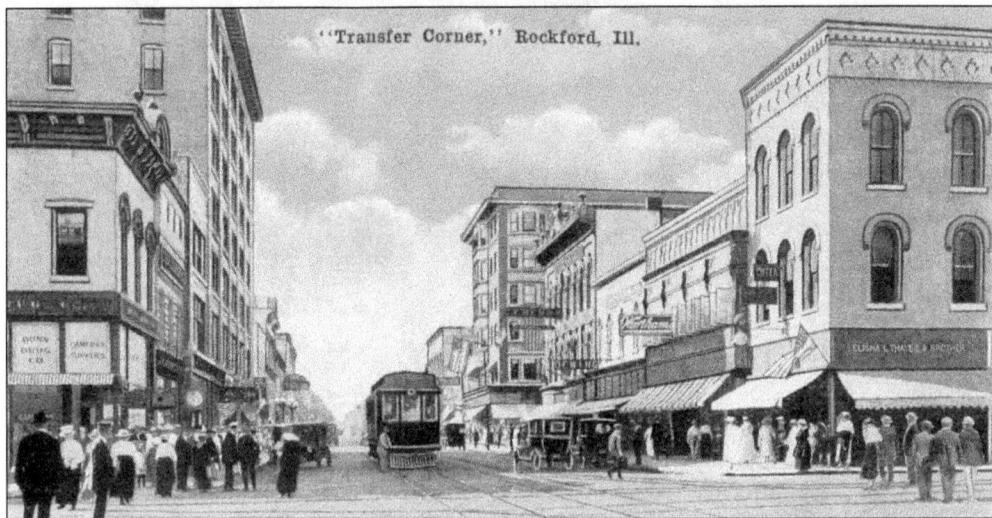

The main intersection of Rockford's streetcar and interurban lines was at State and Wyman Streets and was known as "Transfer Corner." At the time, this could be considered a transportation wonder and thus rated postcard-picture status. This c. 1910 view of the intersection looks west along State Street at Wyman Street. The Rockford & Interurban's downtown depot was just out of the photograph, to the left of the photographer. (BLc.)

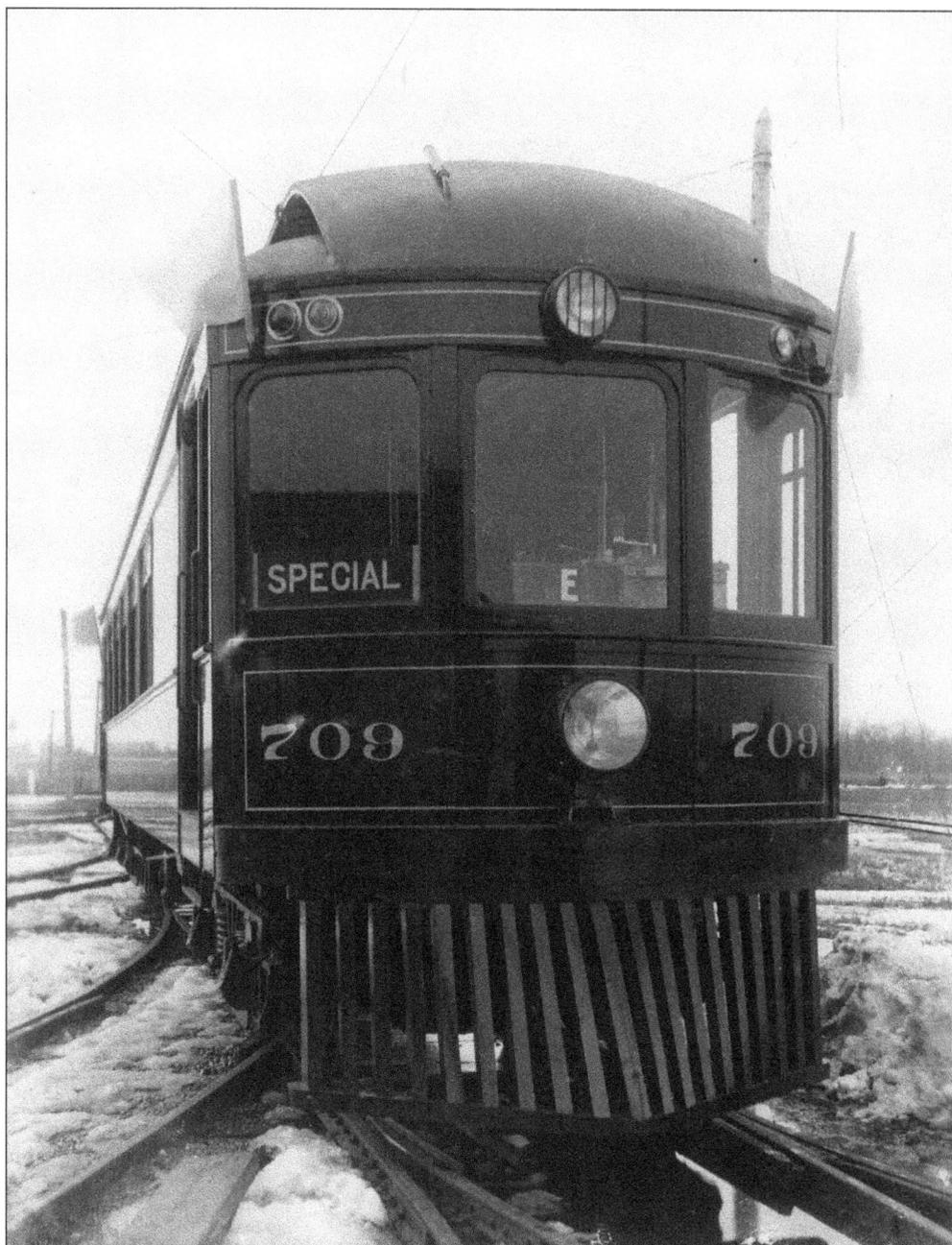

Fresh out of the Rockford & Interurban's North Shops from a rebuild, this car's varnish still glistens. R&I car No. 709 looks flashy in its pinstriped livery. All 10 of R&I's 700-series cars had been built in 1902 and 1903 as Rockford, Beloit & Janesville cars No. 1–11. Around 1912, all cars were lengthened, rebuilt, and otherwise upgraded at R&I's North Shops and then renumbered as 700-series cars (odd numbers only). Though the location of this photograph was not noted, it appears to have been taken at the North Shops complex. The green flags and "special" sign indicate that the freshly out of shop car is heading out for a test run. (Krambles-Peterson Archive.)

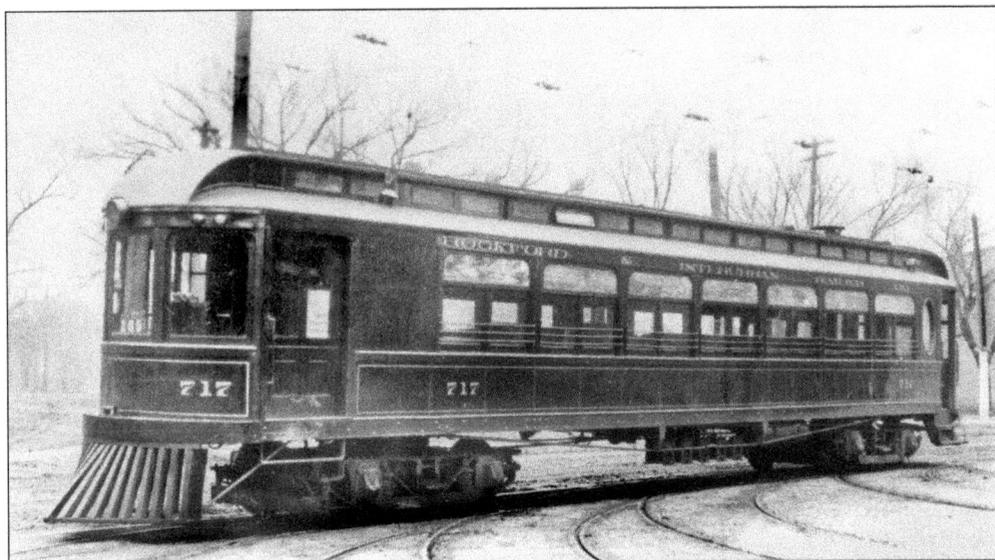

Stately car No. 717 was one of three of the eleven 700-series cars (719 and 721 were the other two) built by Kuhlman Car Company for the Rockford, Beloit & Janesville Railway in 1902–1903. All of these cars—originally numbered 1 through 11 for the RB&J—were acquired by the R&I for systemwide service. This view of No. 717 shows how it appeared shortly after being lengthened in the mid-1910s with the addition of a baggage/express compartment. These beauties served the R&I well, lasting until the late 1920s, when all were replaced by the all-steel 300-series cars. (Gordon H. Geddes collection.)

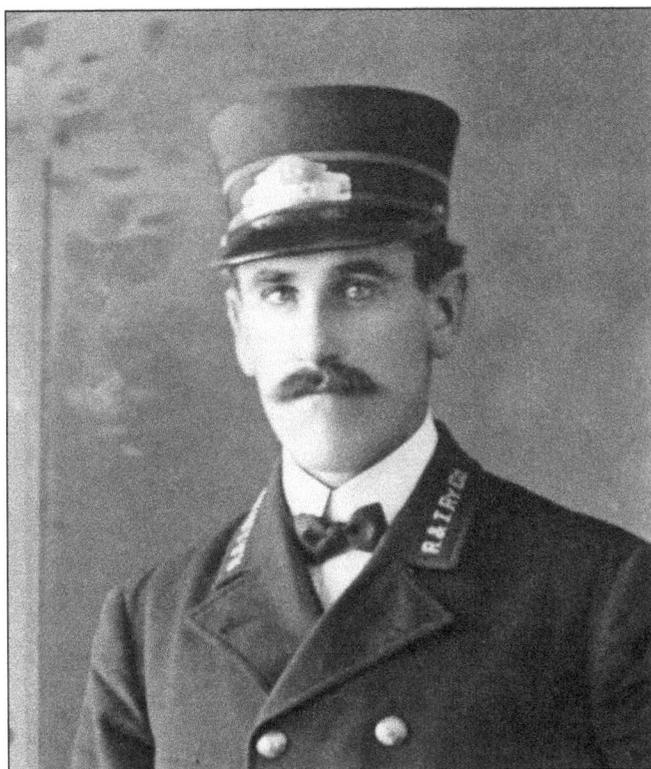

R&I trainmen wore dignified uniforms that were on par with those of any of the big-time steam railroads and their luxury passenger trains. R&I conductor Oscar Johnson proudly wears his uniform for a portrait taken around 1905. "R & I Ry Co" is prominently embroidered on each lapel, providing a symmetrical base for a crisp collar and small bow tie. Though not readily visible here, the hat badge reads "R & I Conductor." (Roy Peterson collection, courtesy Cedric and Rory Peterson.)

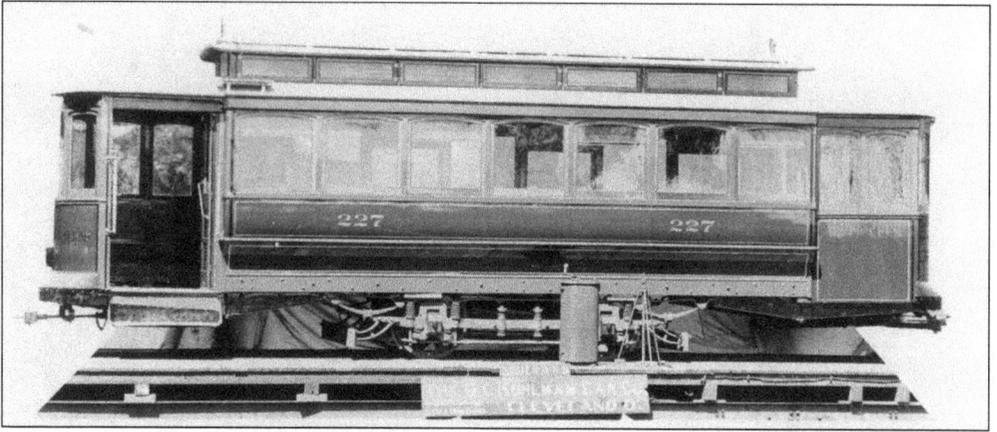

Double-end, single-truck car No. 227 is shown in what is known as a builder's photograph just prior to delivery to the R&I around 1907. This and several sister cars were built by the Kuhlman Car Company at Collinwood, Ohio, a suburb of Cleveland. The cars in this series were intended for city-line service only. They seated 30. (Photograph by Kuhlman Car Company, Gordon H. Geddes collection.)

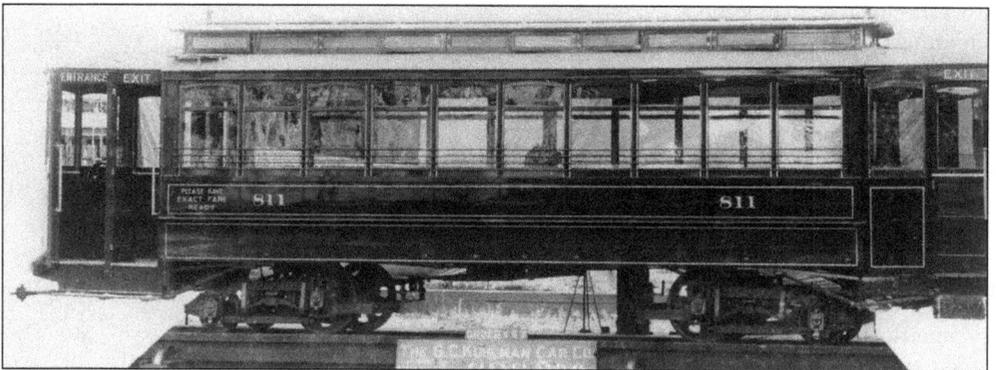

The G.C. Kuhlman Car Company built R&I car No. 811 and sister car No. 813 in 1910 for city-only service. The R&I rostered several 800-series cars by several builders, all of them similar in format, though seating varied anywhere from 34 to 40. All were 40–41 feet long. The 800s show up in many photographs taken of Rockford city streetcar service. (Photograph by Kuhlman Car Company, Gordon H. Geddes collection.)

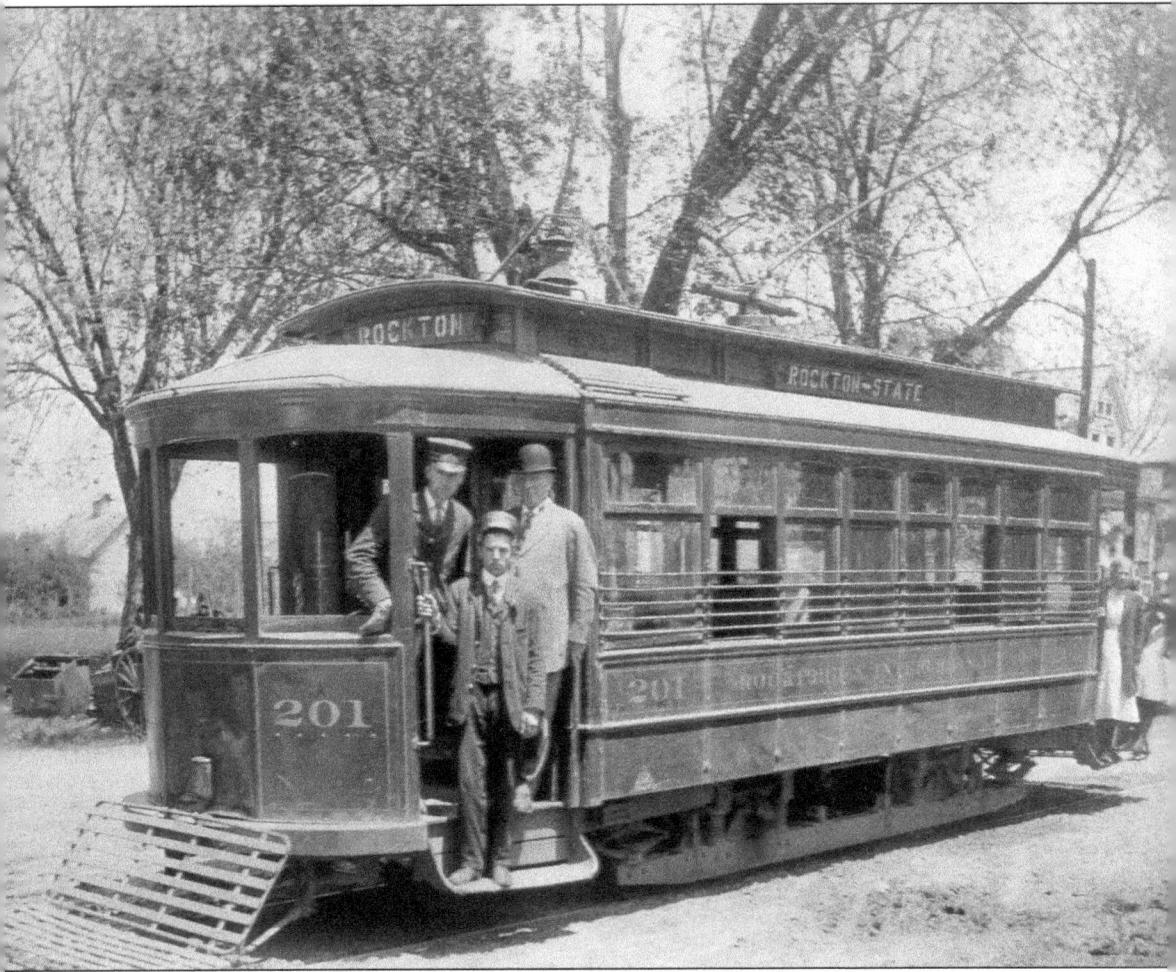

Lettered for the Rockford & Interurban, car No. 201 and its eight sisters (cars No. 202–209) were built by the St. Louis Car Company during 1906–1908 expressly for city service. These were single-truck, lighter-weight, compact cars designed for economical operation for lightly patronized routes. Equipped with a fence-like "scoop" pilot, thought to keep wayward pedestrians from being accidentally run over, the car is shown while working the Rockton Avenue route in the late 1920s. (BLc.)

A construction crew building one of the future Rockford & Interurban routes pauses with work flatcar No. 97 and pile driver No. 1000 at an unidentified location around 1900. It appears the men might be working on a river or creek crossing. (Gordon H. Geddes collection.)

The R&I depot at Winnebago, Illinois, about seven miles west of Rockford, is shown around the time of World War I. Like its sister depots at Pecatonica and Ridott, this was a sturdy brick structure that was set up for handling express packages as well as passengers. The building has survived the ages and is still being used—repurposed, of course. (BLc.)

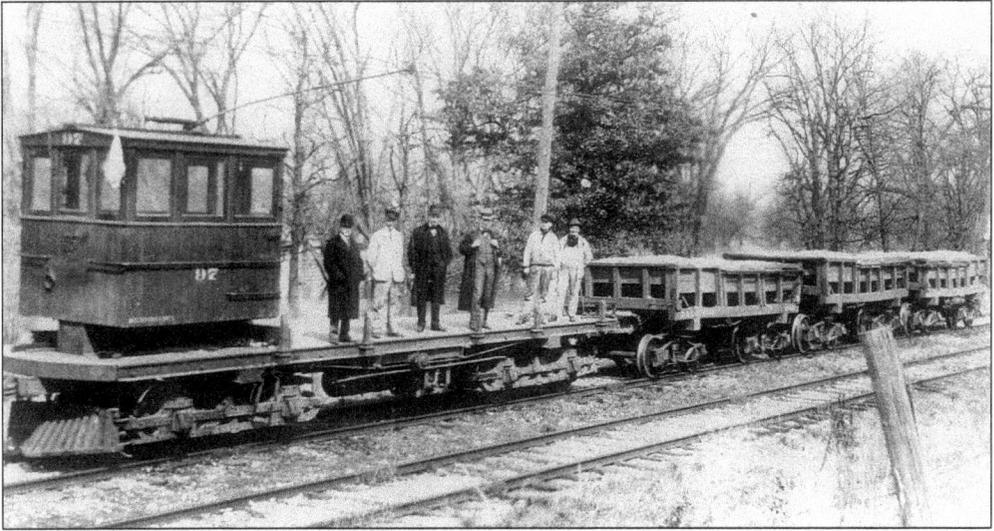

R&I work car No. 97 leads a short work train west of Pecatonica at siding No. 5 in the Pecatonica River bottoms during what is presumed to be the construction of the Rockford & Freeport Electric. The photograph was taken around 1903. (Photograph by R. Wright, BLc.)

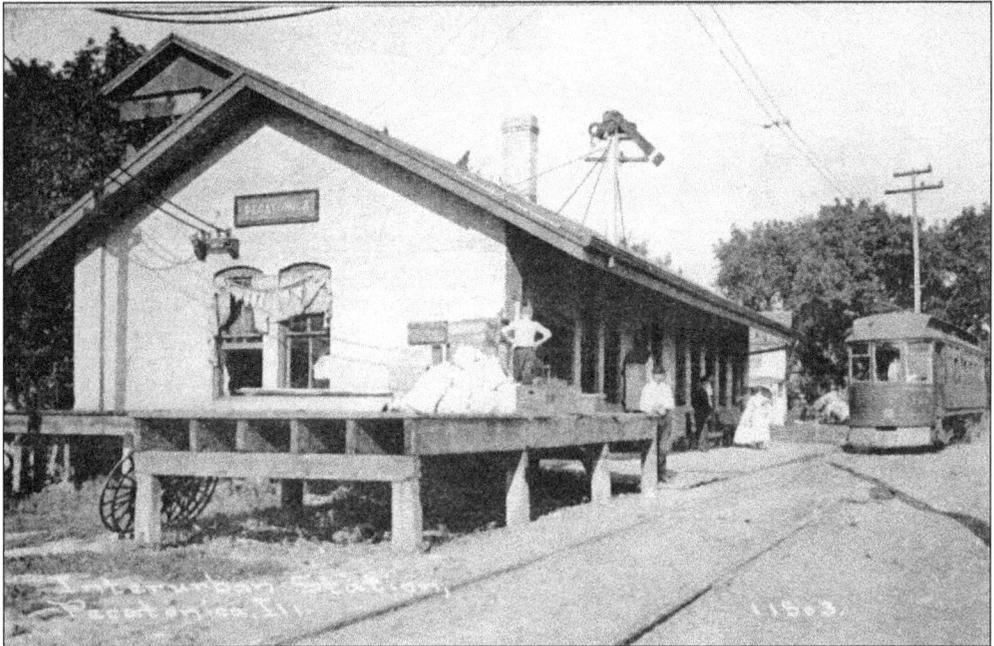

This view shows the ample brick depot in Pecatonica, on what was the R&I's old Rockford & Freeport Electric route connecting its namesakes. Here, Freeport-bound R&FE car No. 127 approaches the station. There are not only passengers to pick up, but also bags of grain. As of 2015, the depot still stood. (BLc.)

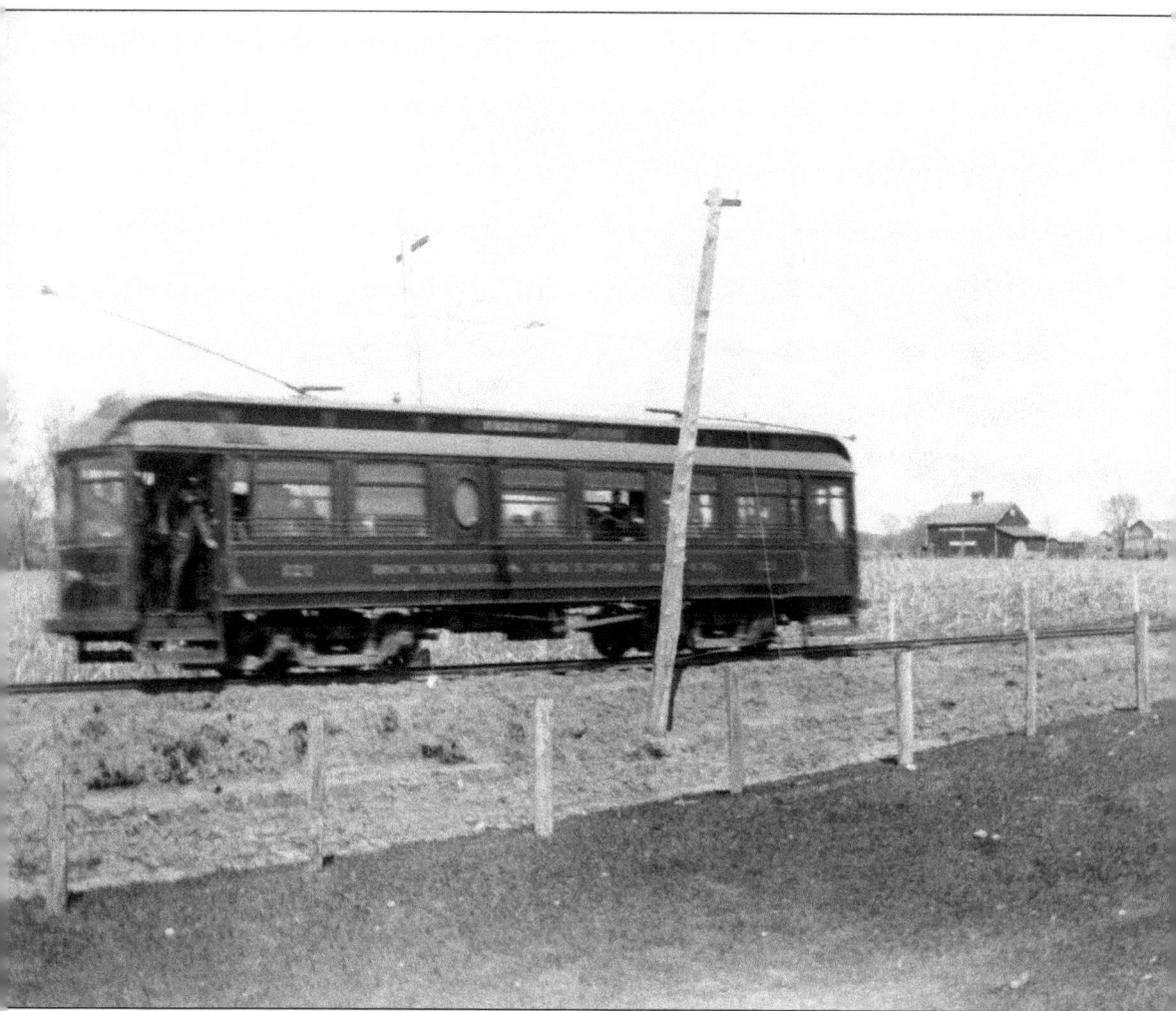

This interurban car is lettered for the Rockford & Freeport Electric Railway, a company that was created by R&I interests as a means for building a line between Rockford and Freeport. Eventually, the R&FER was formally merged into the R&I. The specific location of this scene is unidentified, but it is somewhere west of Rockford on the 28-mile R&FER line. The car appears to be moving at a fair clip. The 100-series cars built for the R&FE could be identified at a glance by the oval window in the middle of the side of the car, denoting the unusual location for the car's lavatory. Traditionally, day coaches on both steam railroads and interurbans had their restroom facilities at one or both ends of the car. (William C. Janssen collection, SLIHS.)

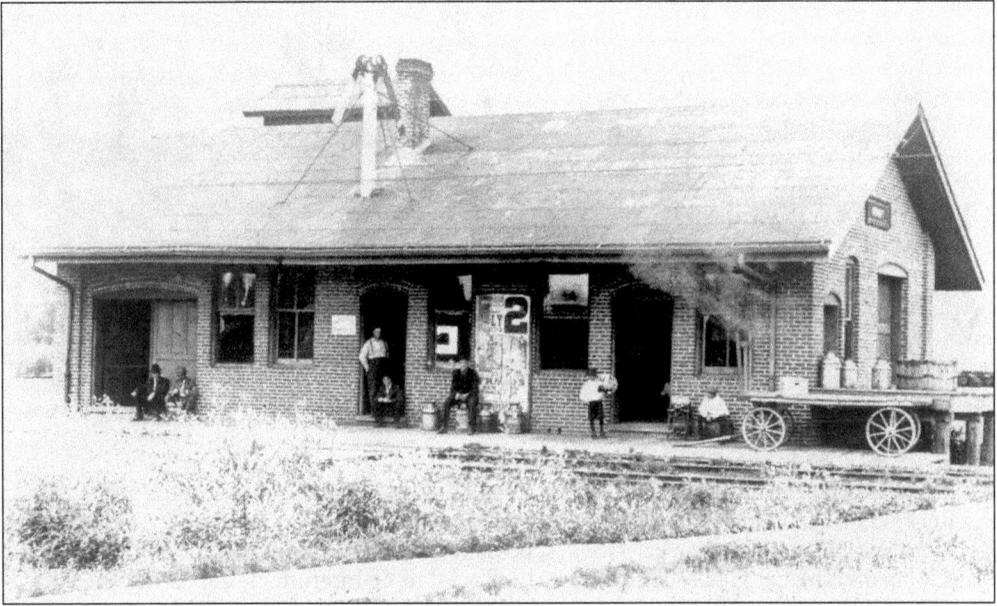

The R&I depot at Ridott, about 20 miles from Rockford, had the same overall design as the stations at Pecatonica and Winnebago, with facilities for freight/express handling as well as amenities for waiting passengers. Note the milk cans about the station. Rockford-bound or Freeport-bound morning trains would take milk into the city, and empty cans were returned later in the day. This photograph was taken in 1918. (BLc.)

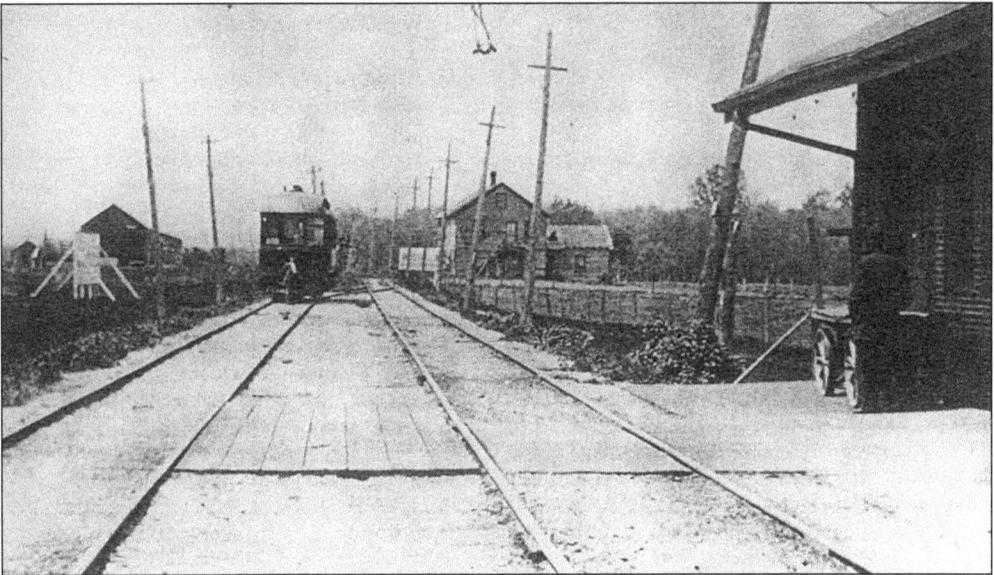

Car No. 131 (St. Louis Car Company, 1903) approaches the Ridott, Illinois, depot in 1908. It has entered the siding, probably to meet an opposing car that will hold the main line. (BLc.)

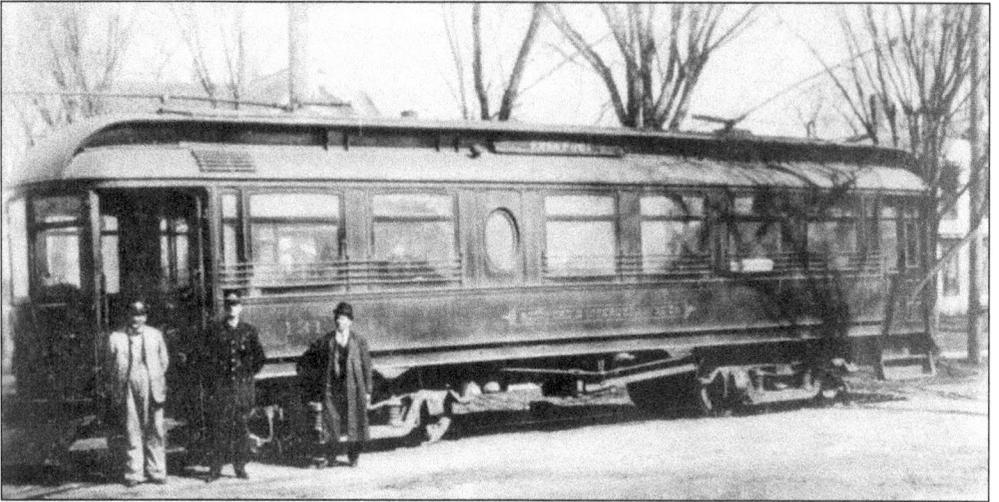

An R&I motorman (left), conductor (center), and probably a company officer pose along former Rockford and Freeport Electric car No. 131, possibly at Freeport. Built in 1903 by the St. Louis Car Company, the car is here lettered for the Rockford & Interurban, indicating that it was photographed sometime after the R&I absorbed the R&FE. (SLIHS.)

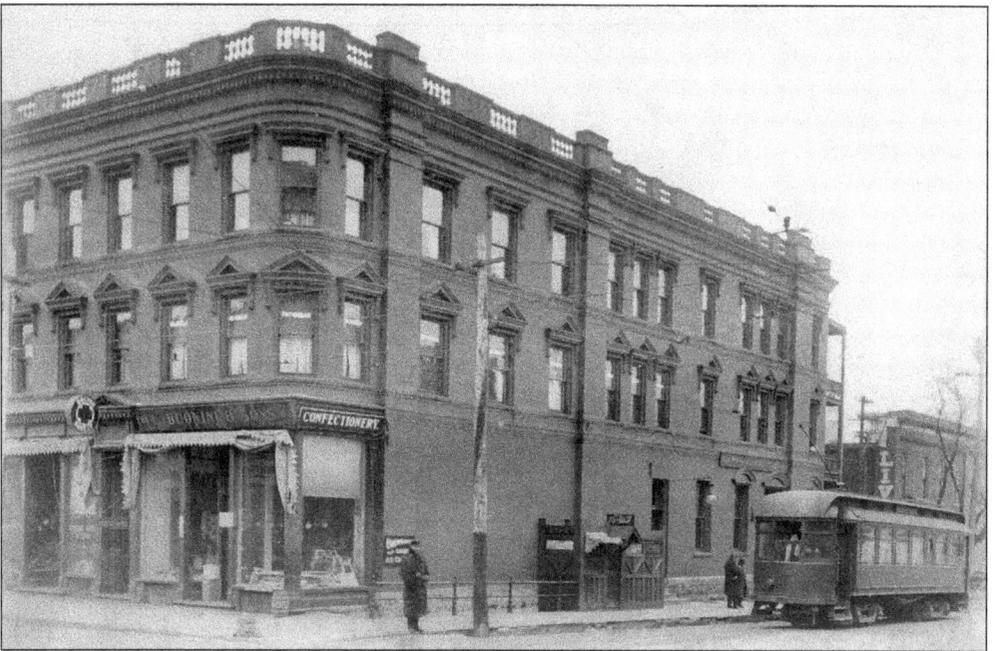

R&I Freeport trains terminated at this impressive building in downtown Freeport, although the railway used only a small section of it, on the street side, to serve customers. (BLc.)

Built under the auspices of the Rockford & Freeport Electric Railway Company, the Rockford & Interurban's line to Freeport, Illinois, opened all the way through to Freeport on April 6, 1904, with regular service commencing the next day. It took about 90 minutes to cover the 28 miles separating Rockford and Freeport. R&I cars used the tracks of the Freeport's city railway (Freeport Railway Power & Light Company) to reach into downtown via Stephenson Street, shown here in 1906. (BLc.)

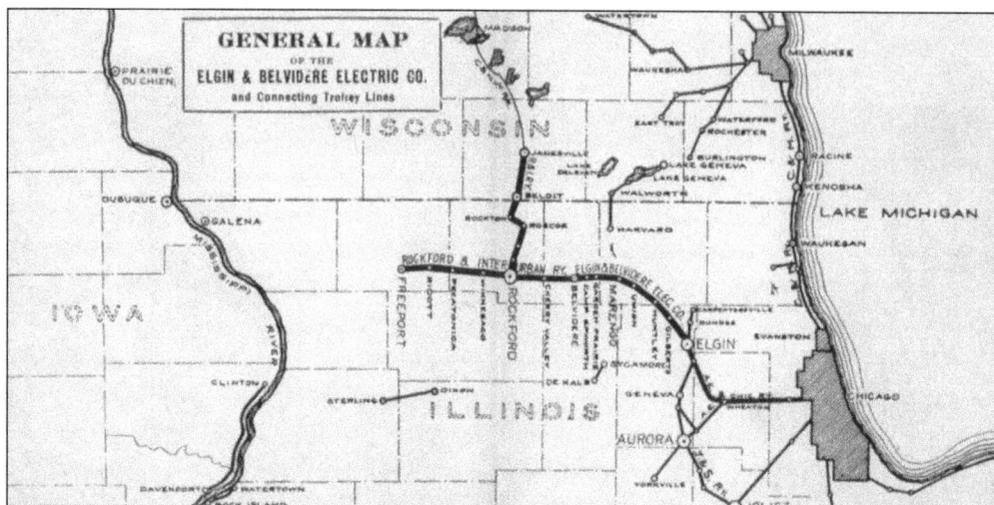

This map appears in the Elgin & Belvidere Electric public timetable released on September 15, 1909. It shows the growing network of area interurbans, in particular the amalgamated R&I-Elgin and Belvidere Electric–Aurora Elgin & Chicago system. R&I and E&BE schedules were coordinated with those of the AE&C to provide near-seamless travel between Rockford and Chicago, though a change of trains was required at Elgin. The AE&C employed a third-rail power system for its trains, incompatible with the R&I and E&BE's cars, which were set up with the more traditional overhead trolley wire distribution. (BLc.)

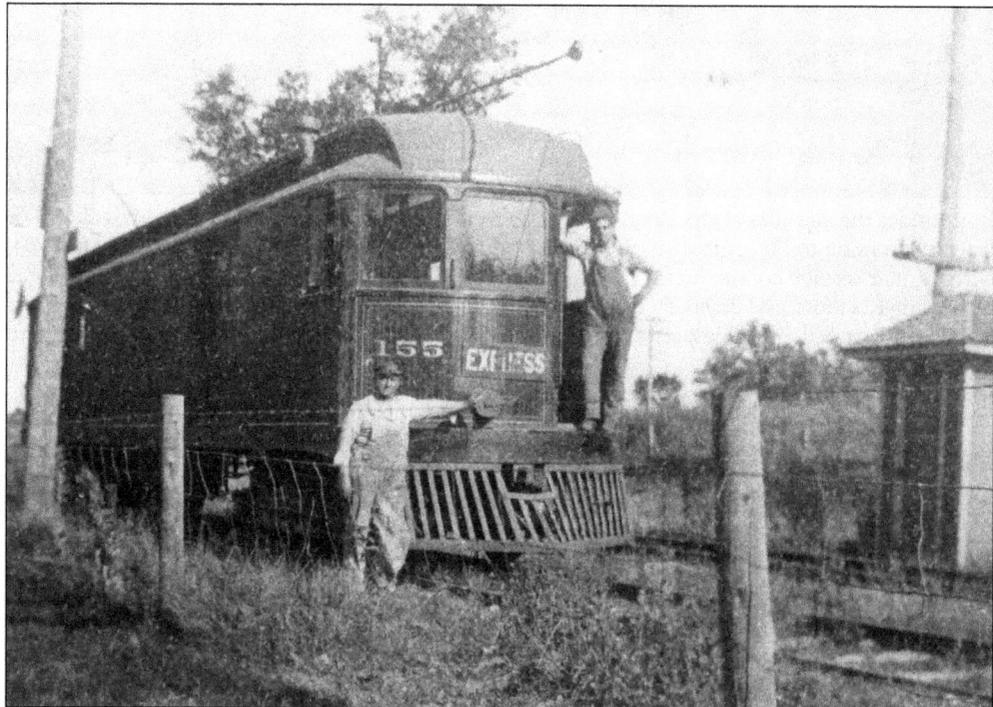

R&I express "motor" No. 155, built by the R&I in 1906, pauses at a siding west of Rockford on the Freeport line around 1908, probably to await an opposing passenger run. These express cars worked the whole R&I system, moving time-sensitive packages and goods between towns and often carrying goods to on-line grocery stores. (SLIHS.)

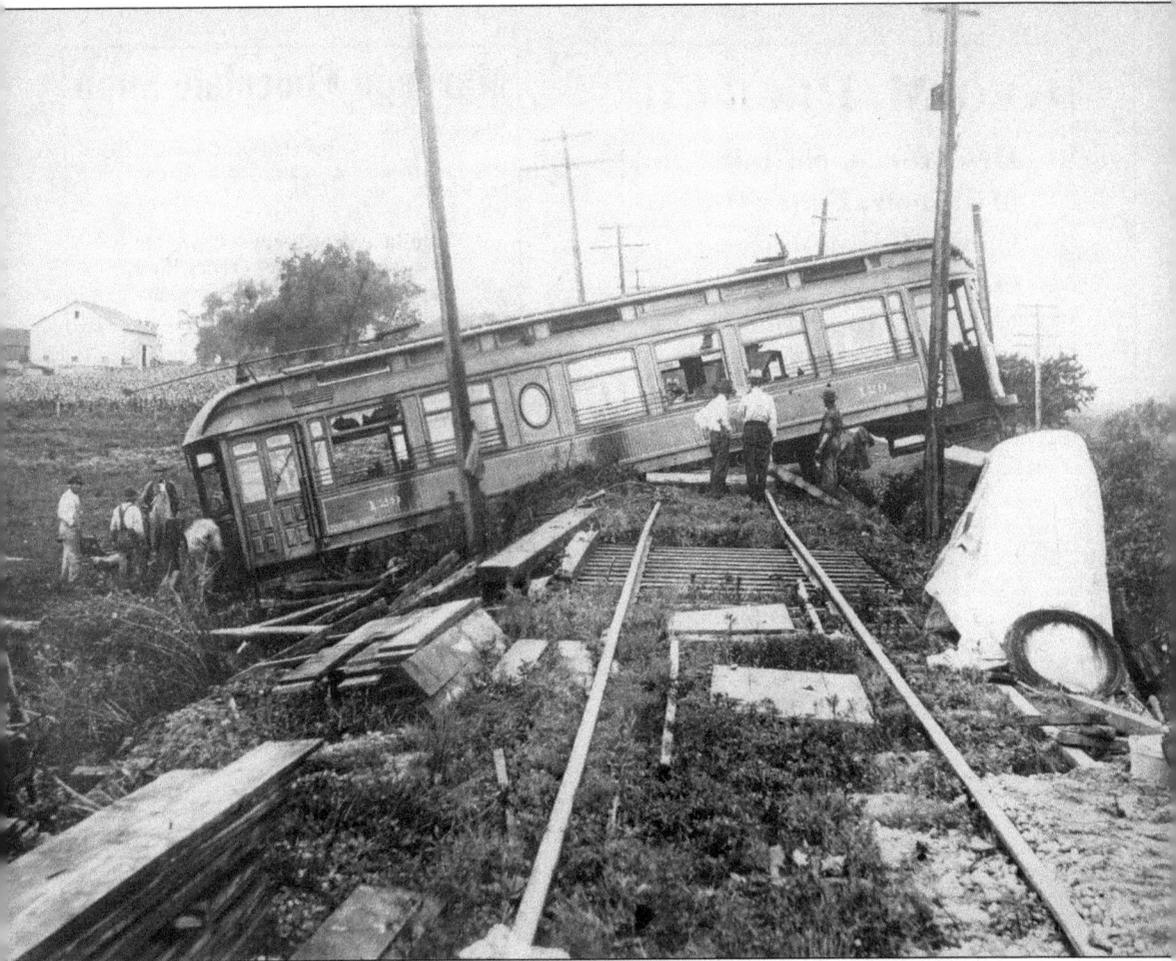

As with any railroad, accidents are inevitable, and this one was probably the Rockford & Interurban's most well publicized, but not its worst. Handsome car No. 129 met its match while making a run on the Rockford-Freeport line when it hit a cow on the tracks along West State Road, several miles west of Rockford. In the early days of railroading, livestock wandering onto tracks was a common occurrence, hence the need for extended pilots ("cowcatchers") on early locomotives and interurban cars. But, in the case of No. 129, its pilot failed to keep the offending cow from becoming wedged under the train, lifting it off the rails as well as its trucks. By the time the car came to rest, it was at a nearly 90-degree angle to the tracks, its steel underframe resting on the embankment. Windows shattered, and cow parts bombarded motorman Buckson. (Photograph by Philip Keister, William C. Janssen collection, SLIHS.)

EAST BOUND Local Schedule with Through Connections **EAST BOUND**

	Mls	a.m.	a.m.	a.m.	a.m.	a.m.	a.m.	a.m.	a.m.	a.m.	a.m.	p.m.	p.m.	p.m.	p.m.	p.m.	p.m.	p.m.	p.m.	p.m.			
Janesville Lv.						6:00	7:15	8:15	9:15	10:15	1.15	12:15	1:15	2:15	3:15	4:15	5:15	6:15	7:15	8:15	9:15	Janesville Lv.	
Freeport Lv.					5:35	6:35	7:35	8:35	9:35	10:35	11:35	12:35	1:35	2:35	3:35	4:35	5:35	6:35	7:35	8:35	9:35	Freeport Lv.	
Rockford Lv.	.0			6:00	7:00	8:00	9:00	10:00	11:00	12:00	1:00	2:00	3:00	4:00	5:00	6:00	7:00	8:00	9:00	10:00	11:00	Rockford Lv.	
Rockford Lv.	.0				7:30									4:30								Rockford Lv.	
Belvidere Ar.	14.5			6:50	7:50	8:50	9:50	10:50	11:50	12:50	.50	2:50	3:50	4:50	5:50	6:50	7:50	8:50	9:50	10:50	11:50	Belvidere Ar.	
Belvidere Ar.	14.5				8:08								5:08									Belvidere Ar.	
Belvidere Lv.	.0	6:00	7:00		8:10	9:10	10:10	11:10	12:10	1:10	1:10	2:10	3:10	4:10	5:10	6:10	7:10	8:10	9:10	10:00	11:10	12:00	Belvidere Lv.
Kiswaukee	2.0	6:06	7:06			9:17	10:17	11:17	12:17	1:17	1.17	2:17	3:17	4:17		6:17	7:17	8:17	9:17	10:06	11:17	06	Kiswaukee
Camp Epworth	4.0	6:10	7:10			9:22	10:22	11:22	12:22	1:22	1.22	2:22	3:22	4:22		6:22	7:22	8:22	9:22	10:10	11:22	10	Camp Epworth
Garden Prairie	6.1	6:14	7:14	8:26		9:28	10:28	11:28	12:28	1:28	1.28	2:28	3:28	4:28	5:26	6:28	7:28	8:28	9:28	10:14	11:28	14	Garden Prairie
Rogers Junct.	7.0	6:15	7:15			9:29	10:29	11:29	12:29	1:29	1.29	2:29	3:29	4:29		6:29	7:29	8:29	9:29	10:15	11:29	15	Rogers Junct.
Thorns Sdg.	9.0	6:19	7:20			9:35	10:35	11:35	12:35	1:35	1.35	2:35	3:35	4:35		6:35	7:35	8:35	9:35	10:19	11:35	20	Thorns Sdg.
Marengo Shop	11.7	6:24	7:25			9:40	10:40	11:40	12:40	1:40	1.40	2:40	3:40	4:40		6:40	7:40	8:40	9:40	10:24	11:40	24	Marengo Shop
Marengo	12.2	5:25	6:25	7:25	8:37	9:42	10:42	11:42	12:42	1:42	1.42	2:42	3:42	4:42	5:37	6:42	7:42	8:42	9:42	10:25	11:42	25	Marengo
Schneider's Rd	14.9	5:33	6:33	7:36		9:50	10:50	11:50	12:50	1:50	1.50	2:50	3:50	4:50		6:50	7:50	8:50	9:50	10:33			Schneider's Rd
Union	16.9	5:34	6:34	7:37	8:44	9:52	10:52	11:52	12:52	1:52	1.52	2:52	3:52	4:52	5:44	6:52	7:52	8:52	9:52	10:34			Union
Smith Sdg.	18.8	5:40	6:40	7:43		9:57	10:57	11:57	12:57	1:57	1.57	2:57	3:57	4:57		6:57	7:57	8:57	9:57	10:40			Smith Sdg.
Coyne	21.7	5:46	6:46	7:49		10:02	11:02	12:02	1:02	2:02	1.02	3:02	4:02	5:02		7:02	8:02	9:02	10:02	10:46			Coyne
Huntley	23.3	5:49	6:49	7:52	8:55	10:05	11:05	12:05	1:05	2:05	1.05	4:05	5:05	5:55	7:05	8:05	9:05	10:05	10:49			Huntley	
Mark's Sdg.	27.0	5:54	6:54	7:57		10:13	11:13	12:13	1:13	2:13	1.13	4:13	5:13		7:13	8:13	9:13	10:13	10:54			Mark's Sdg.	
Freeman	27.6	5:55	6:55	7:58		10:14	11:14	12:14	1:14	2:14	1.14	4:14	5:14		7:14	8:14	9:14	10:14	10:55			Freeman	
Gilberts	28.3	5:58	6:58	8:01	9:03	10:18	11:18	12:18	1:18	2:18	1.18	4:18	5:18	6:03	7:18	8:18	9:18	10:18	10:58			Gilberts	
Almora	33.1	6:07	7:07	8:09		10:28	11:28	12:28	1:28	2:28	1.28	4:28	5:28		7:28	8:28	9:28	10:28	11:07			Almora	
Illinois Park	34.0	6:14	7:14	8:14		10:32	11:32	12:32	1:32	2:32	1.32	4:32	5:32		7:32	8:32	9:32	10:32	11:14			Illinois Park	
Wing Park	34.6	6:15	7:15	8:15		10:33	11:33	12:33	1:33	2:33	1.33	4:33	5:33		7:33	8:33	9:33	10:33	11:15			Wing Park	
Elgin Ar.	36.4	6:25	7:25	8:25	9:25	10:44	11:44	12:44	1:44	2:44	1.44	4:44	5:44	6:25	7:44	8:44	9:44	10:44	11:25			Elgin Ar.	
Elgin Lv.	.0	6:30	7:30	8:30	9:30	11:00	12:00	1:00	2:00	3:00	4:00	5:00	6:00	6:30	8:00	9:00	10:00	11:30				Elgin Lv.	
Chicago Ar.	41.5	7:40	8:40	9:40	10:40	12:25	1:25	2:25	3:25	4:25	5:25	6:25	7:25	7:40	9:25	10:25	11:25	12:25				Chicago Ar.	

This page from a 1909 Elgin & Belvidere timetable illustrates the coordinated services of the R&I, E&B, and the Aurora Elgin & Chicago interurban companies. Although R&I cars sometimes operated through to Elgin, while E&B car operated through to Rockford to provide seamless service between Rockford and Elgin, a change of trains was necessary at Elgin to continue to Chicago. The running times between Rockford, Elgin, and Chicago were considerably longer than parallel steam railroad passenger schedules, but fares were cheaper. Interurbans were at their best connecting larger cities with smaller towns and burgs skipped by steam railroad passenger trains. (BLc.)

ELGIN & BELVIDERE ELECTRIC CO,

AUDITOR'S STUB — Not Good for Passage.

MARENGO, ILL.

To PECATONICA

To be sent to Auditor with daily
or trip report.

Form S-19 Via E&B, R&I

1052

The Elgin & Belvidere Electric and the R&I were closely affiliated, feeding passengers to each other and together providing an alternate transportation option between Rockford and Elgin that was cheaper and cleaner than the parallel C&NW, and certainly more comfortable than the rutted dirt roads of the day. This ticket shows the carriers' joint ticketing arrangement. In this case, a single ticket is all that is needed for travel between the E&B stop at Marengo and the R&I's Pecatonica stop on the old R&FE. (BLc.)

100 RIDE COMMUTATION TICKET.

No. 26033

FOR PERSONAL USE OF

M _____

Each coupon contained in this book is good for One 5c. Ride in either direction on the FREEPORT DIVISION between STATION 2 (which is the first station east of Freeport) and STATION 12 (which is the first station west of Rockford), and on the BELVIDERE DIVISION between STATION 14 (which is the first station east of Rockford) and BELVIDERE, and on the R. B. & J. DIVISION between SNOW'S CROSSING (which is the first station north of Rockford) and JANES-VILLE.

Subject to the conditions of the contract herewith attached, which must be signed by the purchaser before this ticket is valid for passage.

NOTICE TO CONDUCTORS.

Each numbered coupon on enclosed strip represents One 5c. Ride. Therefore you must detach enough coupons to cover the distance to be traveled. The rubber band used to confine the strip must not be removed, as the strip can easily be drawn out or back, as required, while under the band.

Do not honor strips unless attached to cover bearing same consecutive number, nor any portion of a strip if already detached when presented.

T. M. ELLIS,
General Manager.

Multiride commutation tickets are still used today by commuter railroads, just as they were used on the Rockford & Interurban some 100 years earlier. The coming of the interurban increased options as to where people could live; they no longer had to reside close to their places of employment if they could commute to work on a streetcar or interurban. This R&I commutation was good for 100 rides. The fine print explains the limitations. (BLc.)

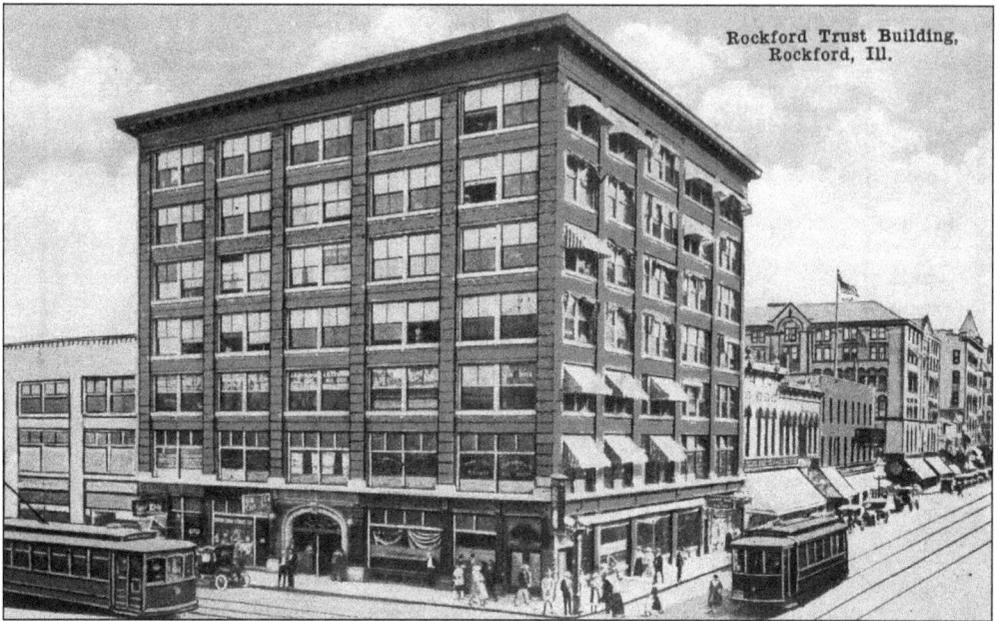

Rockford Trust Building,
Rockford, Ill.

Opened in 1909, the Rockford Trust Building became a downtown landmark. It is shown around 1915 in this postcard view looking south. The R&I streetcar at left is working its way west on West State, and the car on the right has come up South Main Street. In 1922, four more floors were added to the building. (BLc.)

The Rockford & Interurban played its part in World War I by building a branch line off the Seventh Street line at Harrison Avenue to Camp Grant, at what is today Chicago Rockford International Airport. Camp Grant was a major US Army mobilization facility in the Midwest (referenced by the Colonel Potter character on the TV series M*A*S*H), and thousands of soldiers arrived and departed here by steam trains of the Chicago, Burlington & Quincy; Chicago, Milwaukee & St. Paul; Chicago, Milwaukee & Gary; and the Rockford & Interurban. This R&I timetable carries advertising from Rockford's most-well-known clothier at the time, E&W Clothing House, urging recruits to get their uniforms there. E&W's South Main store shows up in some of the downtown Rockford photographs in this book. (BLc.)

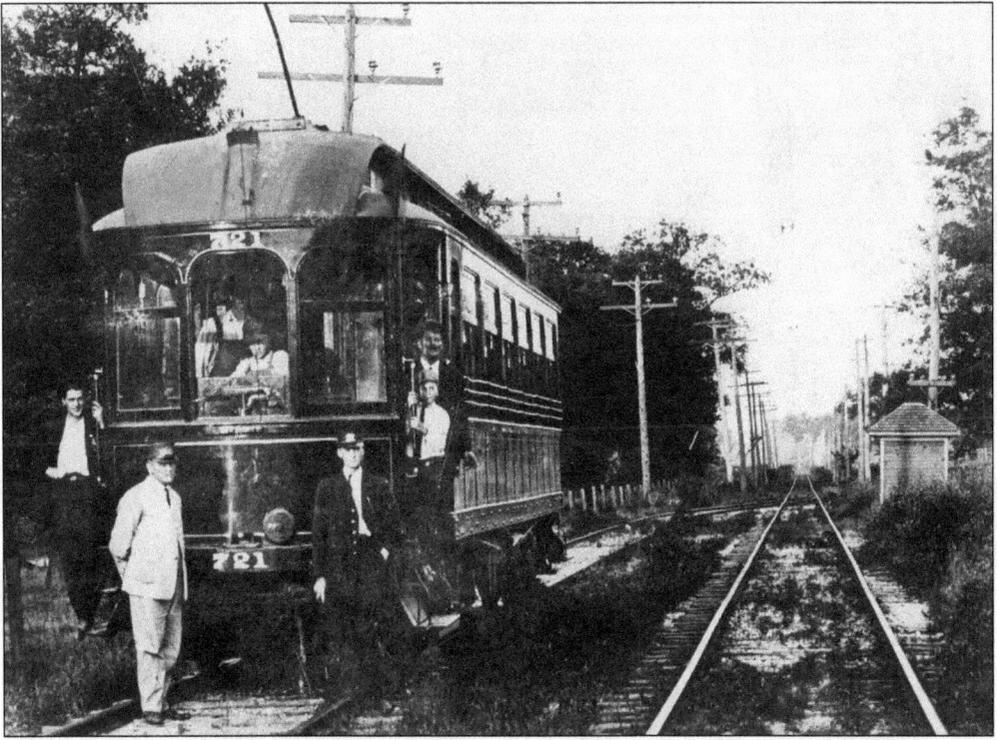

R&I car No. 721, a former Rockford, Beloit & Janesville car, is on the passing siding at an unidentified location, awaiting an opposing train around 1910. It seems that some of the passengers have even gotten into the picture. The R&I system outside of its cities was largely a single-track operation. Employee timetables indicated at which sidings, such as this one, opposing trains were to meet. If a train were running late or had been annulled, the dispatcher could issue an order to the motorman and the conductor via phone at a siding's phone booth (right) and change the meet location. (Krambles-Peterson Archive.)

This concrete whistle post from the Rockford, Beloit & Janesville still stands today near Main Street and Wallace Drive in Roscoe. People would wait for the interurban at these posts or inside a shelter. At night, they would light a match and the motorman would stop and pick them up. Almost all grade crossings had whistle posts with a big W on them. (BLc.)

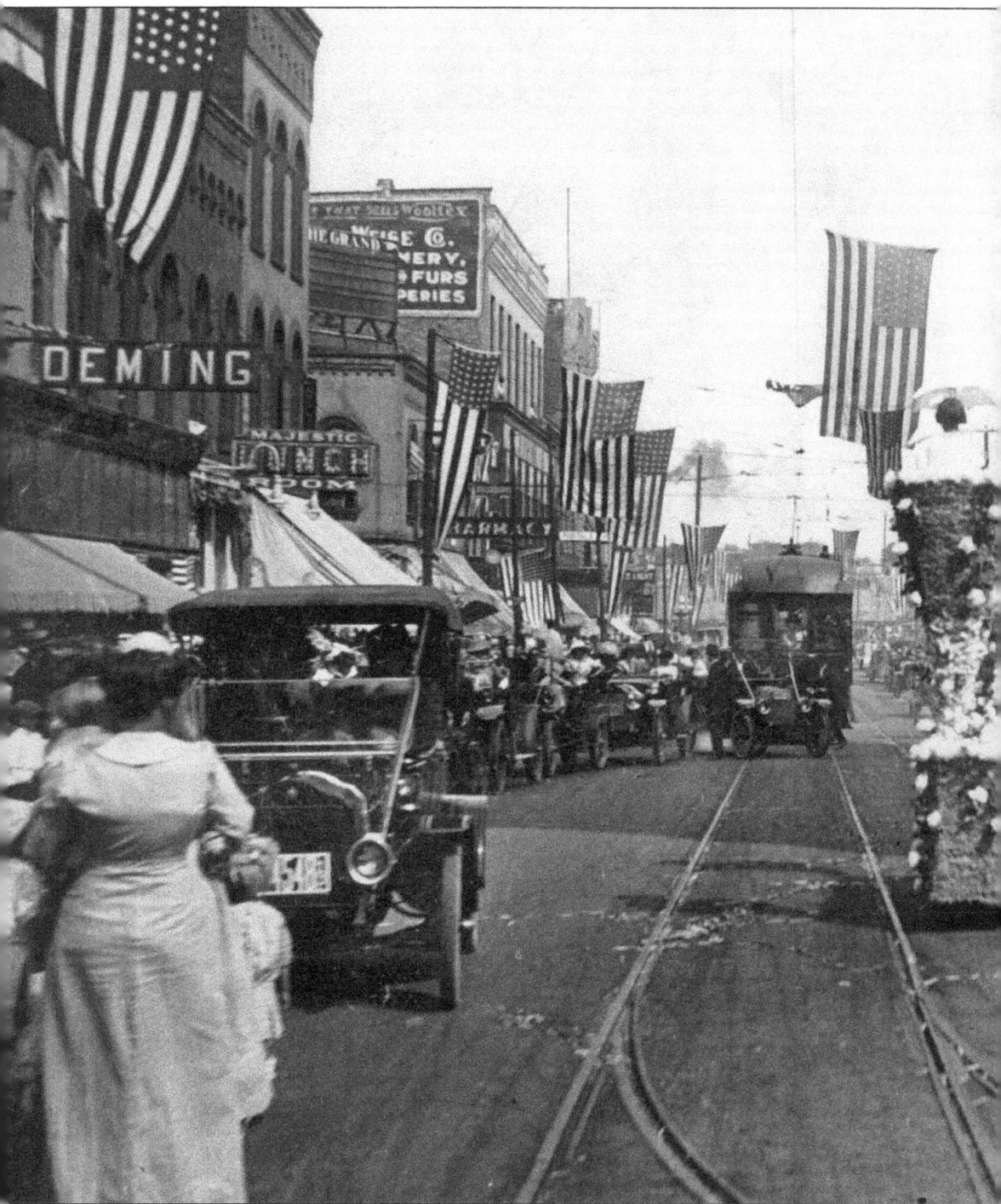

An R&I interurban car seems have become part of the Spring Festival parade on State Street in downtown Rockford around 1920. In an era without television and personal computers, simple events such as this often drew huge crowds, as folks looked for an excuse to get out and about

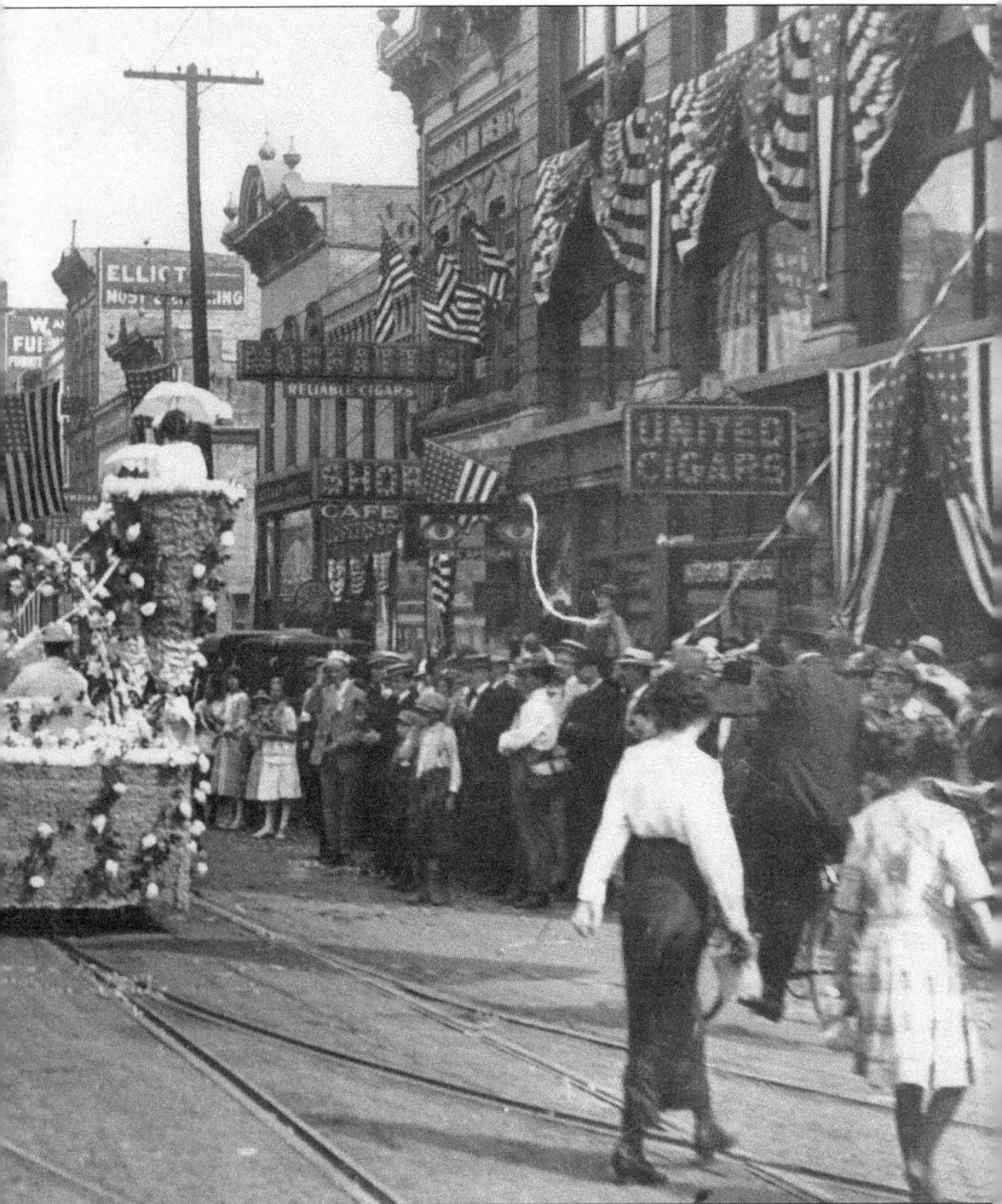

following a six-day work week. The view in this photograph looks east down State Street from Main Street, where the city line down Main Street branches south. (BLc.)

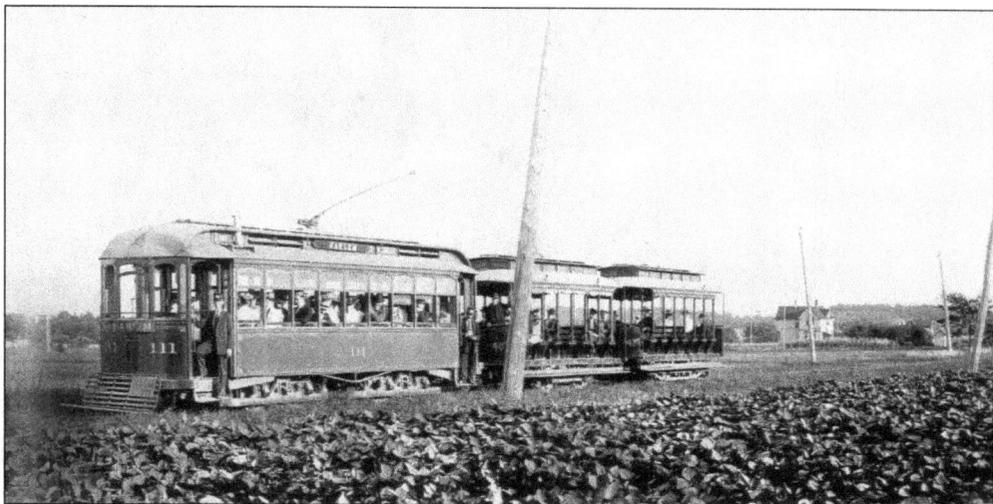

Car No. 111, with a full load of passengers, is on its way to Harlem Park, probably on a Sunday afternoon, around 1902. The sporty little interurban car was built in 1901 by Jackson & Sharp. It is pulling two former open-air horse-car trailers. (BLc.)

The

Rockford & Interurban
Railway Company

and

Rockford City Traction Co.

HARLEM PARK *and*
HONONEGAH PARK

The Ideal Places to Hold your Picnics

For Further Information
Address C. C. SHOCKLEY, G. F. & P. A.
Rockford, Illinois.

Our slogan is "Safety First—Courtesy Always." Also to render good service at all times.

Hononegah Park, located on the Beloit Division, north of Rockford, is the most beautiful park in the state, scenically and historically. Mr. Goss, manager of Hononegah park, is doing everything possible to make this park the playground for picnic parties. The R. & I. Ry. Co. are glad to assist him in any way and will make special rates during the summer.

Harlem Park is located on the lines of the Rockford City Traction Co., only a fifteen minute ride over the new double track line, and has all the amusements that are found in any up-to-date park. It has a roller skating rink which is the largest in the state, a fine dancing pavilion, roller skating afternoon and evening, dancing every night. In connection with the amusements found in the park, the management furnishes plenty of free entertainment, making this the ideal place for recreation.

The R. & I. Ry. Co. conducts a fast freight and express business. Freight is forwarded to all points on our line twice daily except Sundays. Express is hauled on all passenger cars, which gives hourly service. For further information address any agent of the Company or C. C. Shockley, General Freight & Passenger Agent.

The R&I and its subsidiary Rockford City Traction sought ways to fill otherwise empty trains on Sundays. This promotional piece touts two parks, Harlem Park and Hononegah Park. Harlem (amusement) Park is long gone, but Hononegah Park today survives as the Hononegah Forest Preserve. (BLc.)

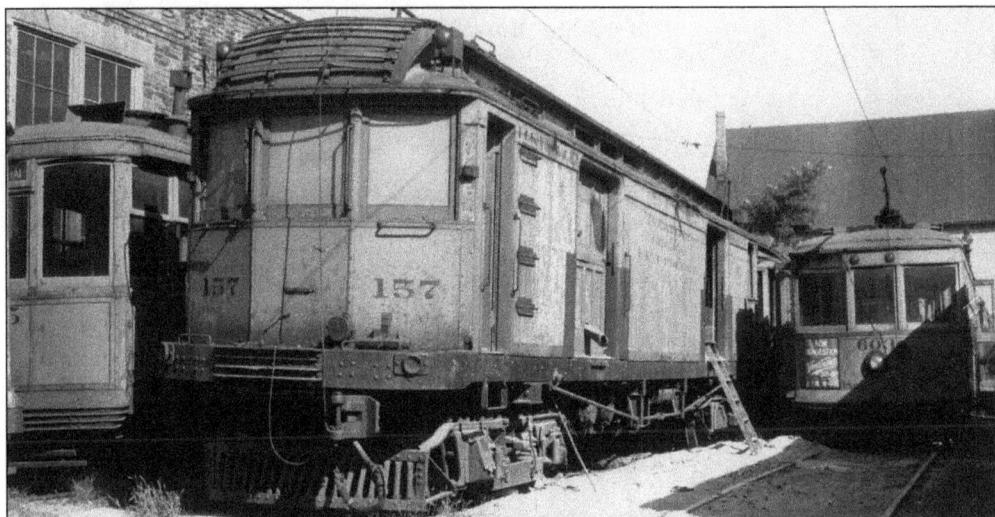

Like many interurbans, the R&I offered express service, moving packages, milk, and other time-sensitive shipments. There used to be enough freight and express business to warrant having cars built expressly for this purpose, such as car No. 157, shown here at the R&I's Kishwaukee Street facility. It was built by the Kuhlman Car Company in 1906. The cars' sides are lettered "Rockford-Chicago Fast Freight," in reference to the coordinated service the R&I had with the Elgin & Belvidere and the Aurora Elgin & Chicago between Rockford and the CA&E's Laramie Avenue freight house in Chicago. (Photograph by R.V. Mellenbach, SLIHS.)

The Rockford & Interurban Railway Company

Fast Express Service

Express now handled on passenger cars between—

ROCKFORD	CHERRY VALLEY	ROSCOE
WINNEBAGO	BELVIDERE	ROCKTON
PECATONICA		BELOIT

Interurbans were a perfect means of dispersing express to any on-line station stops that featured a depot building and an agent. Some interurbans offered express-only trains, which did not carry passengers and often operated during night hours for delivery of merchandise and other goods to commercial concerns before the start of the business day. But express was also often handled on regularly scheduled passenger runs. In 1912–1913, the R&I rebuilt some of its older cars by lengthening them to accommodate a baggage/express section, allowing trains to perform double duty, moving passengers and express. (BLc.)

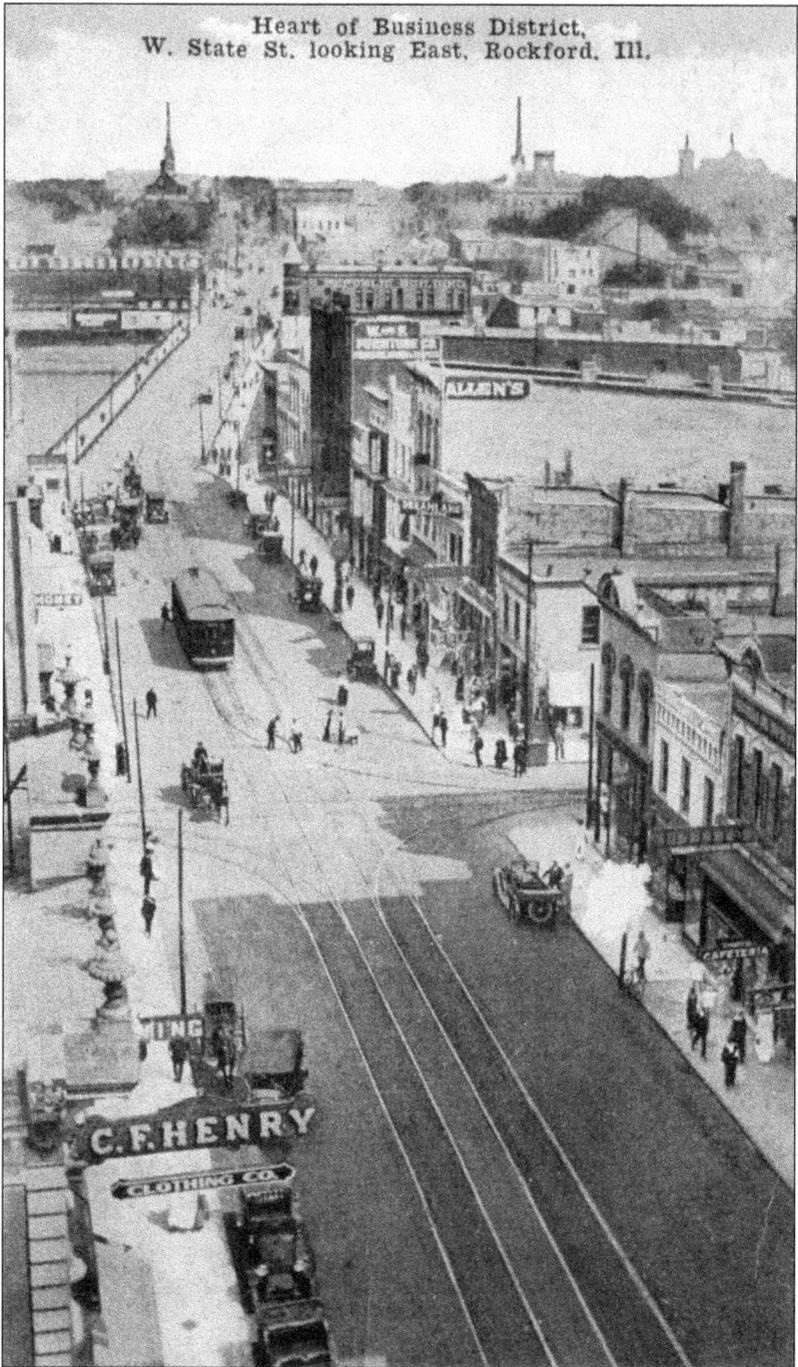

Heart of Business District,
W. State St. looking East, Rockford, Ill.

This c. 1915 postcard offers one of the best-known views of "Transfer Corner"—State and Wyman Streets—where transfers could be made between the R&I trains and local city cars. This view, probably taken from the then new Ashton Building at State and Main Streets, looks eastward toward the Rock River bridge as an R&I car pauses after arriving from the east side. The R&I's depot is the two-story light-colored building at the southeast corner of State and Wyman. A close-up view of this station is on page 25. (BLc.)

The Seventh Street city-car line ran down its namesake street to 23rd Street, then west to Kishwaukee Street, where it looped around to Harrison Avenue to head east to Eleventh Street, the location of this photograph. From here, cars headed back north to Seventh Street via Eleventh Street, Eighteenth Avenue, Ninth Street, and Eleventh Avenue. (BLc.)

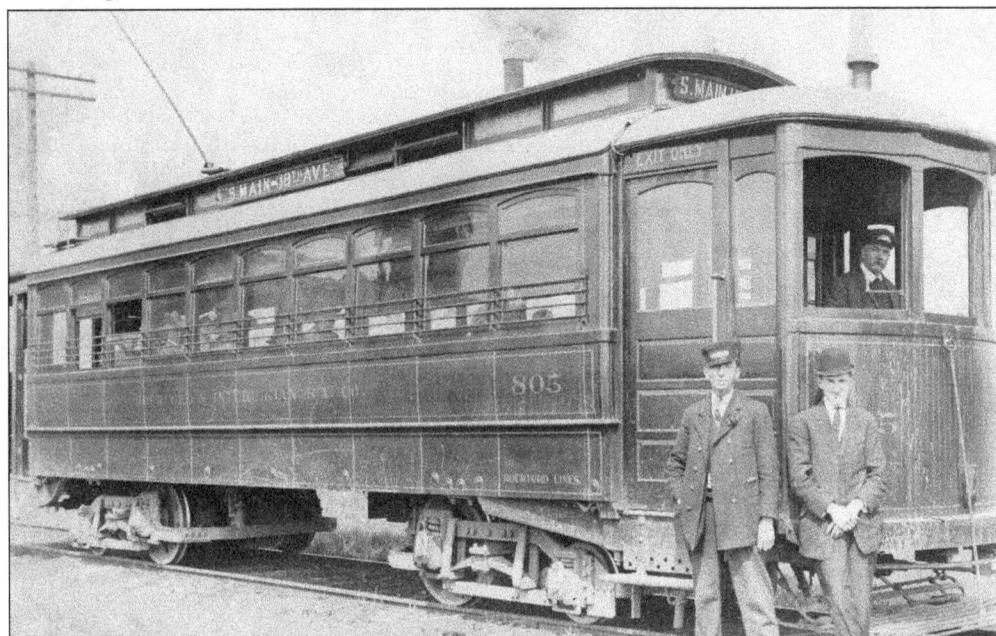

Car No. 805 was just one of a large fleet of 800-series cars on the R&I's city lines. They were built during the 1910s by various companies—American Car, Kuhlman, and St. Louis Car—to similar specifications. In this undated photograph, the motorman is at his post in the cab, and his conductor and an unidentified gentleman (possibly a company official) pose along the Main Street–Eighteenth Avenue line. (BLc.)

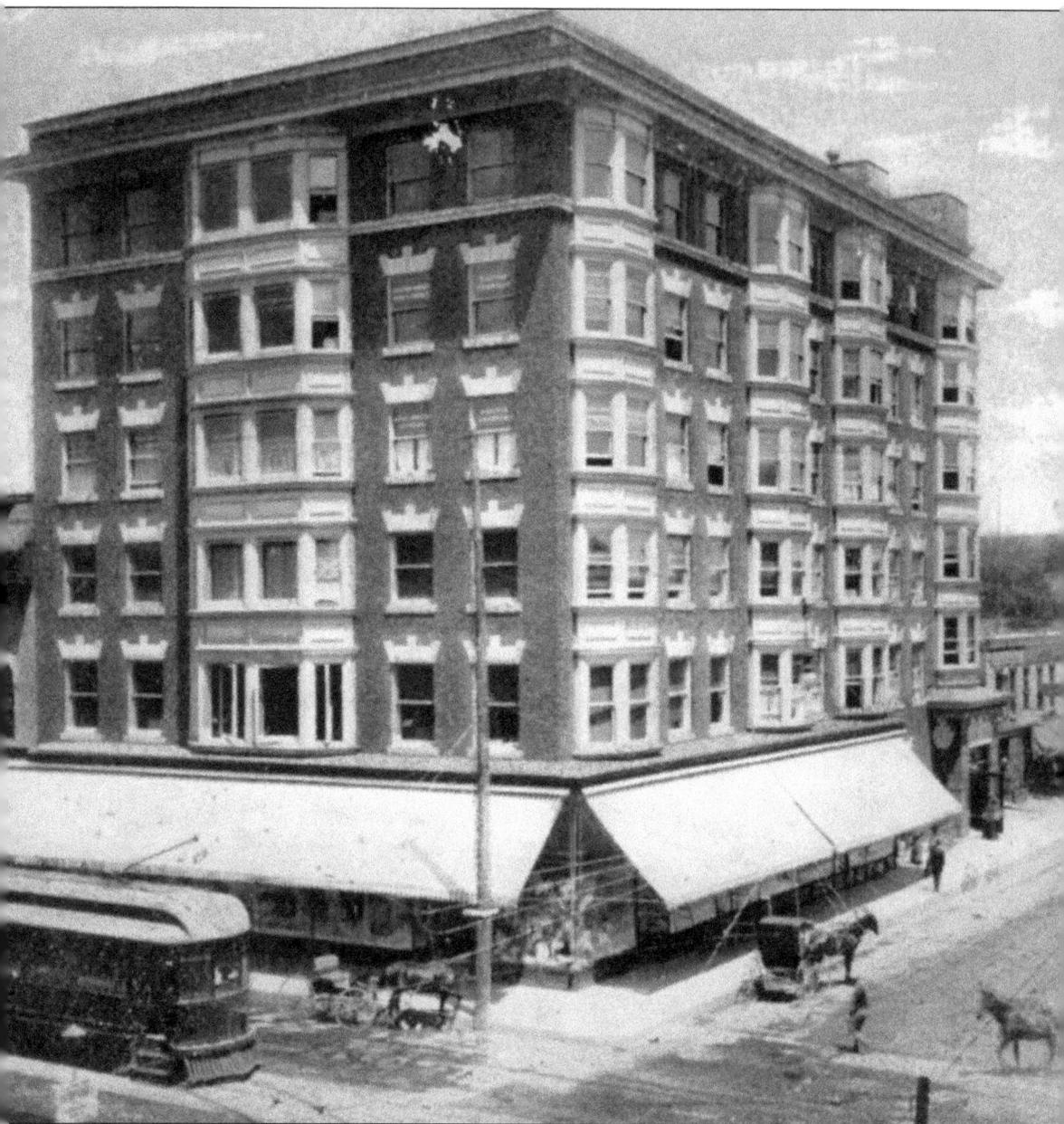

While the Rockford & Interurban was coming of age, so was Rockford itself, with a booming downtown area that would be flush with activity into the 1960s. This c. 1912 postcard photograph, with a view looking northeast, shows the ornate Ashton Building at the corner of State and Main Streets. A 700-series car in from Belvidere heads west along State Street. (BLc.)

Three

The Roaring Twenties
on the R&I

Short-sleeve shirts and patriotic bunting suggest that this photograph may depict an Independence Day celebration in the early 1920s. The view looks east along State Street, just west of the Main Street intersection. The end of World War I ushered in a period of rapid growth and development in the United States—the nature of the development, however, had the opposite effect on the Rockford & Interurban. This was the beginning of the automobile age, and it meant the end of the interurban era. (BLc.)

It is standing-room-only on car No. 221 heading down Blackhawk Boulevard in South Beloit, bound for Harlem Park on a fine day in 1923. The open-air, single-truck 200-series cars were built during 1906–1908 by St. Louis Car Company and the R&I and could seat 30 patrons. Obviously, there are more passengers aboard this car than that. Harlem and Central Parks flourished during the 1920s, but they were hard hit by the Great Depression, which, along with America's love affair with the automobile, eventually would do in the R&I system, as well as Rockford's streetcars. (BLc.)

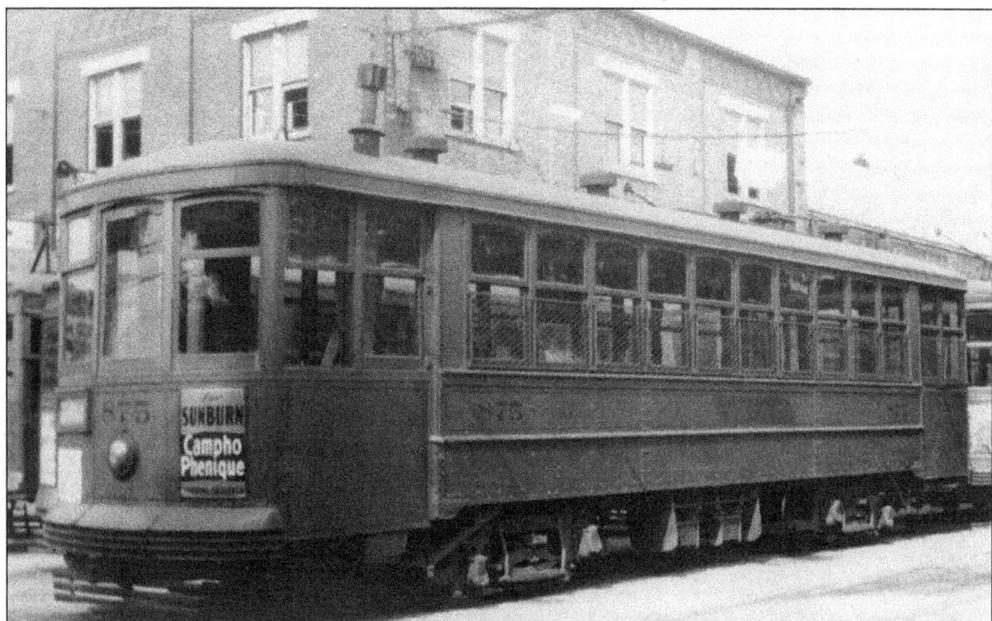

"For Sunburn, Campho Phenique, Soothng Antiseptic" reads the placard advertisement mounted on car No. 875, on layover between runs at the Kishwaukee Street carbarn. No. 875, built in 1917, was among the newest city-service cars. For most of the 1920s, the 800-series cars were the backbone of R&I streetcar operations in Rockford. (Photograph by M.D. McCarter, Gordon H. Geddes collection.)

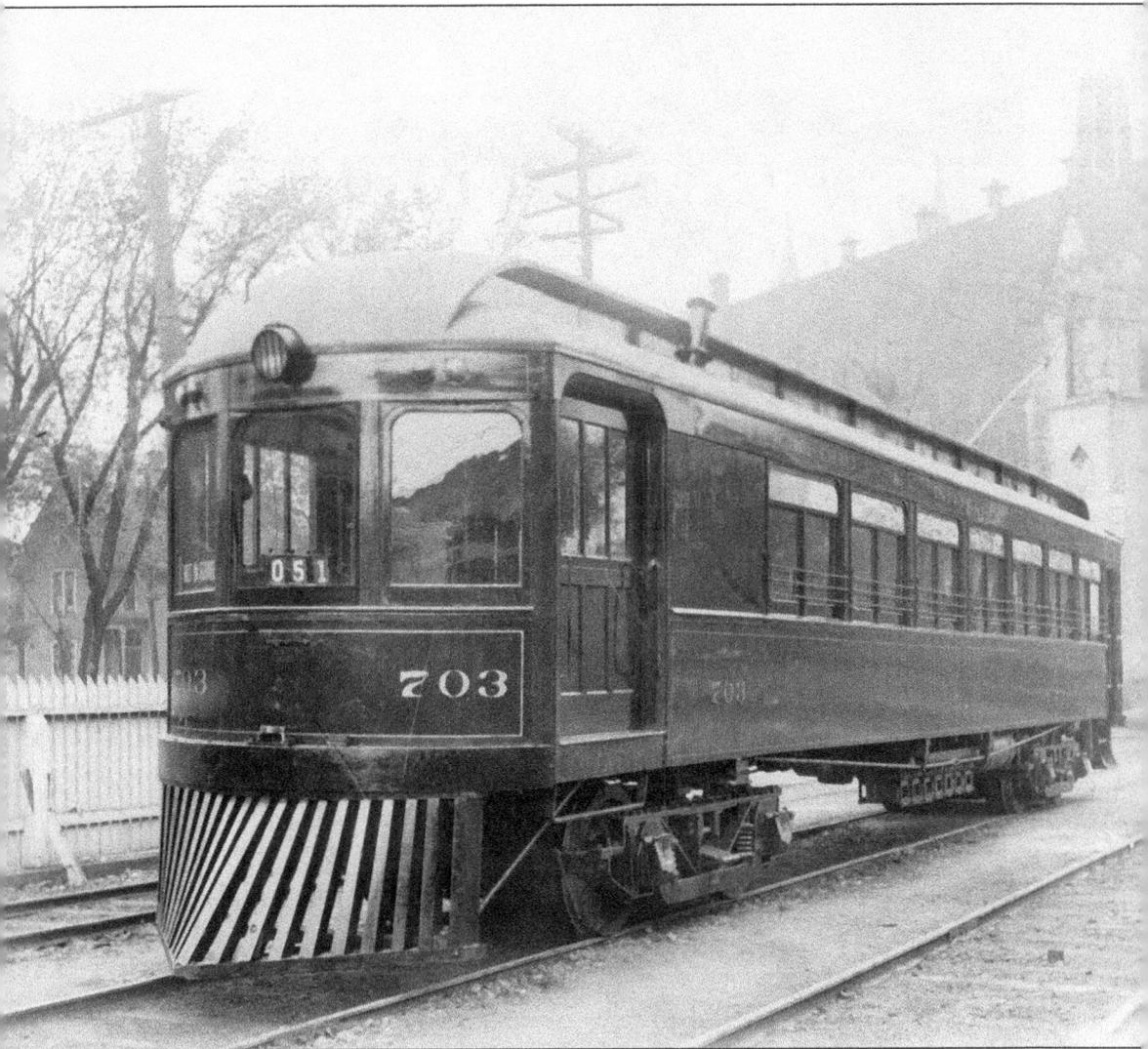

Rockford & Interurban's eleven 700-series cars, rebuilt in the mid-1910s, remained the backbone of R&I's intercity operations between Rockford and Belvidere, Elgin, Beloit, Janesville, and Freeport during most of the 1920s. They were not, however, the only cars that could be found in interurban (versus local streetcar) service. Their pronounced wood pilot— "cowcatcher" in layman terms—was their trademark, though these were replaced with smaller, steel pilots over time. The small numbers in the front window indicate the number of the car's assigned run. No. 703 was photographed on Kishwaukee Street across from the carbarn. (William C. Janssen collection, SLIHS.)

The R&I brought students to the doorstep of Harlem Consolidated School at North Second Street and Harlem Road, as seen in this publicity photograph. Throughout the Midwest and Northeast in the 1910s and 1920s, it was not uncommon for rural students to use interurbans to get to and from school, much like students use school buses today. This location is not too far from where coauthor Brian Landis lives. (BLc.)

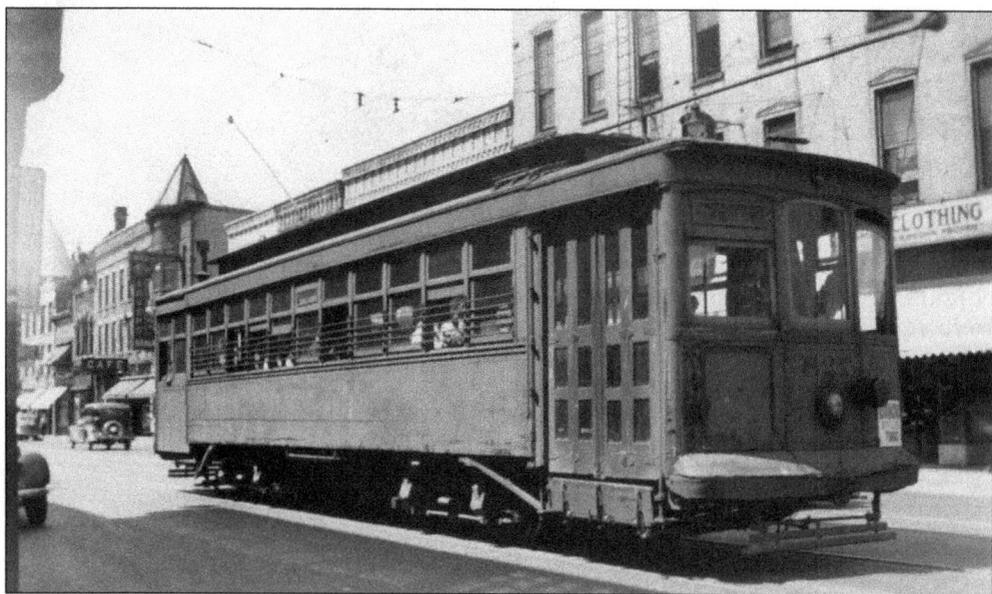

Car No. 827 is working its way along State Street late in its life, judging by the worn condition of the 1912-built streetcar. The R&I had some 50 cars of this format and design, most of them built by St. Louis Car Company, with the rest from Kuhlman Car and American Car companies. (Photograph by M.D. McCarter, Gordon H. Geddes collection.)

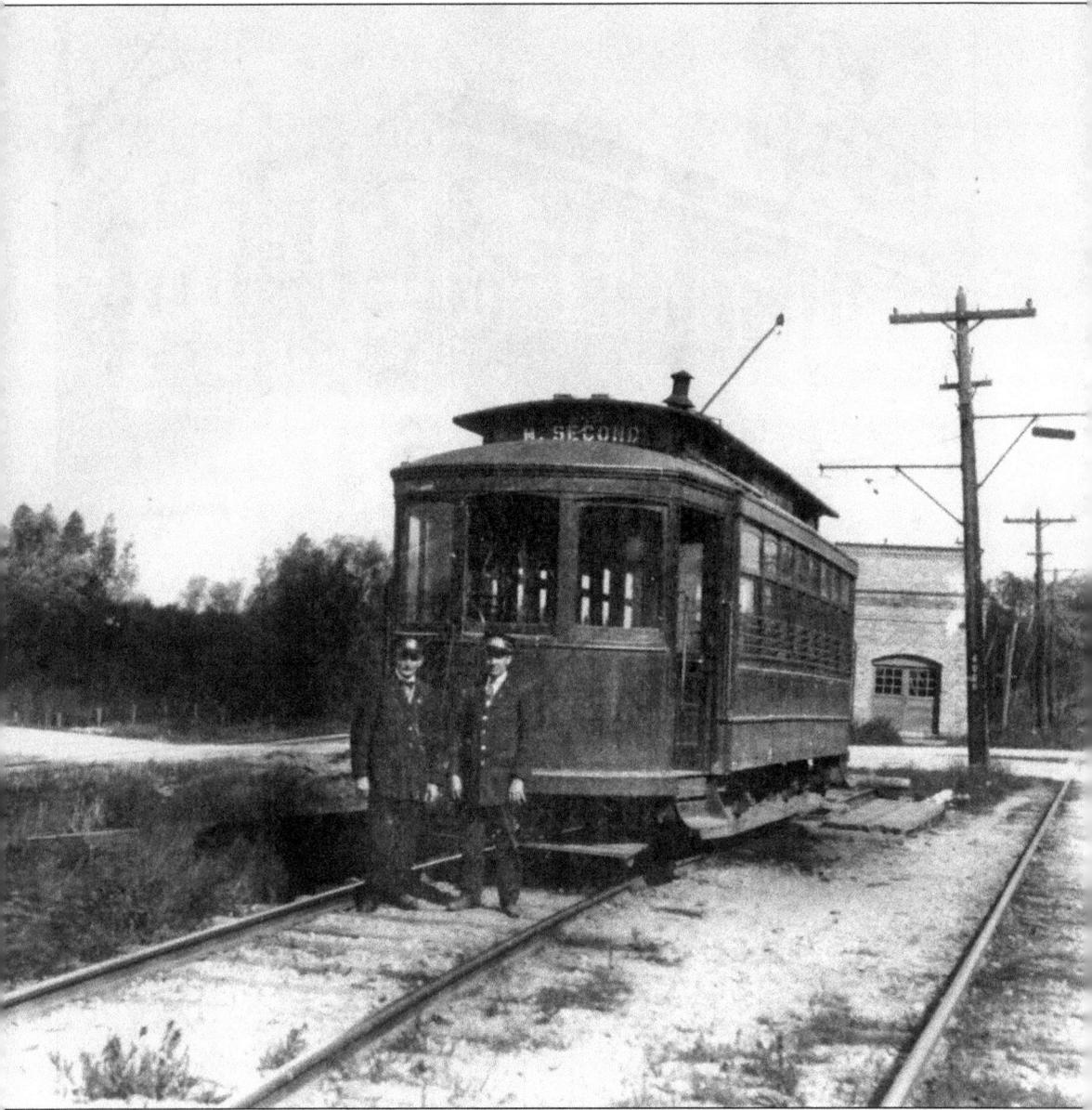

An R&I city car is at the end of its North Second Street run, in High Bridge siding at Blueberry Hill in 1926. Substation No. 4 is in the background. This site is unrecognizable today, as the widening of North Second Street (Business US 51) to six lanes has obliterated the location. (BLc.)

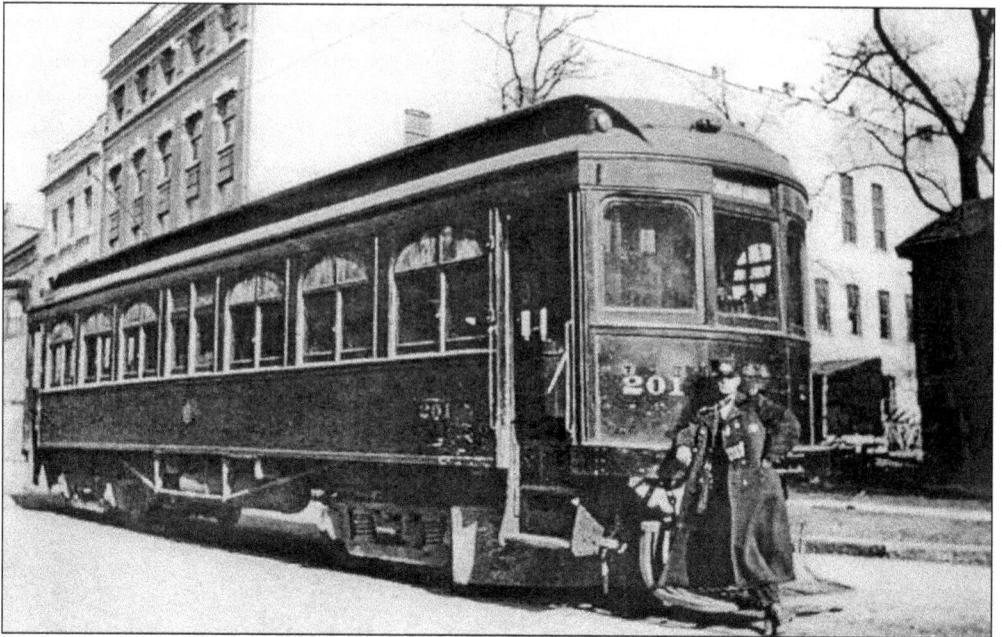

R&I men loved to pose with their cars. This conductor shows off his winter uniform while standing in front of Rockford & Freeport Electric car No. 201 in Freeport. Judging by the destination sign, "Chicago Limited," the train is poised to depart for Rockford and may well run through to Belvidere and Elgin, where Chicago-bound passengers will change to the Chicago Aurora & Elgin. (BLc.)

JOINT TIME CARD

CHICAGO, AURORA & ELGIN R. R.
ELGIN & BELVIDERE ELECTRIC CO.
ROCKFORD & INTERURBAN R. R.

WESTBOUND Effective **Sept. 28, 1924.** Subject to change without notice

STATIONS	Except Sunday AM	Daily AM	Daily AM	Daily AM	Daily PM	Daily PM	Daily PM	Daily PM	Daily PM	
C.A. & E. Chicago....Lv	7.05	9.30	11.30	1.30	3.30	5.25	7.05	8.35
" Elgin......Ar	8.41	10.46	12.48	2.42	4.48	6.52	8.27	9.54
Sunday Leave Chicago	**7.20**	**9.30**	**11.30**	**1.30**	**3.30**	**5.30**	**7.30**	**8.30**
Sunday Arrive Elgin...	**8.55**	**10.55**	**12.55**	**2.55**	**4.55**	**6.55**	**8.55**	**9.55**
E. & B....Elgin......Lv	7.00	9.00	11.00	1.00	3.00	5.00	7.00	9.00	10.15
" ...Gilberts.... "	7.22	9.22	11.22	1.22	3.22	5.22	7.22	9.22	10.35
" ...Huntley.... "	7.33	9.33	11.33	1.33	3.33	5.33	7.33	9.35	10.45
" ...Union..... "	7.48	9.48	11.48	1.48	3.48	5.48	7.48	9.48	11.00
" ...Marengo... "	7.57	9.57	11.57	1.57	3.57	5.57	7.57	9.57	11.10
" ...Garden Prairie"	8.10	10.10	12.10	2.10	4.10	6.10	8.10	10.10	
" ...Belvidere...Ar	8.24	10.24	12.24	2.24	4 24	6.24	8.24	10.24	
R. & I...Belvidere...Lv	8.25	10.25	12.25	2.25	4.25	6.25	8.25	10.25	
" ...Rockford...Ar	9.05	11.05	1.05	3.05	5.05	7.05	9.05	11.05	
" ...Freeport....Ar	10.15	12.15	2.15	4.14	6.15	8.15	10.15	12.15	
......

No baggage carried between Chicago and Elgin.

The coordinated service between Rockford and Chicago offered jointly by the R&I, E&B, and the CA&E was heavily promoted. This timecard, dated September 28, 1924, illustrates the route's chief virtue: frequency of service. Nearly every town and city listed was also served by steam railroads, whose trains were faster but less frequent and more expensive. Still, the steam railroads were the victor, mainly because of the long overall running time between Chicago and Rockford—nearly five hours in some cases, versus under two hours for IC trains. Further affecting the interurban option was the need to change trains at Elgin. (BLc.)

A longtime R&I ticket agent, Edmund "Eddie" Stemwedel is shown in the ticket office in the R&I's Rockford depot at State and Wyman Streets. The facility looks well worn, suggesting that this photograph was taken in the 1920s, as the R&I slipped into hard times. (Gordon H. Geddes collection.)

Car No. 867 cruises down one of Rockford's numerous tree-lined residential streets later in its career, which began when it came out of the St. Louis Car Company shops in 1917. Rockford was once proudly nicknamed "The Forest City," until Dutch elm disease struck down most of the city's elms in the 1950s. (Gordon H. Geddes collection.)

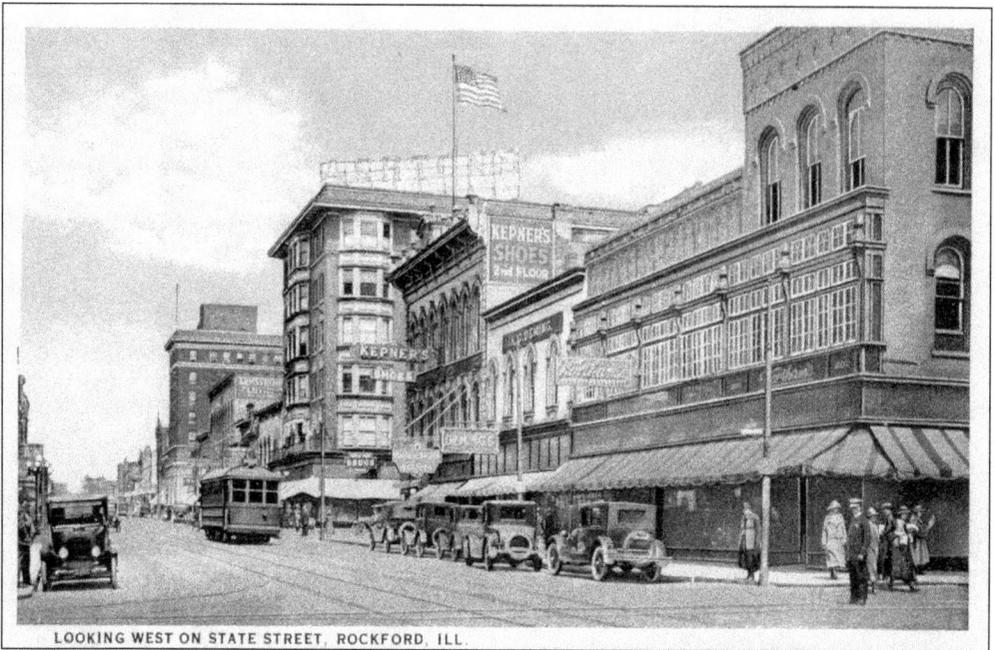

LOOKING WEST ON STATE STREET, ROCKFORD, ILL.

This view of downtown Rockford in the early 1920s looks west along State Street from State and Wyman Streets, "Transfer Corner" (see page 49 for an earlier view). An 800-class streetcar is working its way west toward one of the west-side routes: School Street, West State, Preston Avenue, or Rockton Avenue. Meanwhile, the "enemy" of the streetcar and interurban—the automobile—begins appearing in ever-greater numbers. (BLc.)

Things appear quiet at the Kishwaukee Street carbarn in this northeast-facing photograph, taken from First Street. What was and is arguably Rockford's most iconic building, the Faust Hotel, looms in the background. At 15 stories, it is Rockford's tallest building. It opened in 1929 as the city's premier hotel and today serves as a senior apartment building. To the right, beyond the carbarn yard, is the Ohave Shalom synagogue, which also remains standing in 2015, though it has been repurposed. (Photograph by M.D. McCarter, Gordon H. Geddes collection.)

An 800-series car scoots westbound on State Street in front of the Talcott Building on September 1, 1929. The junction sign refers to the intersection of State and Main Streets and the junction of US 51 and Illinois Routes 2 and 70. At this time, the end was near for the R&I, which would cease interurban service in 1930. City streetcar service would soldier on until 1936. (Photograph by R.V. Mellenbach, SLIHS.)

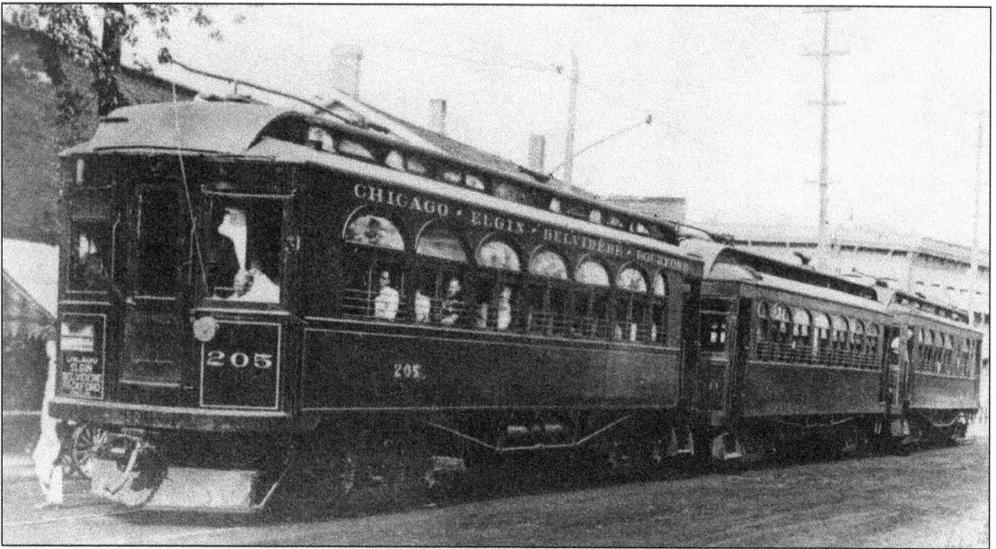

Elgin & Belvidere car No. 205 leads a three-car train through Belvidere in the 1920s. The "Chicago-Elgin-Belvidere-Rockford" lettering across No. 205's letterboard as well as on the destination board on the right front of the car illustrates the highly touted coordinated service of the R&I and E&B. This Chicago-Rockford service was offered well into the 1920s. A change of trains was required at Elgin to continue on to downtown Chicago. CA&E trains operated directly to the Loop by using Chicago Rapid Transit 'L' tracks. (Photograph by Ed Frank, Barney Neuberger collection.)

Intermodalism—the facilitation of easy and timely transfers between various means of transportation—is a lost art in the United States. But, as early as the 1920s, it was common practice for railways and bus companies to connect with one another, as this 1925 timetable shows. R&I patrons could make connections with the Chicago & North Western and the Milwaukee Road at certain locations, notably Janesville for people using the R&I's old RB&J route. In some cases, a short connecting bus ride took travelers to the C&NW or Milwaukee Road depot, or to a hotel of choice. (BLc.)

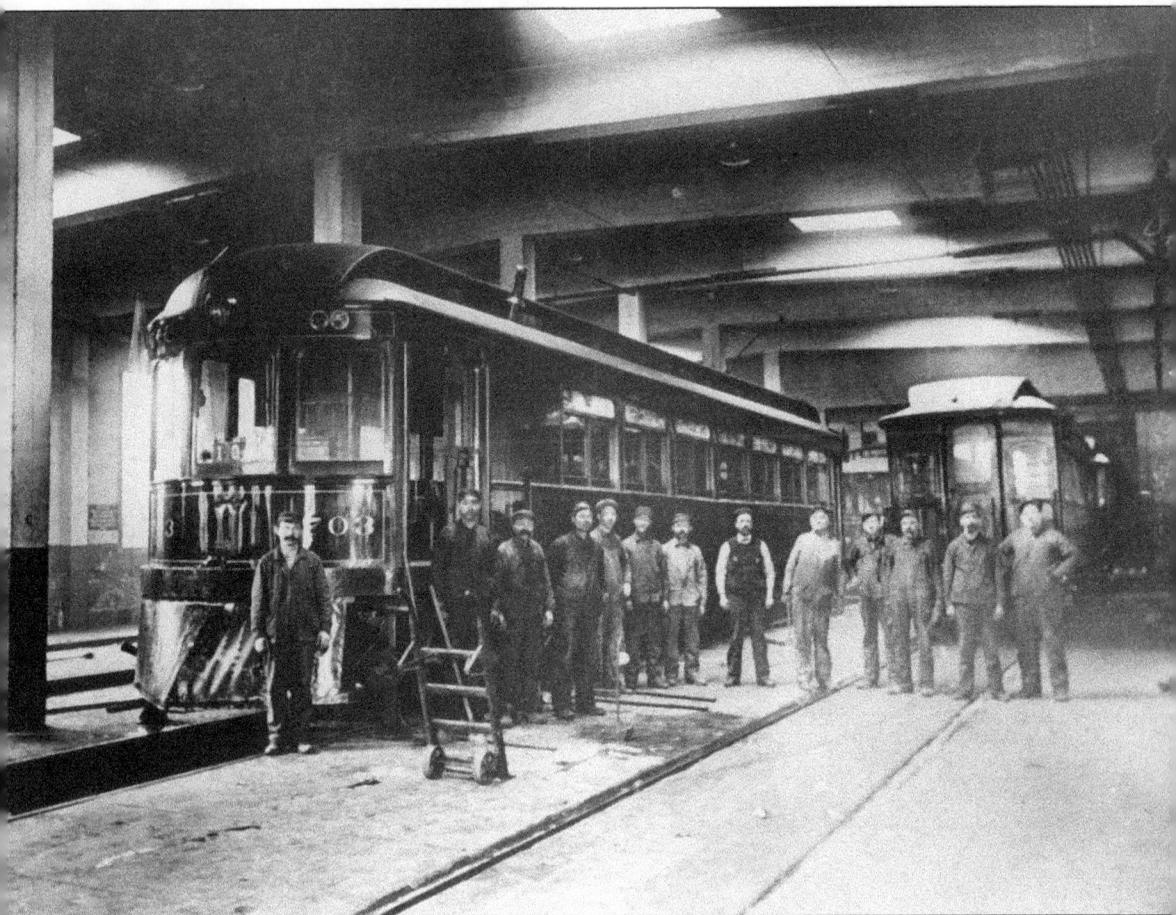

Though the details seem to have been lost to history, it is speculated that this photograph, taken in R&I's North Shops, shows the completed rebuilding of car No. 703. A 1902 product of Niles Car Company, No. 703 and its sister cars went through a rebuilding program beginning in 1912, allowing the cars to provide yeoman duties until almost the end of the 1920s. At right is one of the former "el" (elevated) cars from New York City's transit system, which the R&I had purchased to rebuild into nonpowered trailers for added capacity. (Gordon H. Geddes collection.)

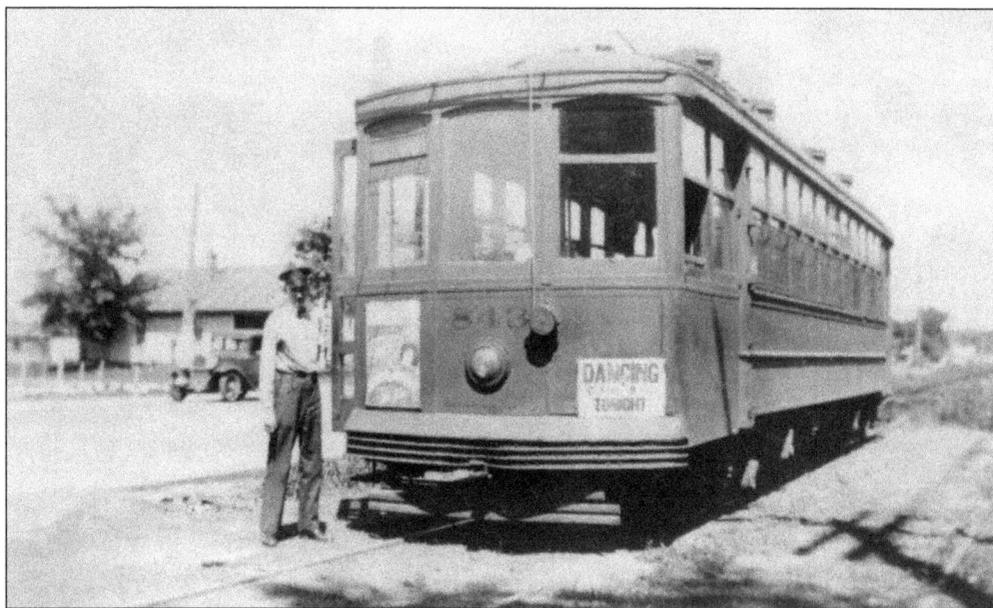

Streetcar motorman Andy Wright stands with city car No. 843, built by the St. Louis Car Company in 1913. In his later years, Wright, the son of R&I interurban motorman John Wright, built an HO-scale model railroad based on the Rockford & Interurban. The photograph's location is unidentified. (Gordon H. Geddes collection.)

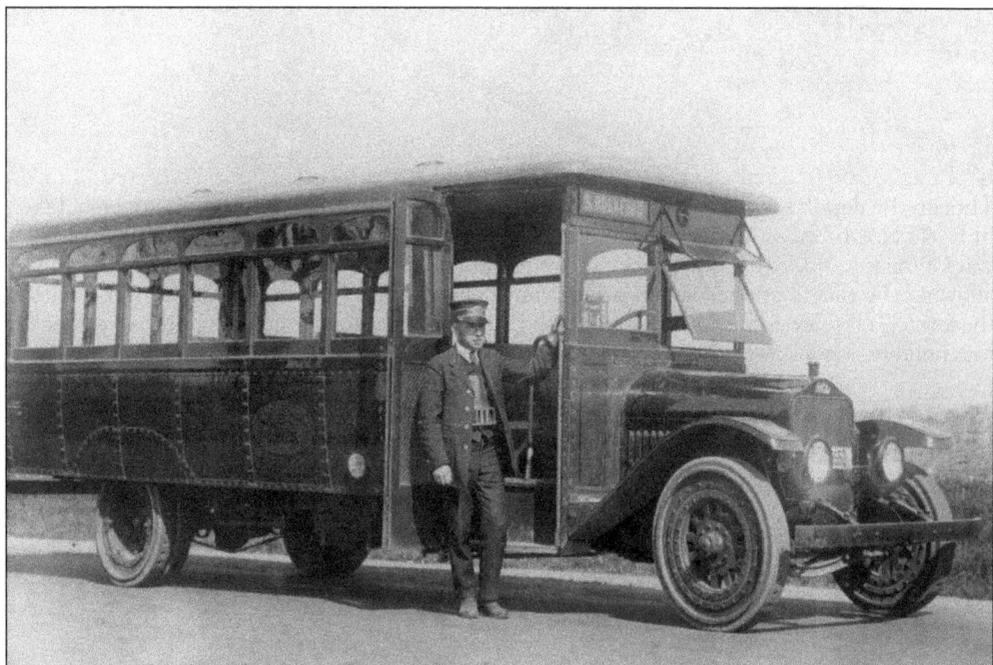

Despite its name, the Rockford & Interurban Railway was not an all-rail system. The railway extended its service reach to neighborhoods lacking interurban or streetcar lines through connecting bus service. In 1922, R&I driver Frank Gilchrist—wearing a uniform with R&I markings—stands beside an R&I bus built by White Motor Company. The destination sign indicates South Rockford. (Gordon H. Geddes collection.)

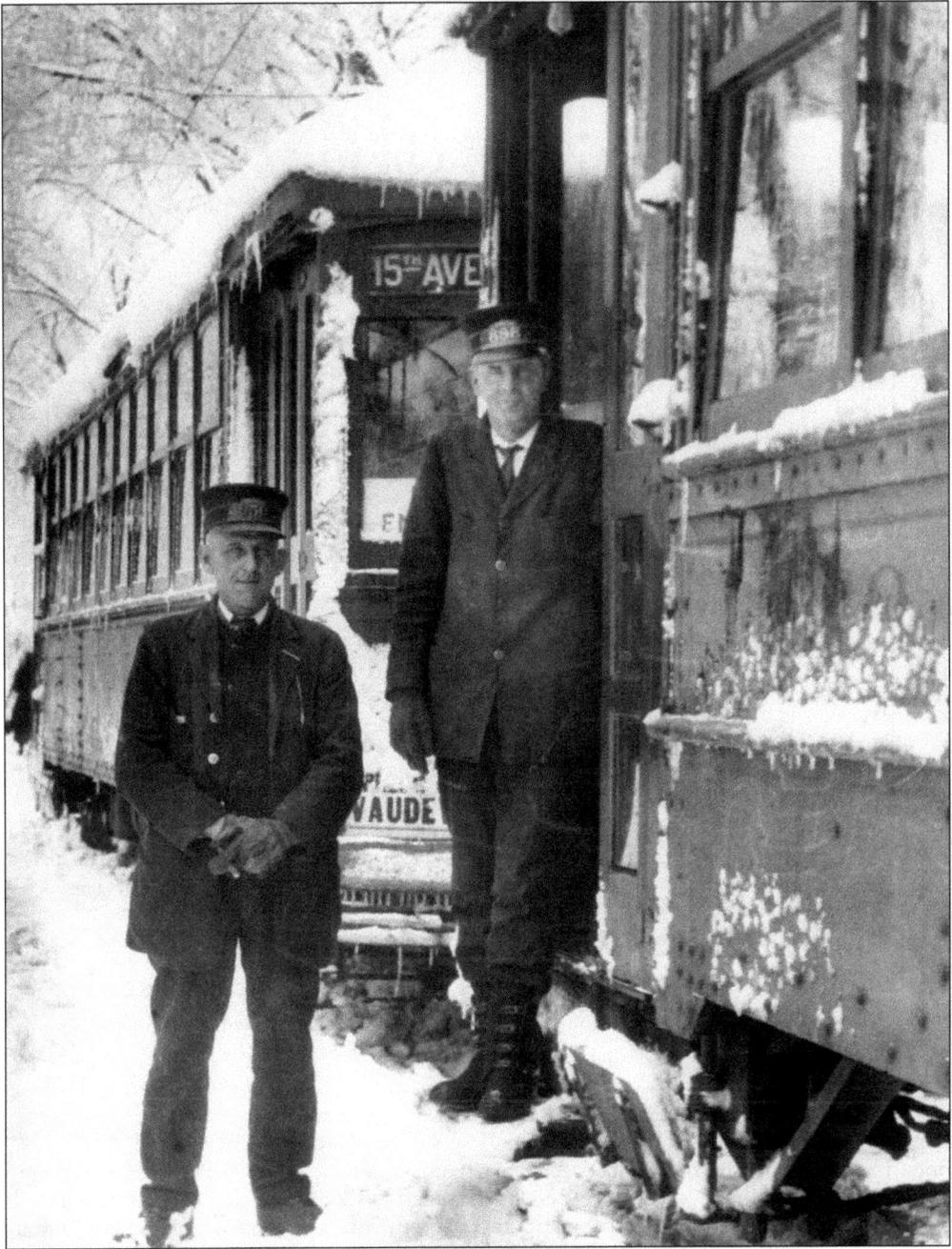

Generally, streetcars cope with snow much better than do buses. The location where these conductors of two cars are standing is not identified, though the Fifteenth Avenue designation on the second car suggests that this might be at the loop off of Fifteenth Avenue at Seminary and Catherine Streets. The men pause for a moment to take in some fresh air before resuming their respective runs back to the home terminal. (Gordon H. Geddes collection.)

THROUGH SCHEDULE OF TICKET FARES

A. E. & C. R. R. CO.　　　E. & B. ELECTRIC CO.　　　R. & I. R. R. CO.

	Miles	Kind of Ticket	Chicago	S. Elmhurst	Lombard	Glen Ellyn	Wheaton	Elgin	Gilberts	Huntley	Union	Marengo	Garden Prairie	Belvidere	Cherry Valley	Rockford	Winnebago	Pecatonica	Ridott	Freeport	Roscoe	Rocton	Beloit	Janesville
Chicago		S																						
		R.T.																						
S. Elmhurst	16.0	S	.20																					
		R.T.	.40																					
Lombard	20.5	S	.25	.10																				
		R.T.	.50	.20																				
Glen Ellyn	23.0	S	.30	.15	.05																			
		R.T.	.55	.30	.10																			
Wheaton	25.5	S	.35	.20	.10	.05																		
		R.T.	.65	.40	.20	.10																		
Elgin	42.0	S	.60	.45	.40	.35	.30																	
		R.T.	1.10	.85	.75	.65	.55																	
Gilberts	8.1 / 50.1	S	.70	.60	.55	.50	.45	.15																
		R.T.	1.25	1.10	1.00	.90	.80	.25																
Huntley	5.0 / 55.1	S	.80	.70	.65	.60	.55	.25	.10															
		R.T.	1.35	1.25	1.15	1.05	.95	.40	.20															
Union	7.4 / 62.5	S	.85	.85	.80	.75	.70	.40	.25	.15														
		R.T.	1.65	1.60	1.50	1.40	1.30	.75	.40	.25														
Marengo	3.7 / 66.2	S	.90	.90	.85	.80	.75	.45	.35	.25	.10													
		R.T.	1.70	1.70	1.60	1.50	1.40	.85	.60	.40	.15													
Garden Prairie	6.1 / 72.3	S	1.00	.95	.90	.85	.80	.55	.50	.40	.25	.15												
		R.T.	1.80	1.75	1.65	1.55	1.45	1.00	.95	.70	.45	.25												
Belvidere	4.0 / 78.4	S	.95	.95	.90	.85	.80	.60	.55	.50	.35	.25	.15											
		R.T.	1.80	1.75	1.65	1.55	1.45	1.10	1.00	.90	.60	.40	.25											
Cherry Valley	6.0 / 84.4	S	1.10	1.05	1.00	.95	.90	.65	.65	.55	.45	.35	.25	.10										
		R.T.	1.90	1.90	1.80	1.65	1.55	1.15	1.15	1.00	.75	.60	.45	.20										
Rockford	8.5 / 92.9	S	1.20	1.15	1.10	1.05	1.00	.75	.75	.70	.60	.50	.40	.25	.15									
		R.T.	2.00	2.00	1.90	1.80	1.70	1.30	1.30	1.20	.95	.80	.65	.50	.30									
Winnebago	7.7 / 100.6	S	1.30	1.25	1.20	1.15	1.10	.85	.85	.80	.70	.60	.50	.40	.30	.15								
		R.T.	2.20	2.20	2.10	2.00	1.90	1.55	1.55	1.45	1.20	1.05	.90	.75	.55	.25								
Pecatonica	7.3 / 107.9	S	1.40	1.35	1.30	1.25	1.20	.95	.95	.90	.80	.70	.60	.50	.40	.25	.10							
		R.T.	2.35	2.35	2.25	2.15	2.05	1.70	1.70	1.60	1.35	1.20	1.05	.95	.75	.45	.20							
Ridott	7.3 / 115.2	S	1.50	1.45	1.40	1.35	1.30	1.00	1.00	.95	.85	.75	.65	.55	.45	.35	.20	.10						
		R.T.	2.55	2.55	2.45	2.35	2.25	1.80	1.80	1.70	1.45	1.30	1.15	1.15	.95	.65	.40	.20						
Freeport	7.0 / 122.2	S	1.55	1.50	1.45	1.40	1.35	1.10	1.10	1.05	.95	.85	.75	.65	.65	.35	.25	.15						
		R.T.	2.65	2.65	2.55	2.45	2.35	2.05	2.05	1.95	1.70	1.55	1.40	1.40	1.20	.90	.65	.45	.25					
Roscoe	27	S	1.35	1.30	1.25	1.20	1.15	.95	.95	.90	.80	.70	.60	.50	.40	.25	.40	.50	.60	.70				
		R.T.	2.30	2.30	2.20	2.10	2.00	1.70	1.70	1 60	1.35	1.20	1.05	.90	.70	.40	.65	.85	1.05	1.30				
Rocton	31	S	1.40	1.35	1.30	1.25	1.20	1.00	1.00	.95	.85	.75	.65	.55	.45	.30	.45	.55	.65	.70	.08			
		R.T.	2.40	2.40	2.30	2.20	2.10	1.80	1.80	1 70	1.45	1.30	1.15	1.00	.80	.50	.75	.95	1.15	1.30	.15			
Beloit	35	S	1.45	1.40	1.35	1.30	1.25	1.00	1.00	.95	.85	.75	.65	.60	.50	.35	.50	.60	.70	.70	.15	.08		
		R.T.	2.55	2.55	2.45	2.35	2.25	1.80	1.80	1.70	1.45	1.30	1.15	1.15	.95	.65	.90	1.10	1.30	1.30	.25	.15		
Janesville	50	S	1.60	1.55	1.50	1.45	1.40	1.10	1.10	1.05	.95	.85	.75	.75	.75	.60	.75	.85	.95	.95	.40	.35	.25	
		R.T.	2.80	2.80	2.70	2.60	2.50	2.05	2.05	1.95	1.70	1.55	1.40	1.40	1.40	1.10	1.35	1.55	1.75	1.75	.70	.60	.45	

This fare matrix shows fares between all points served by coordinated R&I, E&B, and AE&C lines. The most expensive trip was between Chicago and Janesville, at $2.80. However, considering that direct steam-railroad service between Chicago and Janesville covered the distance in half the time, it is suspected that few people rode the interurban between such outlying terminals already connected by steam roads. (BLc.)

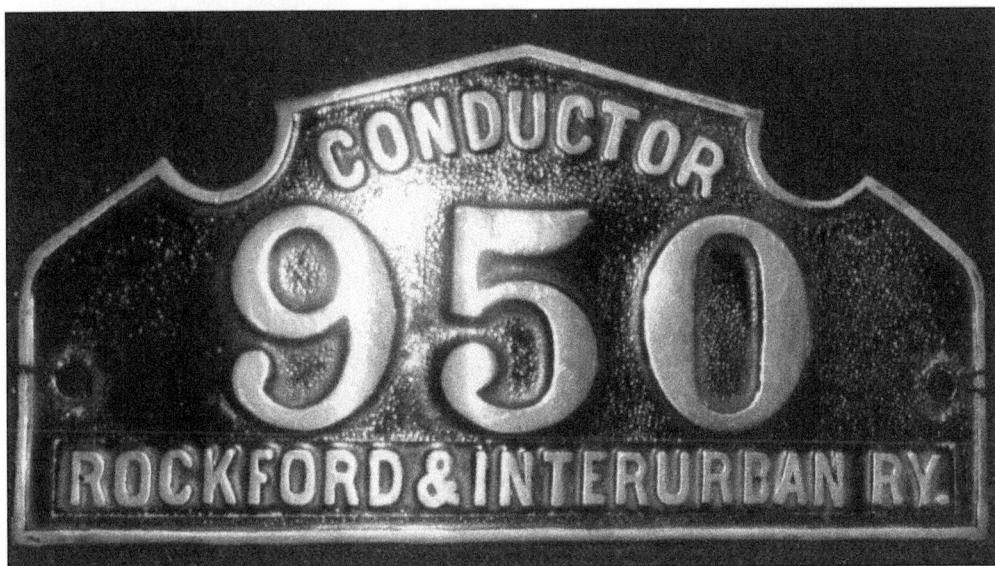

Hat badges have been collectibles for decades, especially those belonging to railways that have vanished into history. This Rockford & Interurban conductor's badge is of cast brass; the number is the employee number, for accounting purposes. (BLc.)

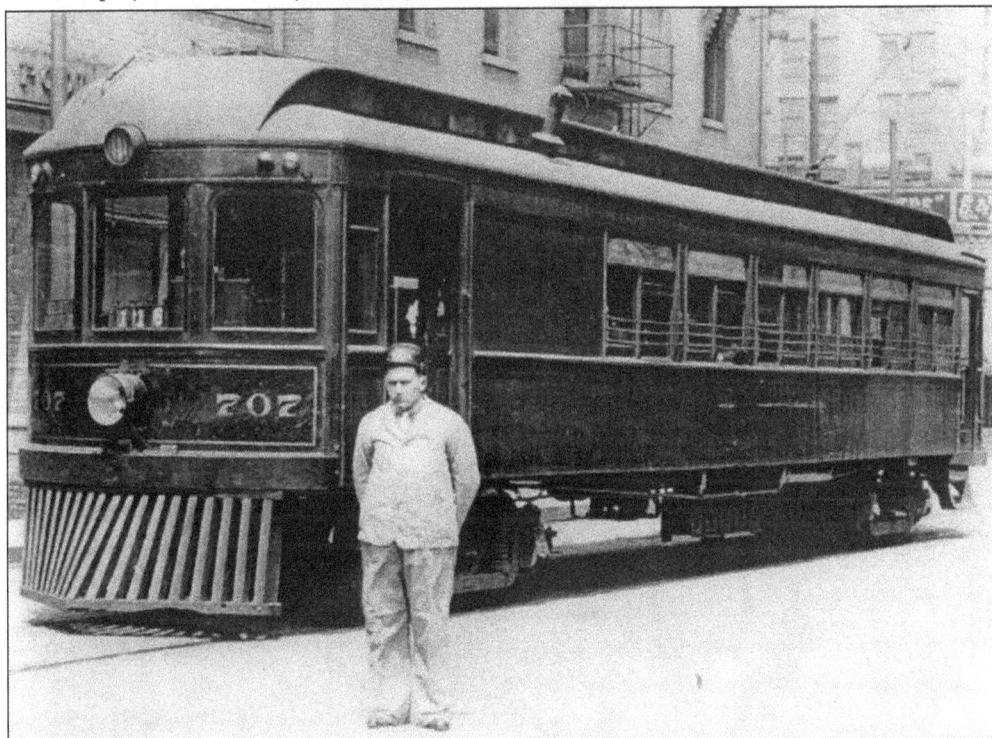

An unidentified motorman stands with his assigned car, No. 707, for run No. 116 in downtown Rockford. It is 1928, and, by now, the Rockford & Interurban is feeling the effects of government-funded competition in the form of improved state and county highways. In two years, classic interurban cars such as the R&I 700s will be a thing of the past in Rockford, Belvidere, Beloit, Janesville, and Freeport. Streetcars in Rockford will remain for another six years. (BLc.)

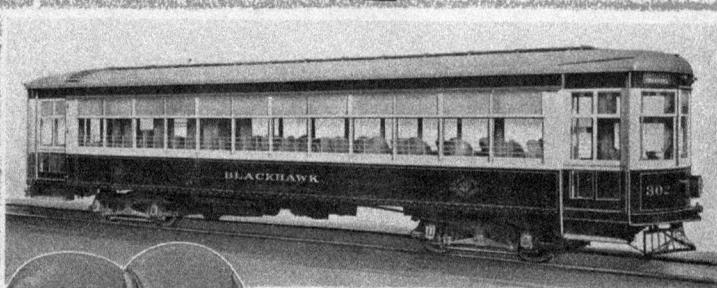

One of these cars exhibited in Cleveland

No. 301 type

Rockford
wanted Modern Cars
and Specified
Brill
Seats

A unique feature of the last seven cars built by the American Car Company for Rockford was the use of Brill No. 301 type leather upholstered seats of a distinctive color in each car.

This popular double-chair seat for single-end cars has loose cushions of both air and spring type mattress construction, and contributes no small part to the success of electric railway service in which they are introduced.

BRILL

The City of Rockford endorsed this advertisement in the October 1927 edition of *Electric Traction* magazine. The advertisement, placed by the J.G. Brill Company, a well-known builder of streetcars and interurbans, calls attention to the well-cushioned seats manufactured by Brill itself rather than by an outside contractor. (BLc.)

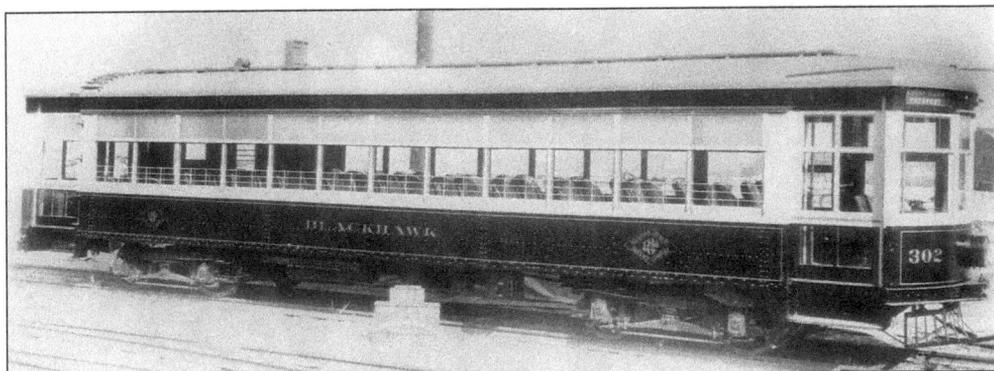

Sporting its sharp red-and-cream livery, Rockford & Interurban car No. 302, christened *Blackhawk* after the Sac (or Sauk) chief of that name, poses for its builder's photograph at American Car Company in St. Louis. The identification sign beside the car shows that the photograph was taken on July 18, 1927. State-of-the-art interurban technology, No. 302 and its sisters supplemented and ultimately replaced the venerable 700-series cars. But, within three years of the arrival of the 300s, the R&I's intercity routes had all been shut down, relegating the 300s to lowly streetcar service. (Gordon H. Geddes collection.)

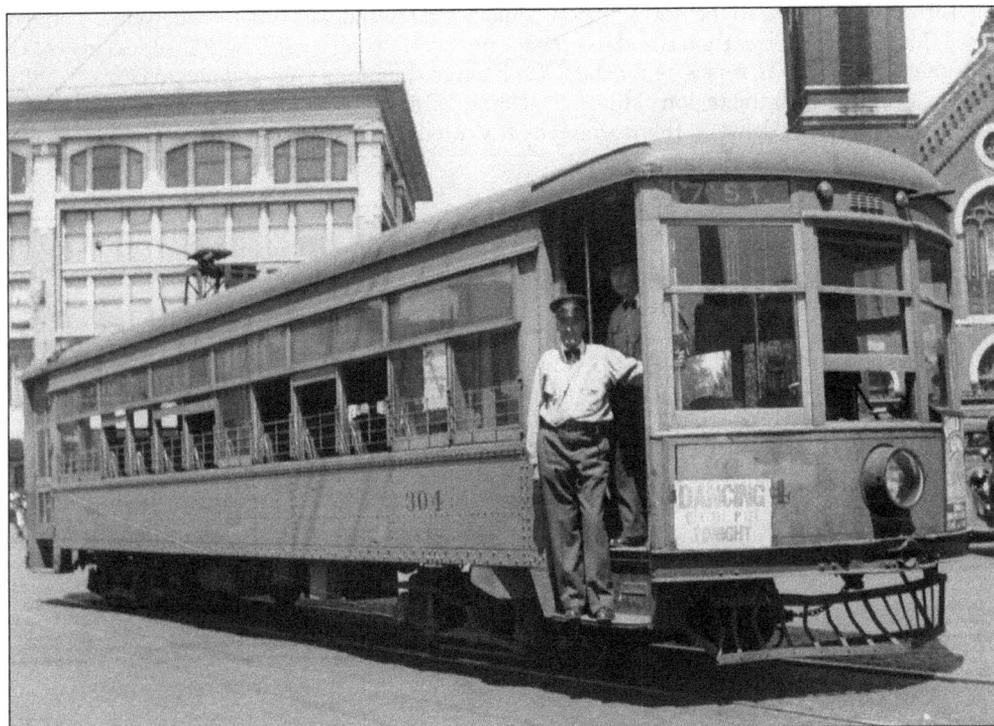

With Hess Brothers department store as a backdrop, car No. 304 pauses at the intersection of Kishwaukee, East State, and Third Streets. The site was called "the Triangle," so called because of the triangular land parcel formed by the junction of these streets. The Triangle was long a popular uptown transfer point for streetcars and buses. Car No. 304 was acquired in 1927 for both interurban and local streetcar service and was working in the latter capacity on a Seventh Street circuit when this photograph was taken. (Photograph by M.D. McCarter, Gordon H. Geddes collection.)

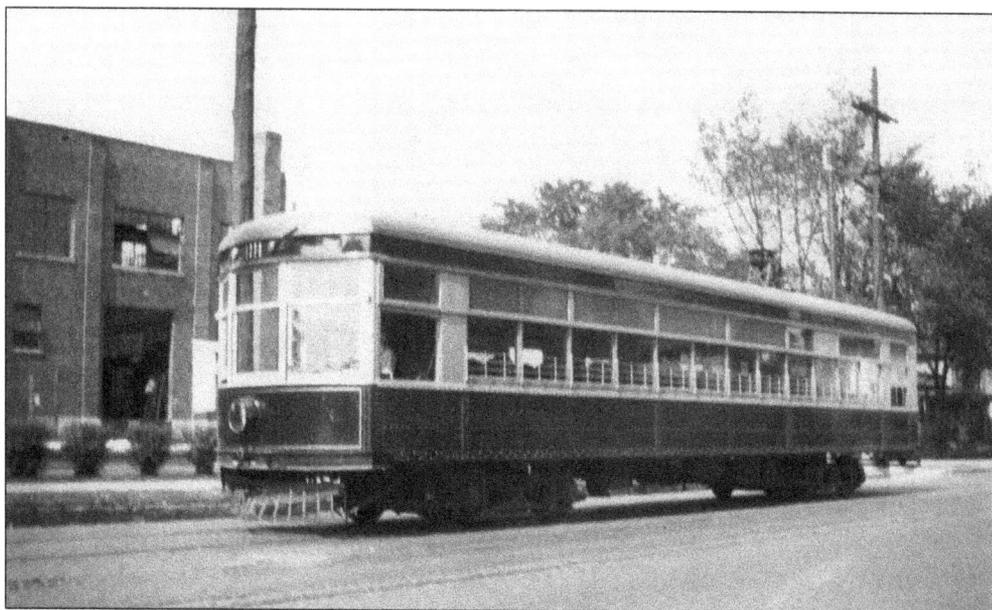

In the late 1920s, the Rockford Public Service Company bought seven all-steel, lightweight interurban cars to lease to the R&I so that it could begin replacing its aging wooden cars. Though more than 10 feet shorter than the classic 700-series cars of yore, these new 300-series cars (Nos. 300–306) could seat 52 versus 54 for the 700s. Each of the nimble red-and-cream cars carried a name associated with the region. This is the *Kishwaukee*, seen on Grove Avenue at Lake Street in Elgin shortly after delivery. (Photograph by R.V. Mellenbach, SLIHS.)

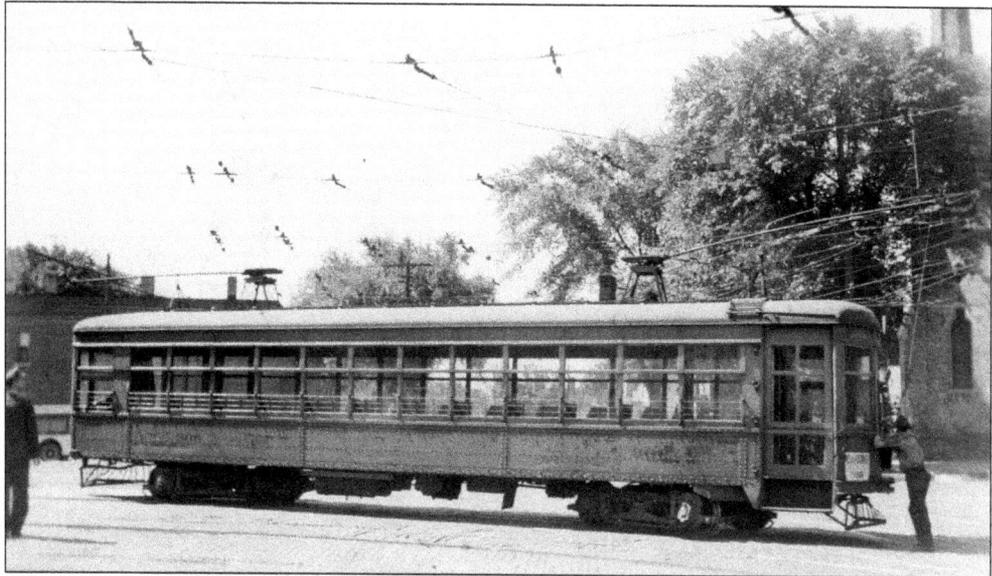

The motorman of car 300 is "changing ends"—that is, lowering the trolley pole at one end of the car and raising it on the other so that the car can head off in the opposite direction for its next run. When the 300-series cars were delivered, only No. 300 itself was double-ended; the rest of the 300s could only be turned on a loop or wye track, since they were intended for interurban service. Eventually, some other 300s were rebuilt as double-ended cars for better utilization in local city service. (SLIHS.)

The above photograph shows the interior of a new 300-series dual-service (interurban and local city lines) car. Note the cushioned seats and ample windows. A 1928 R&I "Rockford Lines" timetable (below) describes the new vehicles as "palatial" and the R&I itself as "a complete transportation service." (Above, photograph by M.D. McCarter, Gordon H. Geddes collection; below, BLc.)

INTERURBAN
Rockford Lines

TRAVEL
The Electric Way

Fast Service

At

Low Rates

Between

ROCKFORD

Winnebago Roscoe
Pecatonica Rockton
Ridott Beloit
Freeport Janesville
Belvidere—Marengo—Elgin
St. Charles—Geneva—Aurora

and

CHICAGO

TIME TABLE
Rockford Lines

NEW PALATIAL ELECTRIC
INTERURBAN CARS

A Complete Transportation Service
SAFE — FAST — COMFORTABLE
—TO—

Belvidere Winnebago Roscoe
Marengo Pecatonica Rockton
Elgin Ridott Beloit
Chicago Freeport Janesville

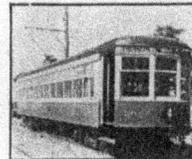

Adam Gschwindt, *Gen'l Mgr.* A. P. Lewis, *Gen'l Supt.*
C. C. Shockley, *Gen'l Passenger Agent*
OCTOBER, 1928

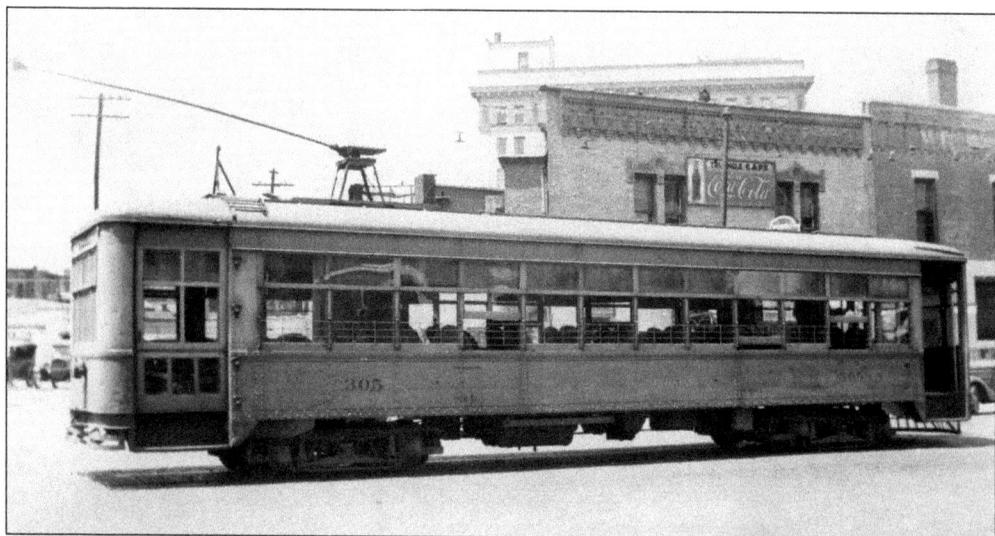

Just rolling in from the Kishwaukee carbarn area, car No. 305 is at the Triangle, a popular transit transfer point in uptown Rockford. This view shows how most 300 cars were formatted, with the back end of the car having a flat, "blind" end—that is, without a controller and motorman's station. Also, there was only a single trolley pole, since 99 percent of the car's operation was forward. Note in the background the Triangle Restaurant, where one of this book's authors occasionally had lunch to visit his favorite waitress, Penny Sweeney. (Photograph by M.D. McCarter, Gordon H. Geddes collection.)

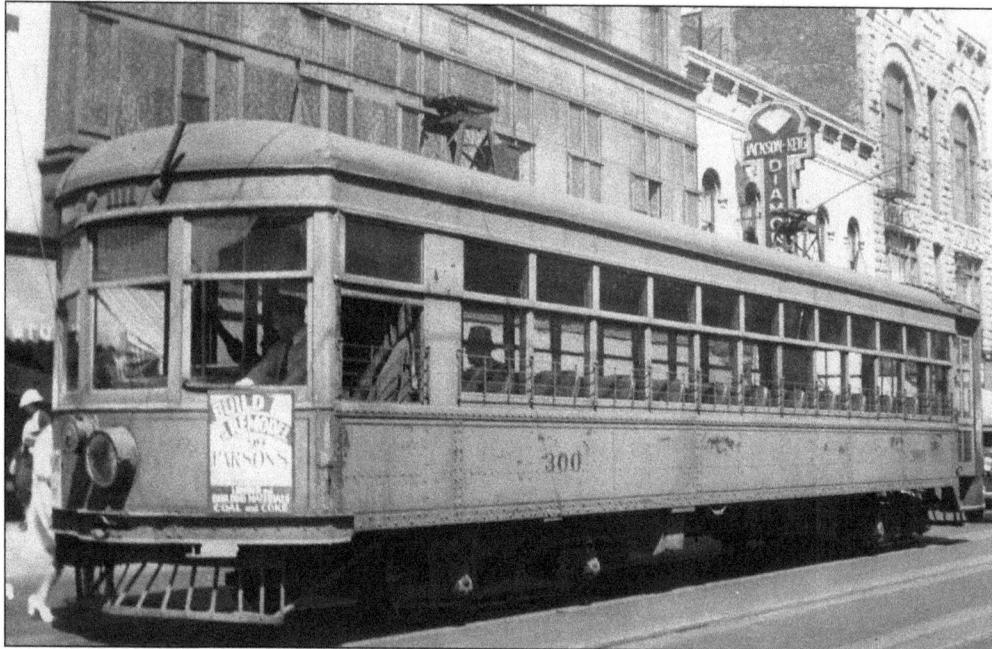

The R&I's 300-series cars were actually owned by the Rockford Public Service Company and leased to the R&I. Car No. 300 is shown on State Street later in its career, after it had traded its snappy cream-and-red colors for a yellow-orange scheme. When delivered in 1927 from American Car Company, No. 300 carried the name *Pecatonica*. (Photograph by M.D. McCarter, Gordon H. Geddes collection.)

ROCKFORD, BELOIT & JANESVILLE DIVISION

NORTH BOUND

		‡	*	*	Lim.	*	*	*	*	*	*	† Lim.	Lim.	*	*	*
Rockford	Lve.	600	700	800	935	1100	1200	100	230	330	440	635	800	945	1130	
" 4th St.	"	603	704	804	938	1104	1204	104	234	334	444	638	804	949	1131	
Roscoe	"	626	729	832	1002	1130	1232	132	302	400	509	701	830	1015	1200	
Rockton	"	635	735	811	1010	1138	1240	141	310	408	516	708	838	1022	1207	
Beloit	"	645	750	850	1020	1150	1250	150	320	420	Ar.525 Lv.540	720	850	1035	1220	
Janesville	Arr.	725	830	930	1100	1230	130	230	400	500	620	800	930	1115		

‡ Daily except Sunday. * Daily. Lim.—Limited; River Lane and station stops only.
Note:—Connections made at 4th St., Rockford, with trains from Belvidere, Elgin and Chicago.
Note:—Cars leaving Rockford at 6:00 A. M., 7 A. M., 9:35 A. M., 11 A. M., 6:35 P. M. and 8:00 P. M. will run direct to C. & N. W. Ry. Co. and C. M. & St. P. Ry. Co. depots to make connections for Madison, Elroy, Rochester, Fond du Lac, Duluth, St. Paul, Minneapolis and other northwestern points.
† Stops at River Lane and stations north of Harlem Road.

SOUTH BOUND

		‡	*	*	*	*	*	*	*	*	*	*	*	*	*
Janesville	Lve.	600	740	840	940	1110	1240	140	250	410	510	625	810	955
Beloit	"	545	645	820	920	1025	1150	120	220	330	450	550	705	850	1035
Rockton	"	553	655	829	929	1034	1159	129	229	340	500	559	715	858	1044
Roscoe	"	601	703	836	936	1041	1206	136	236	348	512	606	723	905	1051
Rockford	Arr.	635	735	910	1010	1115	1240	210	310	425	540	640	755	935	1120

‡ Daily except Sunday. * Daily.
Note:—Trains leaving Janesville at 6:00 A. M., 7:40 A. M., 8 A. M., 11:10 A. M., 12:40 P.M. 8:10 P. M. and 9:55 P. M. will leave from C. & N. W. Ry. Co. and C. M. & St. P. Ry. Co. depots.

FREEPORT, ROCKFORD & BELVIDERE DIVISION

EAST BOUND

		‡	*	*	*	*	*	*	*	*	*	*	*	*
Freeport	Lv.	528	628	830	920	1030	1230	230	430	630	830	1030
Ridott	"	545	645	847	947	1047	1247	247	447	647	847	1047
Pecatonica	"	556	656	858	958	1058	1258	258	458	658	858	1058
Winnebago	"	610	710	912	1012	1112	112	312	512	712	912	1112
Rockford	"	633	735	935	1035	1135	135	335	535	735	935	1135
Rockford	Lve.	600	742	942	1142	142	342	442	542	742	942
Cherry Valley	"	620	808	1008	1208	208	408	508	608	808	1008
Belvidere	Arr.	631	822	1022	1222	222	422	522	622	822	1022

‡ Daily except Sunday. * Daily.

WEST BOUND

		*	*	*	*	*	*	‡	*	*	*		
Belvidere	Lve.	645	825	1025	1235	225	425	525	625	825	1025	
Cherry Valley	"	658	837	1037	1237	237	437	537	637	837	1037	
Rockford	Arr.	725	905	1105	105	305	505	605	705	905	1105	
Rockford	Lve.	515	645	810	910	1110	110	310	510	710	910	1110
Winnebago	"	535	710	832	932	1132	132	332	532	732	932	1132
Pecatonica	"	550	722	844	944	1144	144	344	544	744	944	1144
Ridott	"	602	733	857	957	1157	157	357	557	757	957	1157
Freeport	Arr.	620	750	915	1015	1215	215	415	615	815	1015	1215

Daily except Sunday. * Daily.

Condensed Schedule
FREEPORT, JANESVILLE & ROCKFORD TO ELGIN & CHICAGO

EAST BOUND

		*	*	*	*	*	*	*	*	
Freeport	Lve.	628	830	1030	1230	230	430	630	830
Rockford	Arr.	735	935	1135	135	335	535	735	935
Janesville	Lve.	600	740	940	1110	140	410	510	810
Beloit	"	645	820	1025	1150	220	450	550	850
Rockford	Arr.	735	910	1115	1240	310	540	640	935
Rockford	Lve.	600	742	942	1142	142	342	542	742	942
Belvidere	"	631	822	1022	1222	222	422	632	822	1022
Marengo	"	700	852	1052	1252	252	452	652	852	1052
Elgin	Arr.	748	948	1148	148	348	548	748	948	
Elgin	Lve.	802	1002	1202	202	402	¹ 500	² 800	⁴ 1005	
Chicago	Arr.	910	1119	121	318	520	736	925	1128	

* Daily. ‡ Daily Except Sunday. ¹ On Sunday leaves Elgin at 8:02 P. M.
² On Sunday leaves Elgin at 6:02 P. M. ⁴ On Sunday leaves Elgin at 10:02 P. M.

WEST BOUND

		*	*	*	*	*	*	*	*	
Chicago	Lve.	¹ 705	930	1130	130	330	³ 525	⁴ 705	
Elgin	Arr.	841	1049	1248	250	448	652	827	
Elgin	Lve.	700	900	1100	100	300	500	700	900	
Marengo	"	757	957	1157	157	357	557	757	957	
Belvidere	"	645	825	1025	1225	225	425	625	825	1025
Rockford 4 St	Arr.	720	900	1100	100	300	500	700	900	1100
Rockford	"	725	905	1105	105	305	505	705	905	1105
Freeport	"	915	1015	1215	115	415	615	815	1015	1215
Rockford	Lve.	800	935	a1100	ₐ 100	330	535	800	945	
Beloit	Arr.	850	1020	1150	150	420	720	850	1035	
Janesville	Arr.	930	1100	1230	230	500	800	930	1115	

‡ Daily except Sunday. ¹ On Sunday leaves Chicago at 7:30 A. M.
* Daily. ³ On Sunday leaves Chicago at 5:30 P. M
ₐ Connection made at 4th Street, Rockford. ⁴ On Sunday leaves Chicago at 7:30 P. M
On Sunday leaves Chicago at 7:20 A. M.

This timetable card from the 1920s shows condensed schedules on all intercity routes at about the high point of R&I operations. Hourly service generally was the rule during the daytime, and there was still a big effort to promote coordinated services between Freeport, Janesville, and Rockford to and from Chicago, even though there was already good, fast, direct steam-railroad service between those points. Note, too, how R&I trains between Rockford and Janesville made direct connections with Chicago & North Western and Milwaukee Road trains at Janesville for faraway points such as Duluth, Rochester, and Minneapolis–St. Paul in Minnesota. Note the two limited-run ("Lim.") trains northbound in the late afternoon between Rockford and Janesville. In railwayspeak, "limited" denotes a train making limited stops, versus a local train making all or most intermediate stops. (BLc.)

R&I car No. 811 is shown around 1930 on the Seventh Street route. This stalwart was built in 1910 by the Kuhlman Car Company and had several sister 800-series cars, all of which were about 41 feet long. They were built expressly for local streetcar service and all were double-ended, which meant that the car did not have to be turned about on a loop or wye track at the end of its run, as was the case with most intercity interurban cars. (Photograph by M.D. McCarter, Gordon H. Geddes collection.)

Shown here are two sample tickets used by the Rockford & Interurban in the mid-1920s. By this time, the R&I was treating its different routes as "divisions," a common practice in railroad operation to this day. The tickets are especially interesting in that they show all official stations of a division, many of which are names that have been lost to history. (BLc.)

Four

WINDING DOWN

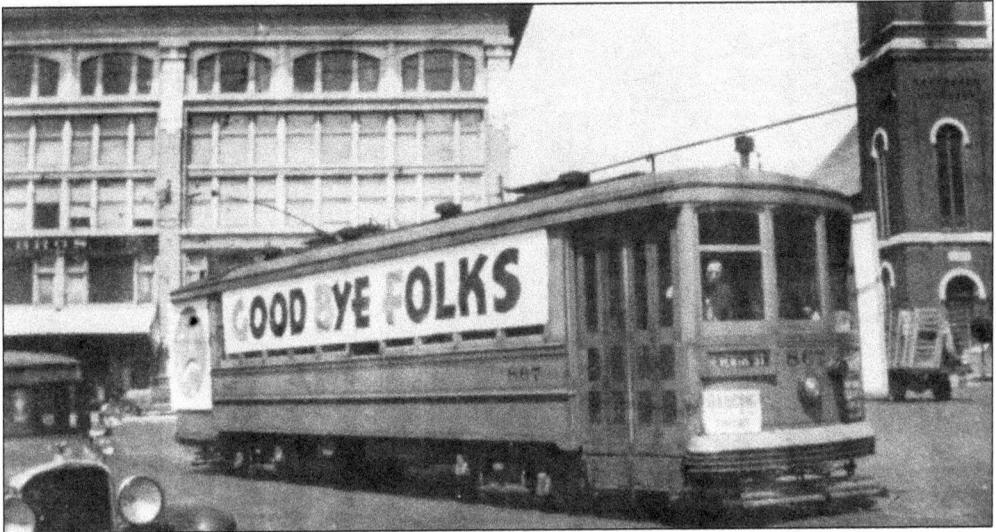

This photograph says it all as to the outcome of the Rockford & Interurban and its legacy Rockford Public Service Company. This car is in front of Hess Brothers, likely on the last day of regularly scheduled service, July 3, 1936. The last streetcar actually ran in the wee hours of July 4, but it was not open to the public. (Photograph by Ed Frank, Mike Schafer collection.)

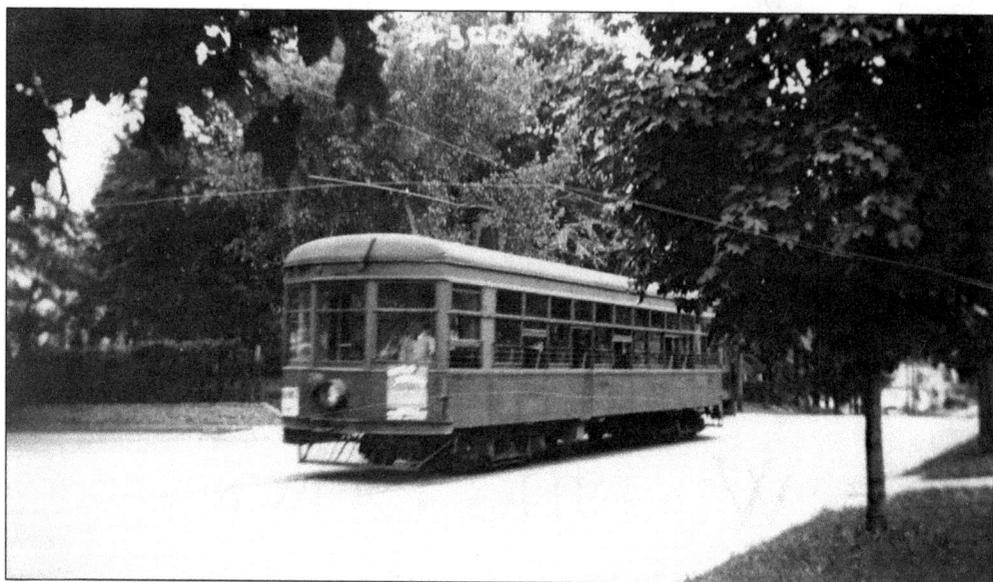

It is May 24, 1936, and car No. 300, the *Pecatonica*, is on its usual post-interurban assignment, the State Street route, trundling along East State at Hollister Avenue. The car had been out of interurban service for about six years, the R&I having been shut down since 1930. In its R&I days, No. 300 routinely made runs throughout the system—and sometimes beyond to Elgin. Ironically, it wound up back in interurban service on the Oklahoma Railway Company until 1947. (Photograph by Roy Peterson, Gordon H. Geddes collection.)

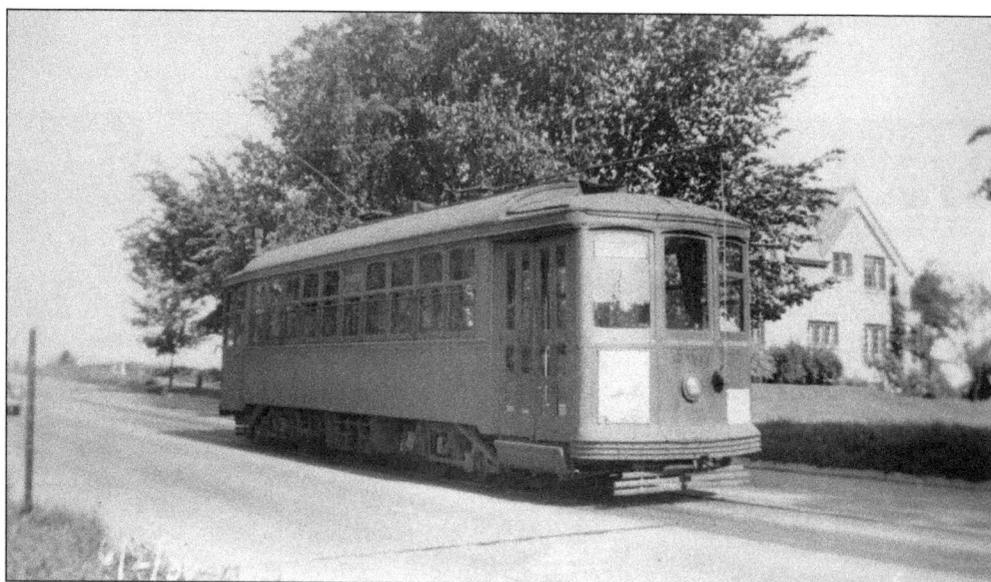

The 300s were not the only cars that operated to the end of streetcar service. Photographer Roy Peterson documented car No. 839 headed downtown at Dawson Avenue on July 2, 1936. The view looks to the southeast. The stately brick house in the background still stands, but it has lost much of its front yard to "progress," as East State was widened to accommodate the automobile boom. Just two days after this photograph was taken, streetcar service in Rockford officially ended. (Photograph by Roy Peterson, Gordon H. Geddes collection.)

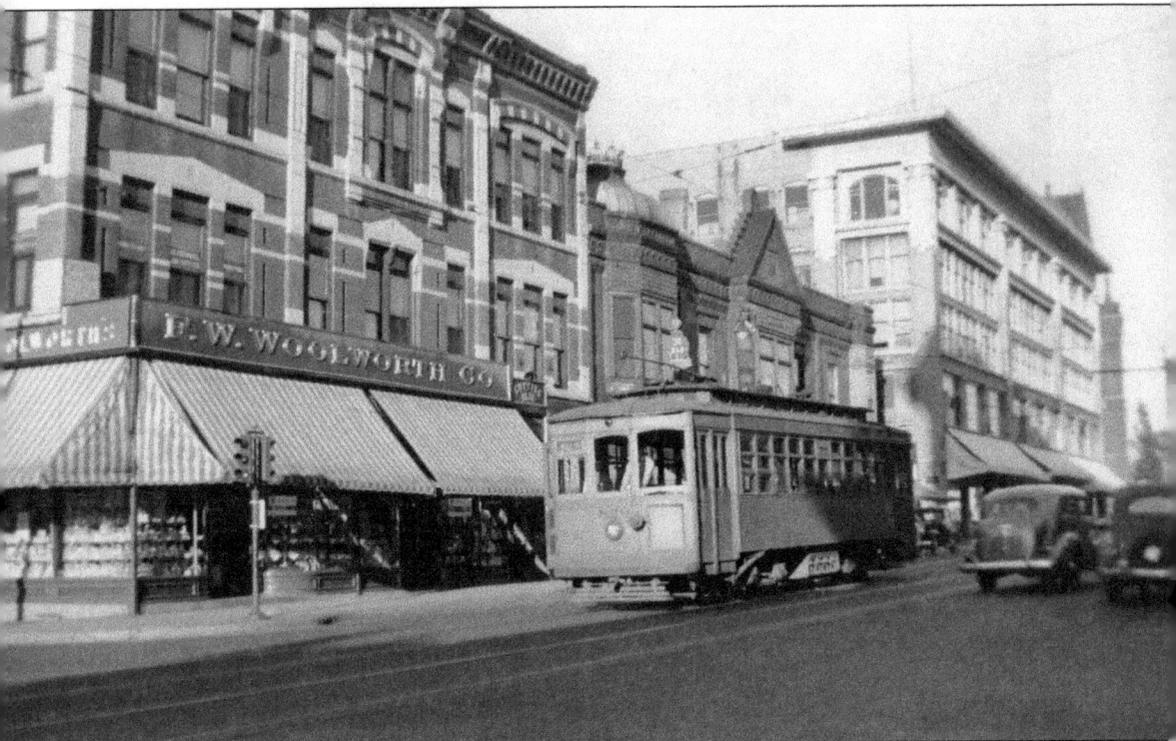

The Hess Brothers department store dominates this photograph, taken on July 2, 1936. Car No. 829—now 24 years old—works its way downhill along East State. The car may be waiting for the traffic signal here at North Second Street in front of Woolworth's, which has since been razed. (Photograph by Roy Peterson, Gordon H. Geddes collection.)

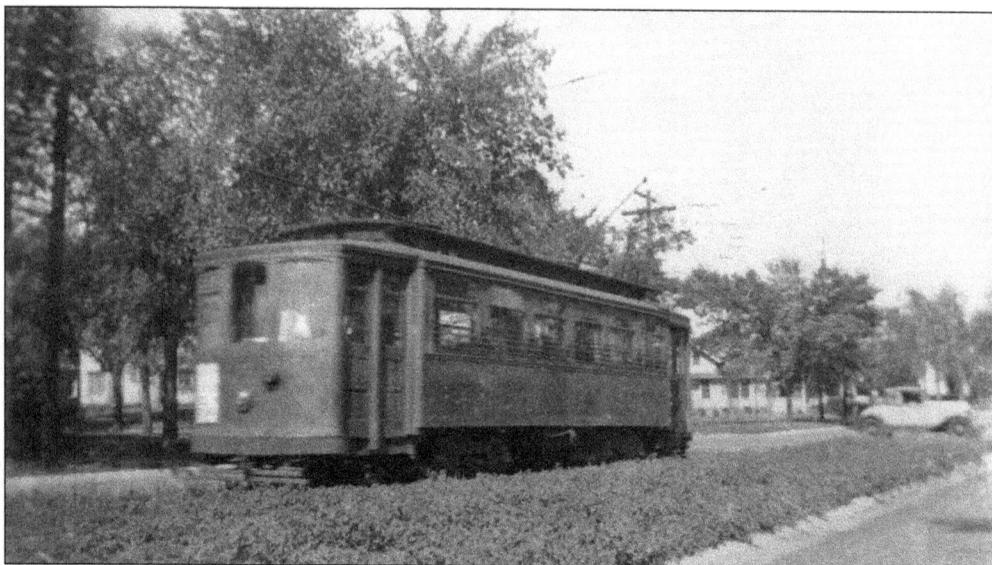

The Seventh Street route made a large, circuitous loop at its outer end to serve several neighborhoods. An outbound car would have come south on Seventh Street, west on Twenty-third Avenue, south on Kishwaukee, east on Harrison, north on Eleventh Street, west on Eighteenth Avenue, north on Ninth Street, and then west on Eleventh Avenue back to Seventh Street. There were three passing sidings on this loop allowing for cars to travel in both directions. In the above photograph, taken on May 14, 1936, car No. 823 has just turned west from Seventh Street onto the boulevard that to this day defines this portion of Twenty-third Avenue. Below, car No. 839 has come down Seventh Street and turned onto Twenty-third Avenue, where it has stopped. Judging by the "7th Street Only" destination sign, the car is not making the entire loop on this trip, but will return back up Seventh Street off of Twenty-third Avenue. (Above, photograph by Roy Peterson, Gordon H. Geddes collection; below, BLc.)

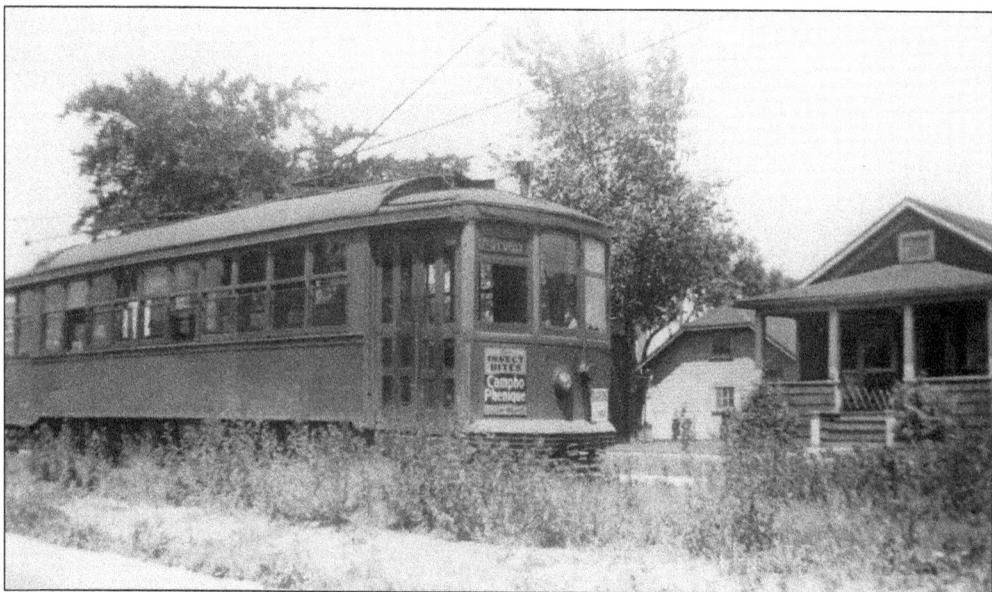

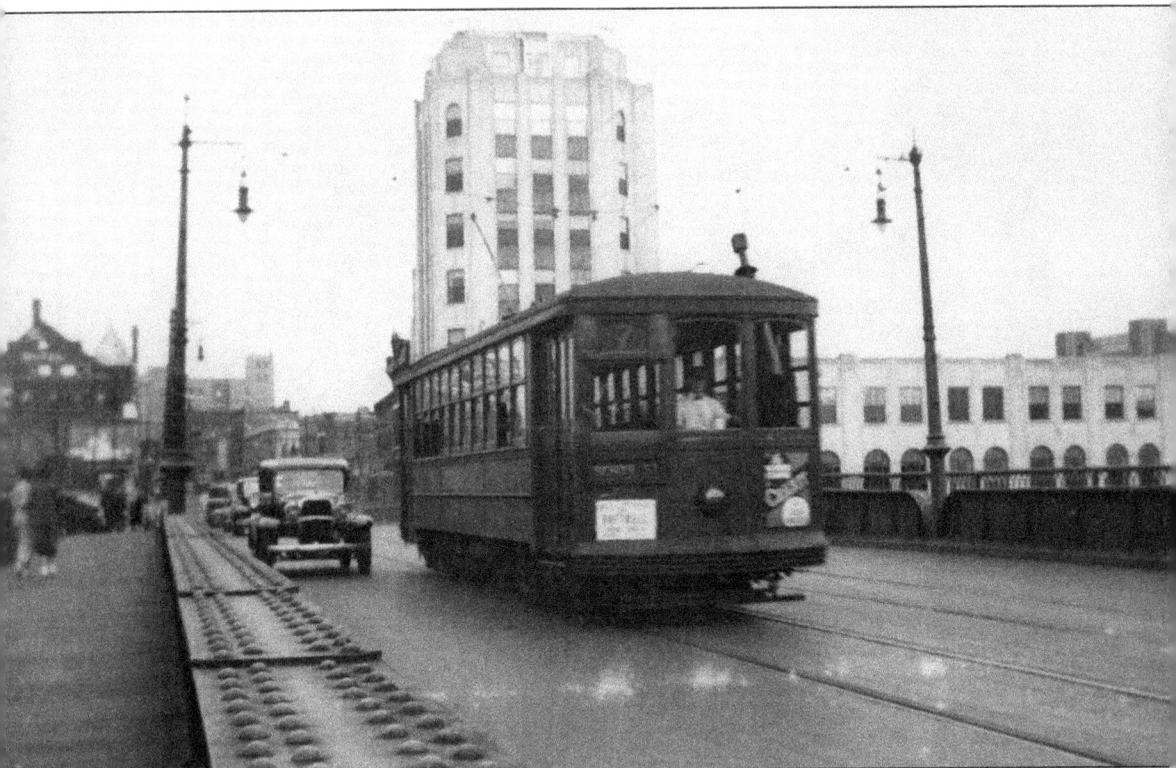

It is May 18, 1936, and this is the west end of the State Street bridge over the Rock River in downtown Rockford. Streetcar No. 863 clangs into the central business district, the new Rockford Newspapers building serving as a new landmark. The Rockford & Interurban Railway and its close associate, the Elgin & Belvidere Electric Railway, have been gone for six years, having succumbed to the emergence of the automobile age and the superior, faster service offered by parallel steam railroads. But Rockford's streetcar network survived as a legacy of the R&I, now operating under the auspices of the Rockford Public Transport Company—but not for long. On July 4, 1936, streetcars made their final scheduled runs as RPT made the switch to buses. (Photograph by Roy Peterson, Gordon H. Geddes collection.)

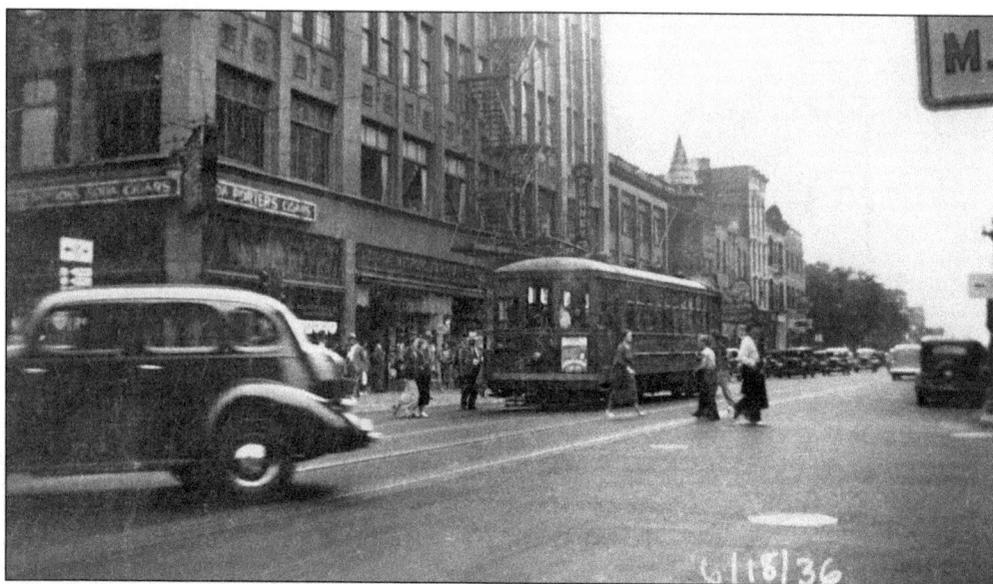

The intersection of State and Main Streets in downtown Rockford is seen on June 18, 1936. Approaching from the west, car No. 867 has stopped on West State in front of the Metropolitan and Fair department store. This was later the location of D.J. Stewart and Company, a popular downtown department store in the 1950s and 1960s. (Photograph by Roy Peterson, Gordon H. Geddes collection.)

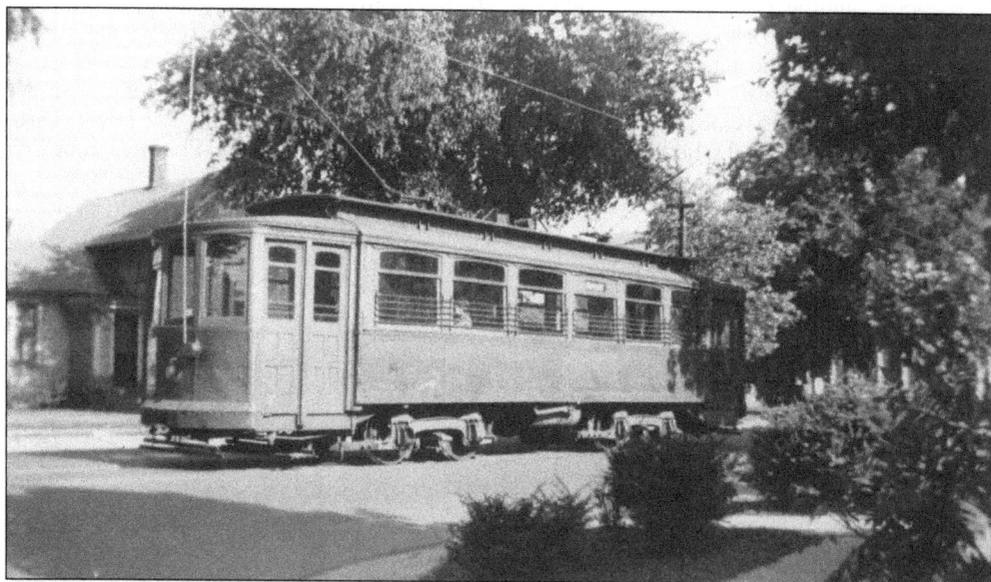

Only two days before the end of streetcar service in Rockford, car No. 823 is seen at an unidentified location, looking a little weathered and worn. By this time, at least four of the 800-series cars—several of which had seen ongoing duty since 1911—had been scrapped. (Photograph by Roy Peterson, Gordon H. Geddes collection.)

One of the 300-series cars stands at State and Church Streets, working the run up and back to Loves Park in 1934. By this time, Loves Park, which was on the old Rockford, Beloit & Janesville, was rapidly growing as a neighbor to Rockford thanks to the Rockford & Interurban as well as the surviving streetcar service. Loves Park was finally incorporated in 1947. (BLc.)

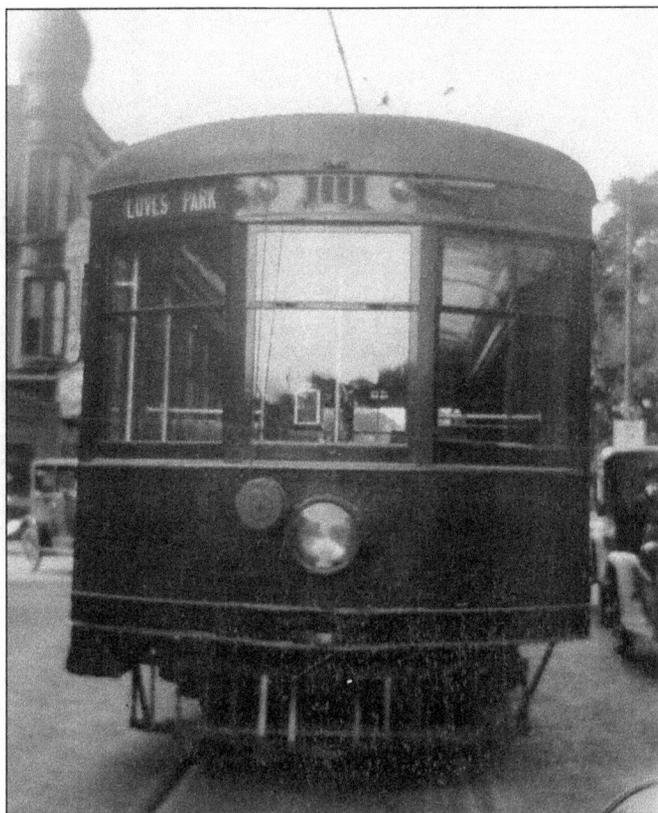

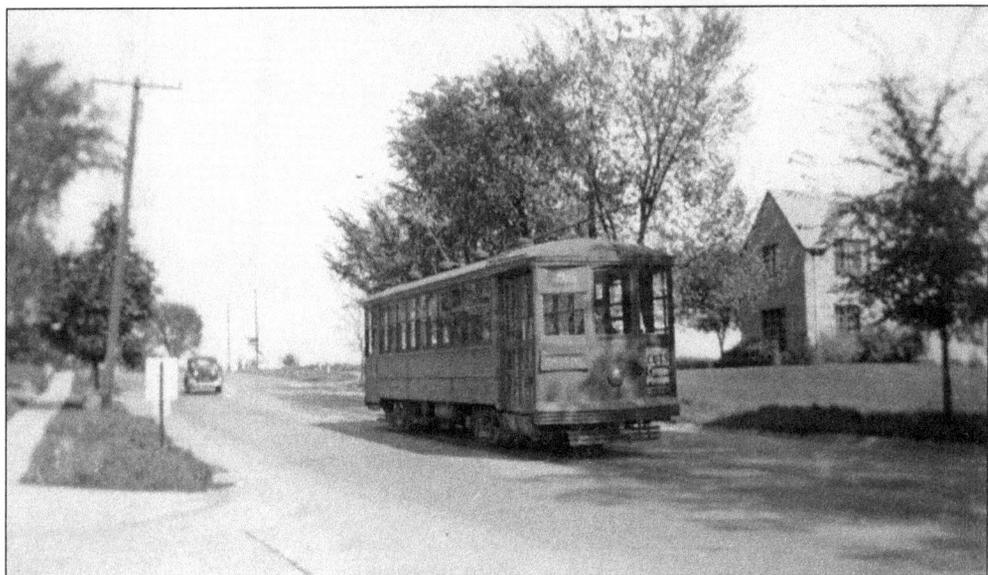

East State Street resembles a country road in this view looking southeast at Dawson Avenue. Car No. 855—one of the newer 800-series cars, having been delivered to the R&I in 1917—heads toward downtown Rockford on May 14, 1936. The streetcar system in Rockford was at this time being operated by the Rockford Public Service Company, the R&I having shut down six years earlier. (Photograph by Roy Peterson, Gordon H. Geddes collection.)

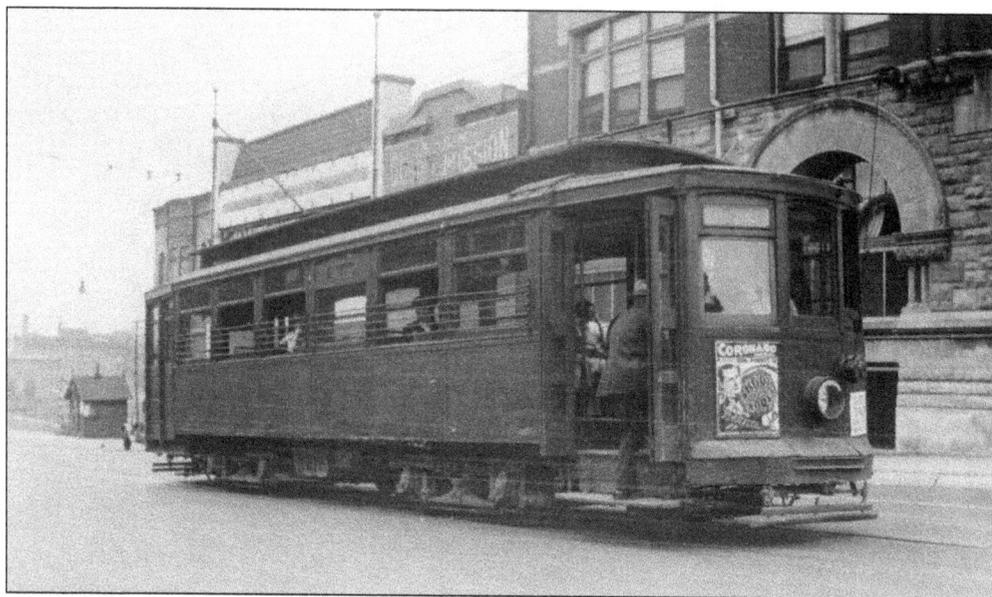

Another Rockford landmark, the YMCA building (with arched doorway) provides a background to streetcar activity. Here, car No. 825 rolls eastbound out of downtown along East State Street. The shanty in the background is for the crossing guard keeping watch over Chicago & North Western's Kenosha line where it crosses East State. Beyond flows the Rock River. (SLIHS.)

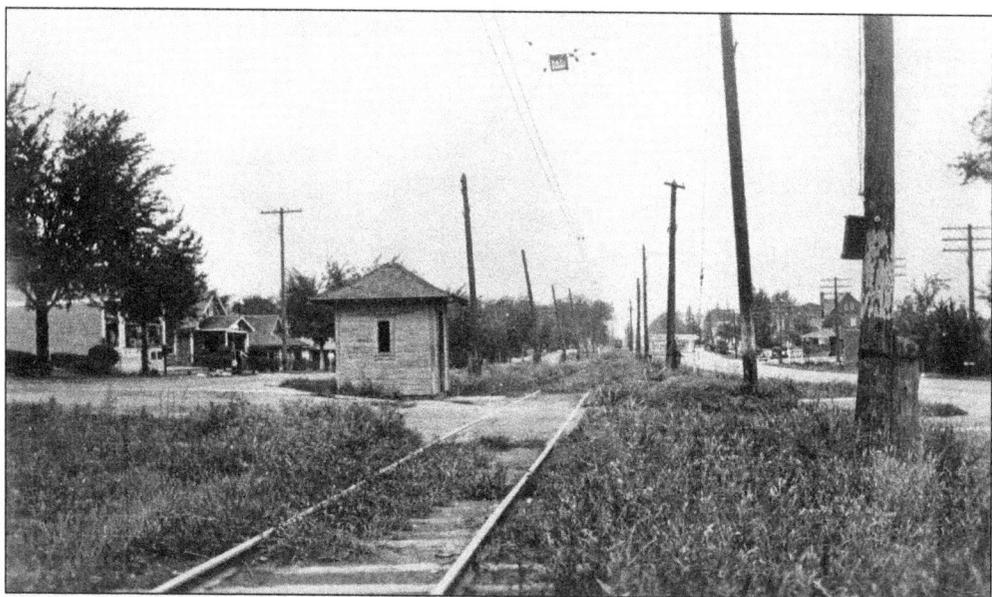

A stretch of the Rockford & Interurban is shown probably early in the 1930s. The shelter is weather worn, and the track is overgrown with weeds. Far in the distance, what appears to be a 300-series car approaches. The location is Springfield Avenue, along what is now a much wider West State Street (right). The sign in the distance points to the "Cottonwood Tourist Camp." The little shelter here, which served as the Lincoln Park stop, survives at the Illinois Railway Museum. (Gordon H. Geddes collection.)

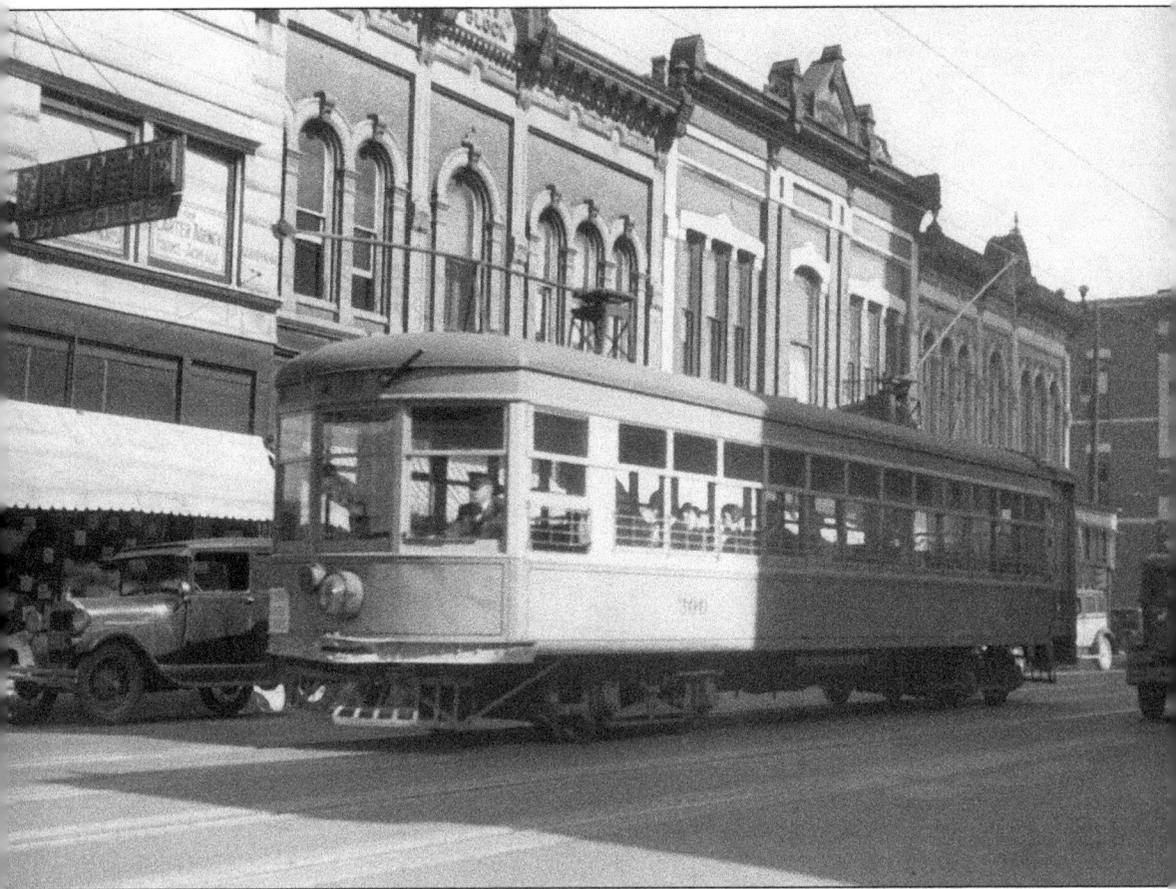

Sporting a new livery following Rockford Public Service Company's takeover of the city streetcar network, formerly operated by the R&I, car No. 300 works its way down East State Street in the vicinity of Third Street in 1932. This is the "uptown" end of downtown Rockford, east of the Rock River. Many of the ornate buildings in this stretch have been restored to their original appearance. Now, if only the streetcars could make a comeback! (Photograph by R.V. Mellanbach, SLIHS.)

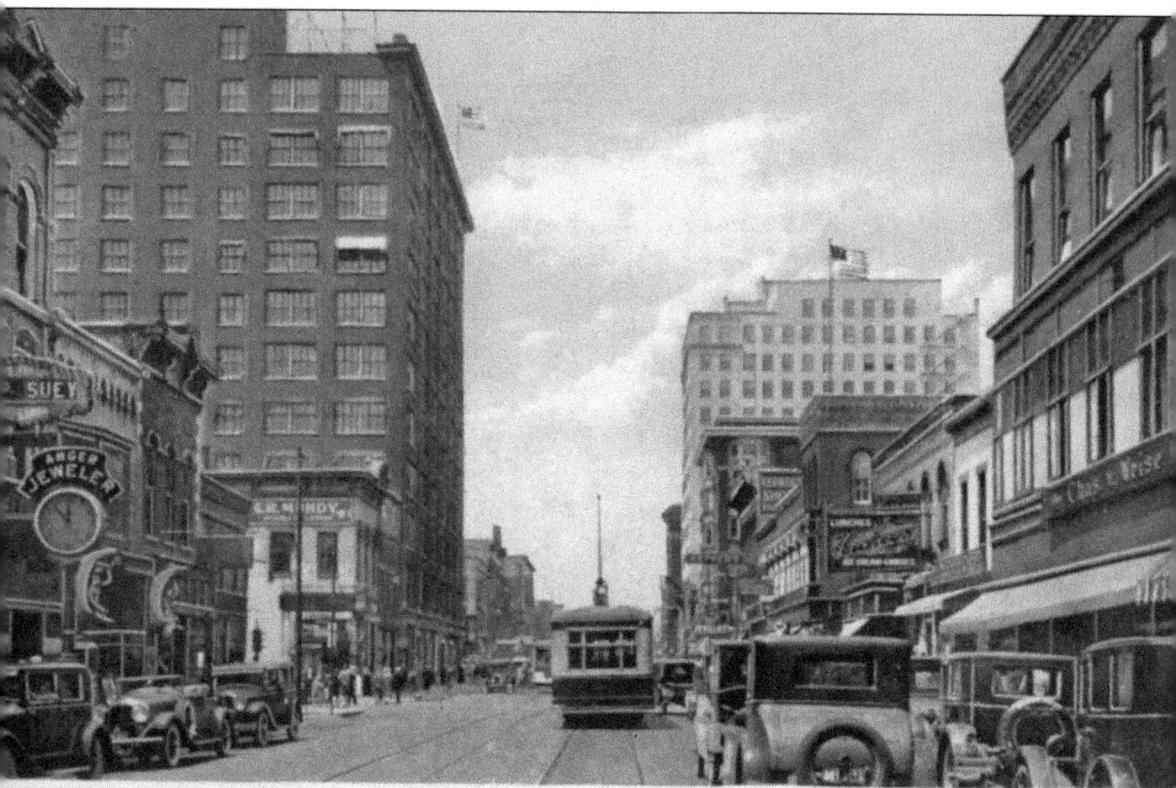

STATE STREET, LOOKING WEST, ROCKFORD, ILL. 121964

Downtown Rockford is choked with automobiles in this postcard scene from the early 1930s. The view looks along State Street. A red-and-cream 300-series car heads west, away from the photographer. Longtime residents of Rockford may recognize some landmarks that survived into the 1970s. The Anger Jeweler's clock (left) was an icon of the city's center, and the new Talcott Building at right in the distance lords above all other multistory downtown buildings. At right is Hickey's Restaurant, although it was destined to move across the street near Anger Jeweler in later years. Also on the right is the Charles V. Weise department store, whose facade would be drastically modernized by the 1950s. At the time the photograph was taken for this postcard, the streetcars themselves were a familiar part of downtown—but not for long. (BLc.)

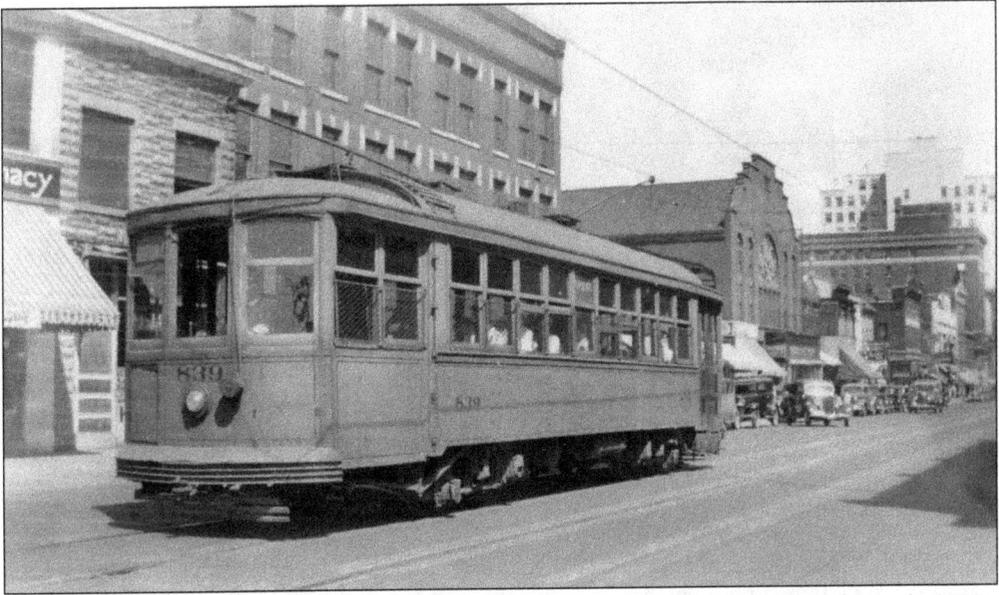

Car No. 839 rambles along West State Street on its way out of downtown in the early 1930s. Traffic was considerably lighter on the west end of State Street. In the coming years, many of the buildings in this photograph would be demolished. Interestingly, however, the new Rockford Mass Transit District hub station for today's bus system occupies the site beyond the car that is pulling out onto State Street. Prominent in the distance at right is the Talcott Building, which still towers over this part of downtown. (SLIHS.)

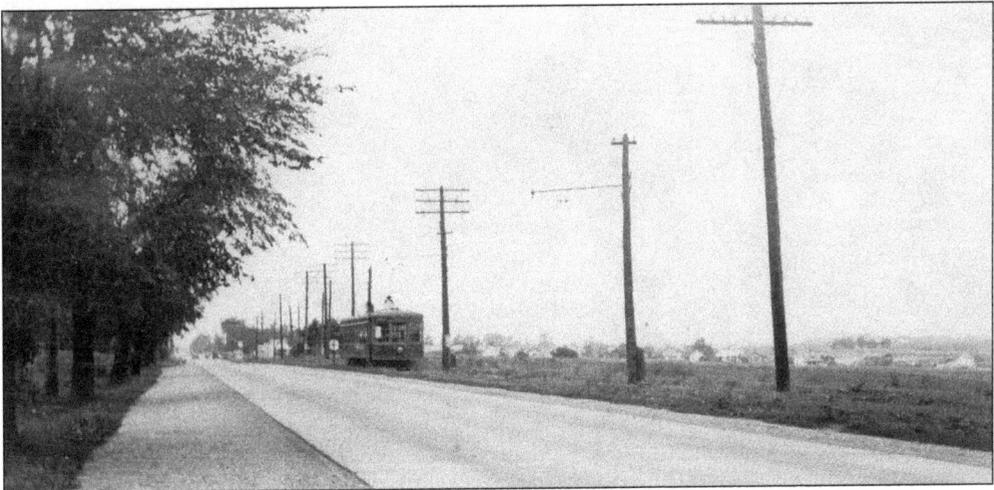

A 300-series car heads west, away from the photographer, along West State Street near Springfield Avenue. In the glory days of the R&I, this was the main line to Freeport. (Gordon H. Geddes collection.)

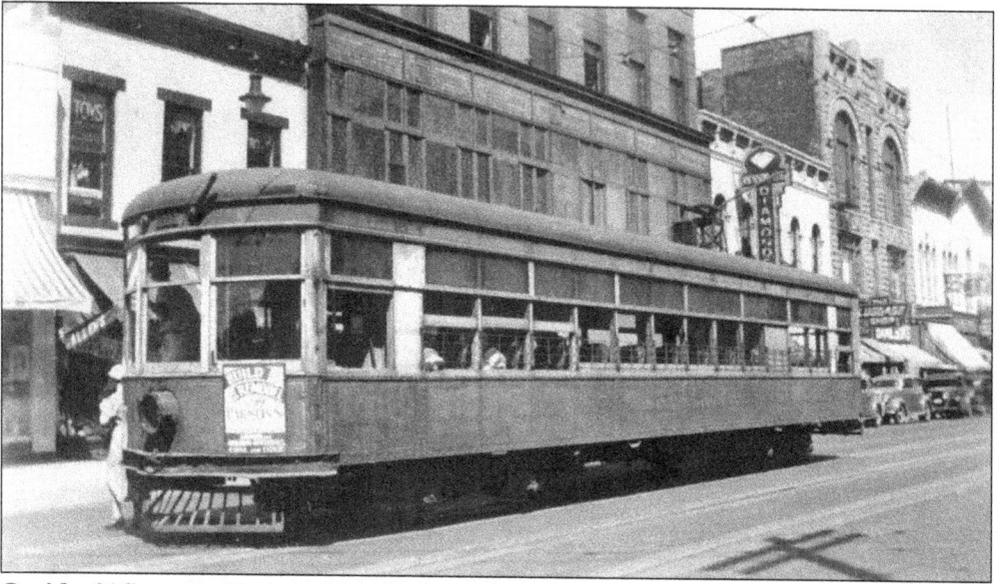

Car No. 306's name, *Sinnissippi*, barely shows through the weathered sides of the car on State Street. It has paused at Wyman Street to let passengers detrain on what appears to be a warm summer day. The car is in front of what would eventually become Weise's department store, a downtown anchor well into the 1960s. (SLIHS.)

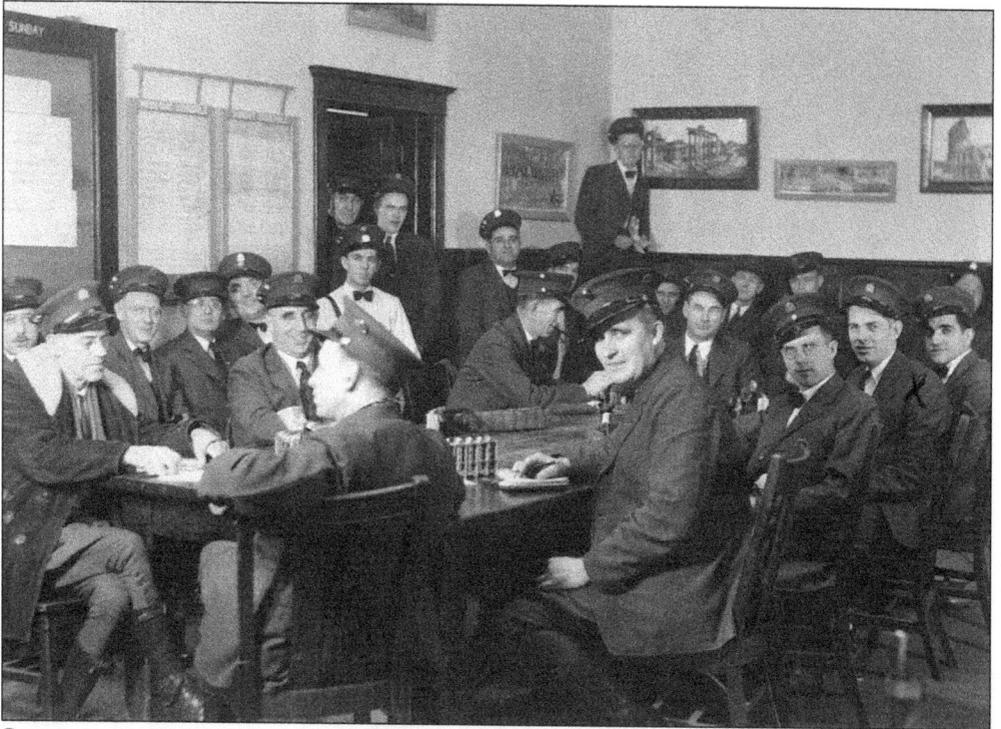

Streetcar motormen gather at the Kishwaukee Street carbarn upstairs offices for an unidentified event in the 1930s. At the start of their shifts, train crews reported here for their assignments before taking a car out on a run. The man second from right is Leland Abbott, who operated both trolleys and buses for the city. (BLc.)

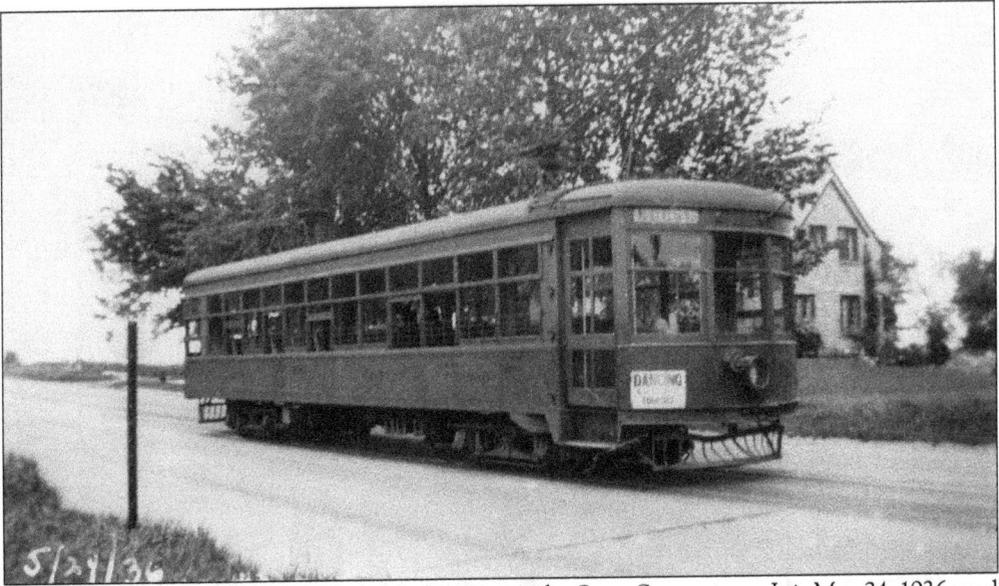

Double-ended car No. 300 is at Dawson Avenue on the State Street route. It is May 24, 1936, and the photographer is making a conscious effort to capture as much of Rockford's streetcar system before it gets wiped out in a few weeks. Today, State Street—Business US 20—is four lanes wide at this point. (Photograph by Roy Peterson, Gordon H. Geddes collection.)

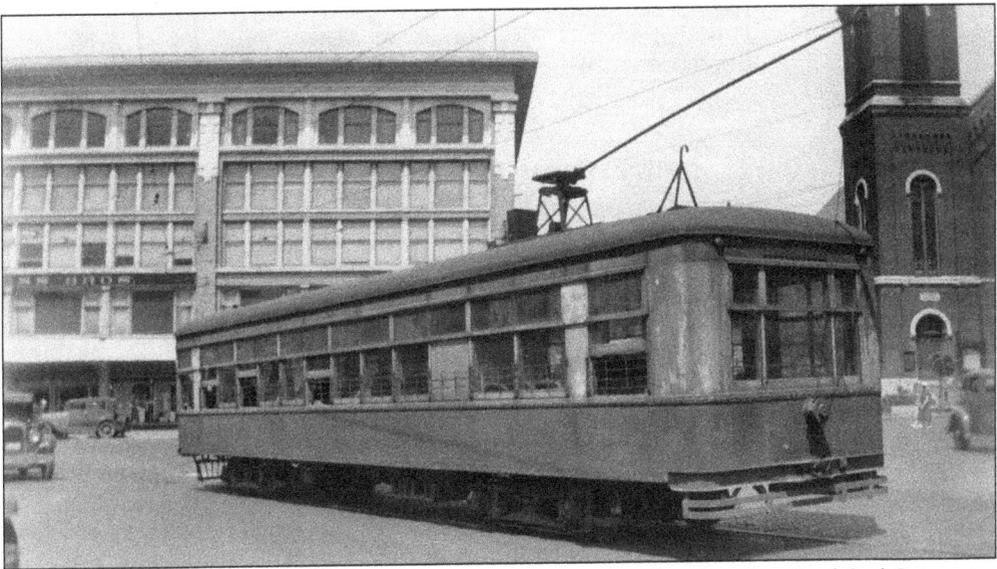

The *Sinnissippi*, car No. 306, looks mighty grimy in its final weeks of work in Rockford. It is on its way out of the Kishwaukee Street carbarn and will swing onto the State Street trackage to head downtown. When it and its sisters went to work in Oklahoma City later in the 1930s, they received renovations to make them look and run like new. In fact, the cars spent more time working the Oklahoma City system than Rockford's by the time they retired in 1947. (SLIHS.)

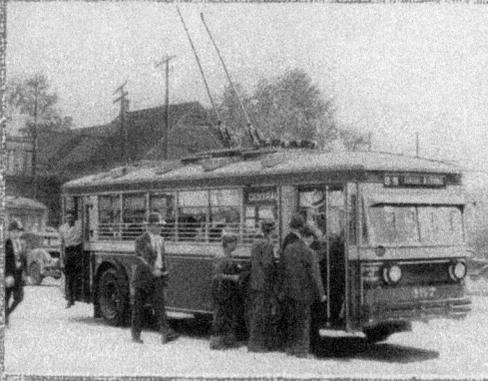
When it was determined that Rockford could no longer afford to maintain a streetcar system, the city began to focus on completely replacing streetcars with buses, which already had been supplementing the streetcar system for some time. Interestingly, for a few years, the city experimented with electric trolley buses, a decision that perhaps was influenced by the fact that portions of the existing overhead distribution system could be incorporated. This advertisement by the J.G. Brill Company, which was manufacturing streetcars as well as trolley buses, appears in the August 1931 issue of *Electric Traction* magazine. (BLc.)

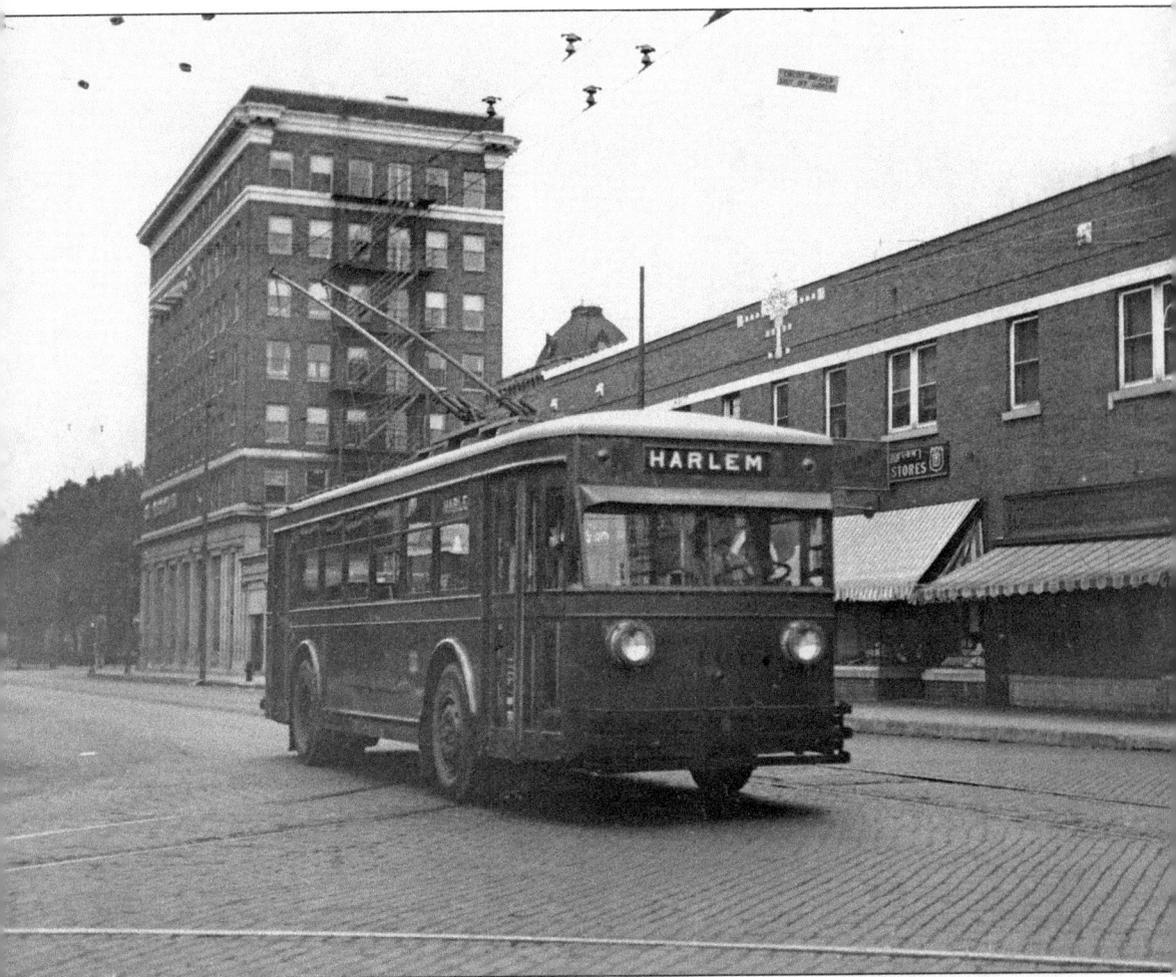

A Rockford Public Transit trolley bus purrs along Church Street at Mulberry Street on August 14, 1932. Trolley buses by nature are smooth and quiet and have quick acceleration. They required double overhead catenary, since there is no way to ground the power, as there is with a streetcar or interurban, through the metal wheels to the rails. Trolley buses take more skill to operate, since steering is required. Although there is a reasonable amount of swivel in the trolley pole rigging to allow the bus to draw near the curb to pick up or drop off passengers, if the bus strays too far off the alignment of the catenary, one or both poles may pop off the wire, bringing the bus to a sudden stop. Trolley bus operations in the United States are now rare, the most notable existing one being in Dayton, Ohio; but they are common in a number of foreign countries. (Photograph by R.V. Mellanbach, SLIHS.)

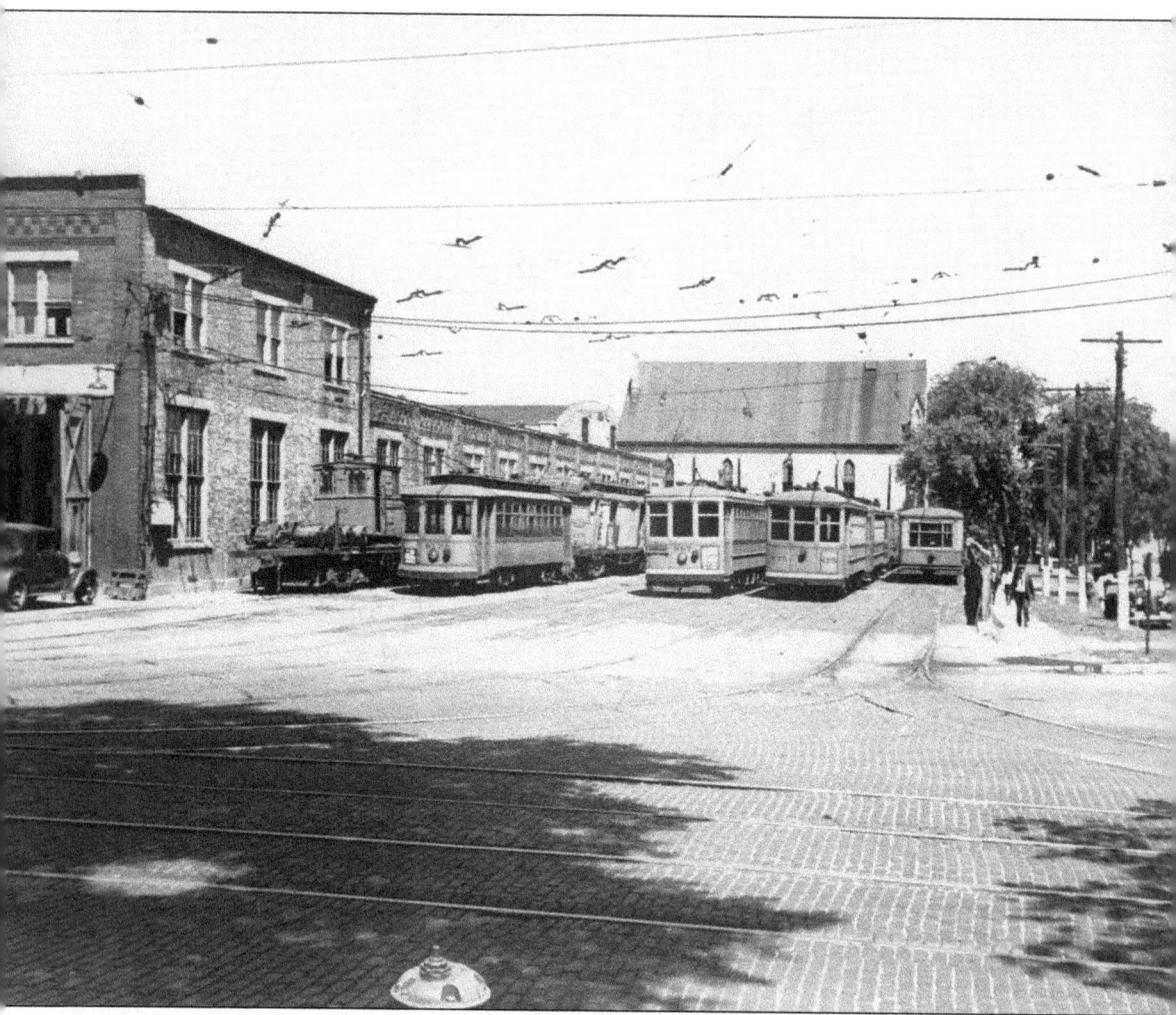

The venerable Kishwaukee Street carbarn—it was still standing as of 2015—is shown in the early 1930s as streetcar operations were on the wane. The cars facing an uncertain future are, from left to right, car No. 817, express motor No. 157, car No. 867, car No. 875 (with others behind it), and a 300-series car. (BLc.)

Rockford promoted its switch to buses rather aggressively, assuming that buses were the panacea for a city transit industry that was quickly becoming the victim of the automobile, not streetcar operation. Would anyone have believed in the mid-1930s that a streetcar revival in the 2000s would help bring downtrodden cities back to life? (BLc.)

Clear the Tracks

. . . make way for

MODERN TRANSPORTATION

Twenty-two new busses are rolling up and down Rockford's beautiful streets, supplying this community with the finest transportation in America.

This fine fleet of buses—noiseless, comfortable, speedy — seem to have 'changed the atmosphere of the city, giving the community a more metropolitan appearance. In order to serve the greatest number of people most conveniently . . .

. . . Goodbye, OLD FAITHFUL

PROGRESS comes to Rockford

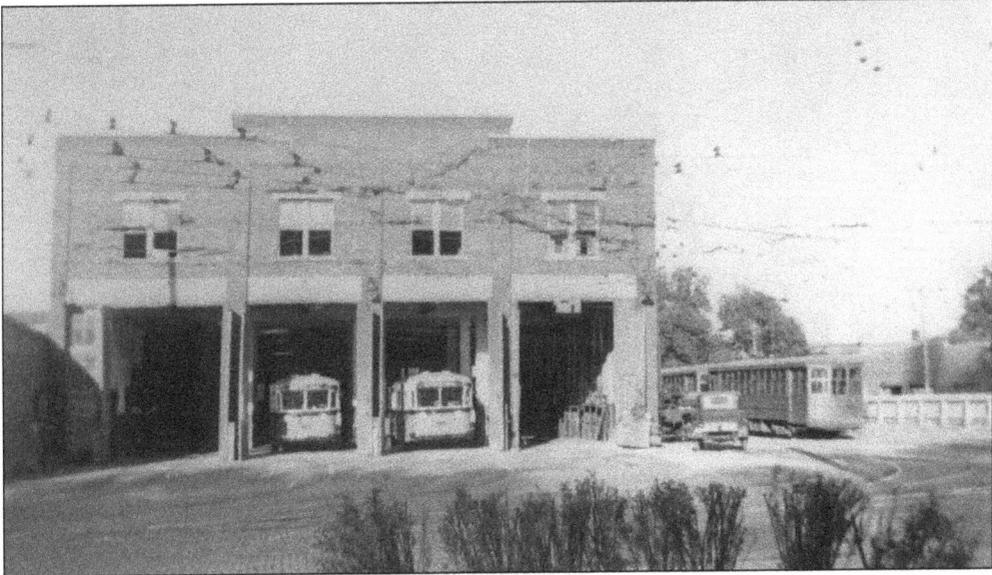

This scene is a streetcar lover's nightmare. The Kishwaukee carbarn is seen on July 2, 1936, one day before streetcar service stopped. City buses have invaded the barn, and there they will remain for well over 30 years, until the city moves operations to a new facility. (Photograph by Roy Peterson, Gordon H. Geddes collection.)

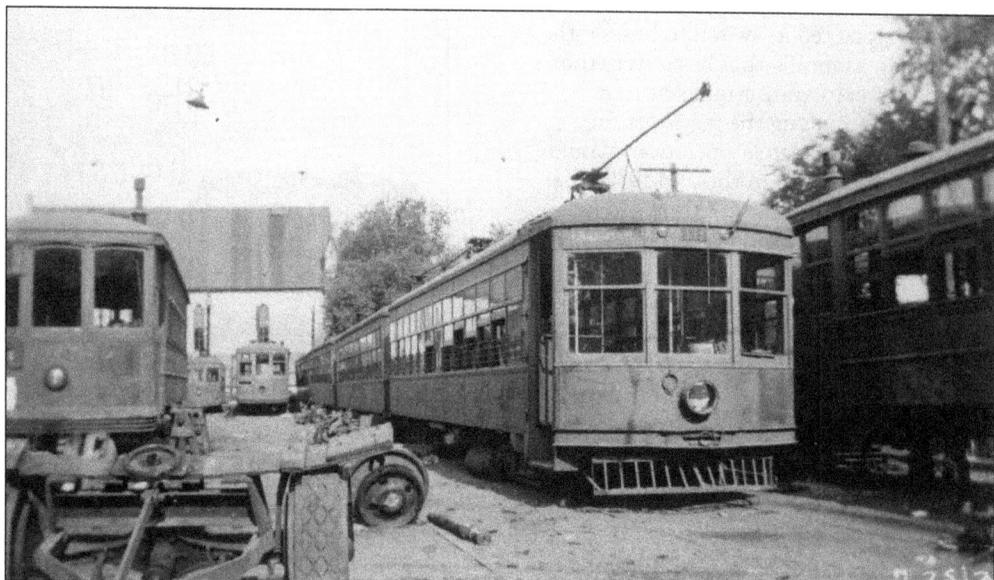

By the end of July 1936, many of the streetcars were well on their way to being dismantled at the Kishwaukee carbarn and sold for scrap. Exceptions were the relatively new 300s, several of which are lined up at center right. They will see new life in Oklahoma. (Photograph by Roy Peterson, Gordon H. Geddes collection.)

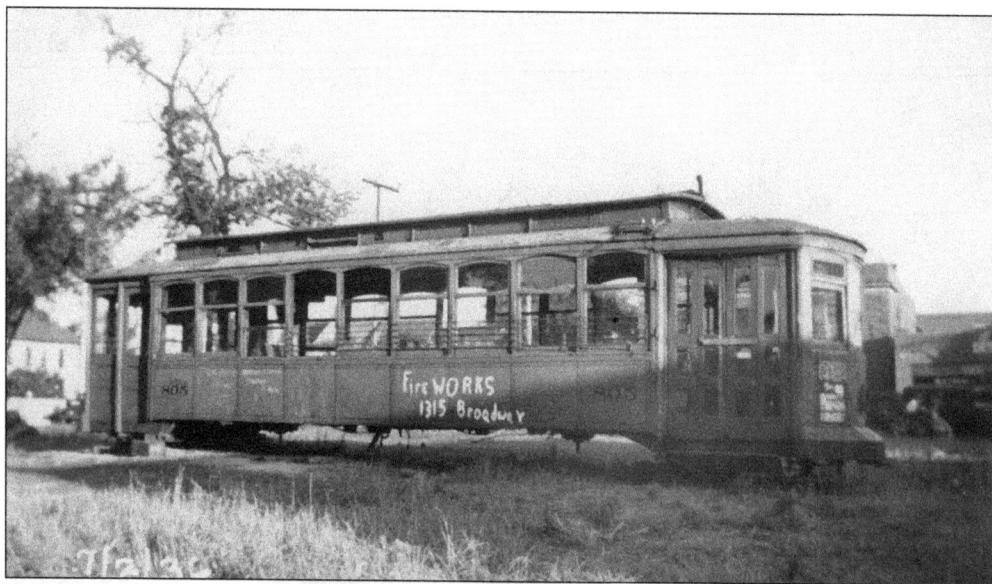

The fate of car No. 805, built by the St. Louis Car Company in 1911, has been sealed. It is shown, sans trucks, in an empty lot along Broadway near Turner School. On July 3, 1936, the car was burned as a "celebration" of the end of streetcar service. Not realizing the full potential and value of electric streetcar service in those days, town fathers and the public naturally assumed that internal-combustion power was the next step in the evolution of public transit. As many cities are discovering today, that was not the case. (Photograph by Roy Peterson, Gordon H. Geddes collection.)

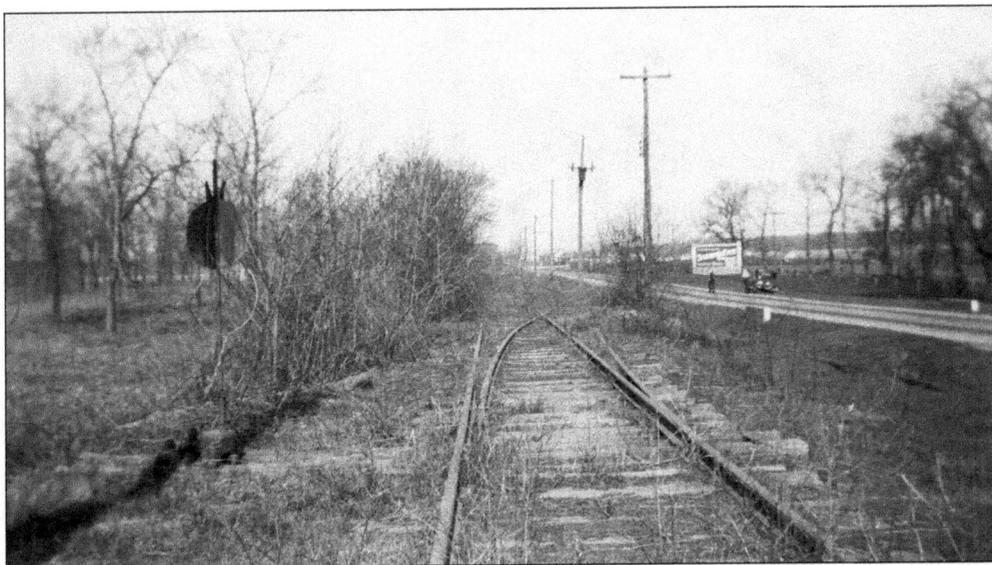

As Rockford's streetcar system was being phased out, this photograph was taken with a view looking westward along Charles Street (Illinois Route 5) on April 29, 1934. Abandoned in 1930, the R&I main line east of Rockford was still intact, if weed-grown. The switch in the foreground marks the east end of siding No. 17. Note that the switch stand at left is also still intact. This location is approximately near today's Arlington Cemetery, just east of Mulford Road. (Photograph by Roy Peterson, courtesy Rory and Cedric Peterson.)

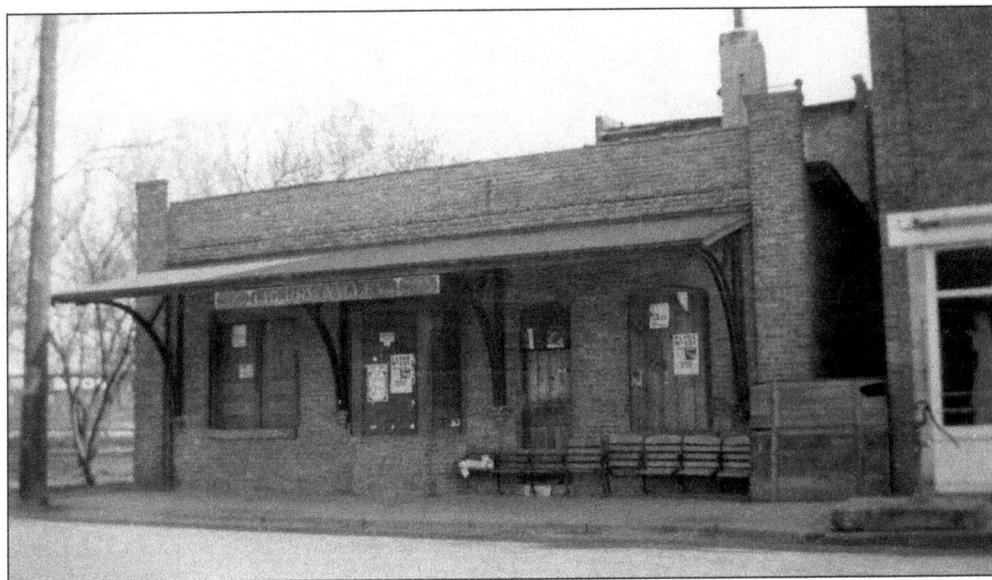

The R&I Cherry Valley depot, also known as Siding No. 18 (noted on depot sign), stands boarded up and forlorn on April 29. 1934, four years following the demise of R&I interurban service. However, the little building, which sat on the north side of Cherry Valley's State Street, survived and was repurposed. (Photograph by Roy Peterson, courtesy Rory and Cedric Peterson.)

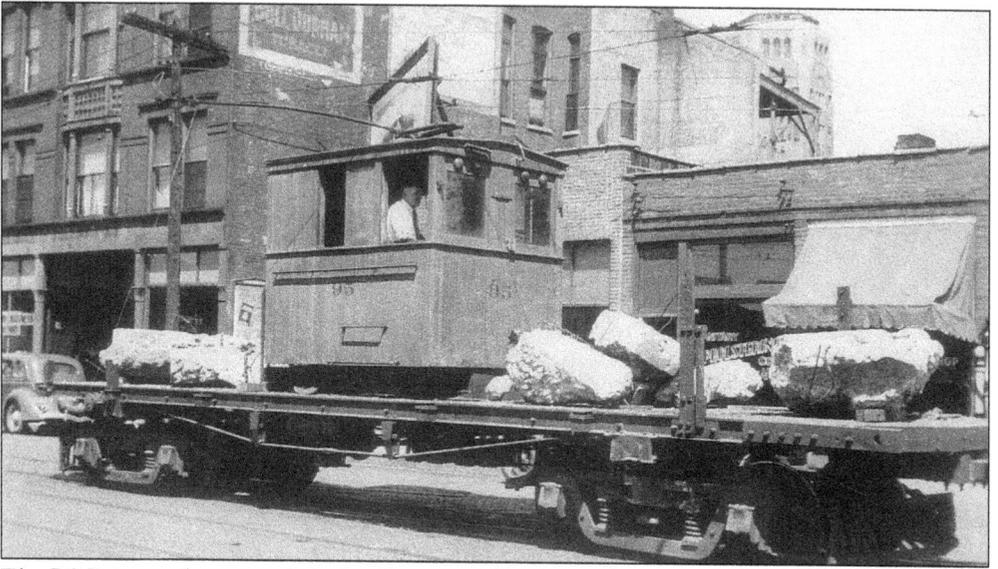

The R&I's interurban main lines had been moribund for nearly a half dozen years when a former R&I work car was photographed on Kishwaukee Street in 1936. This car, built in 1911 by the R&I, had been used in maintenance work ever since. The chunks of concrete being hauled away are likely from the dismantling of the track—no doubt one of the last, sad duties of work car No. 95. (BLc.)

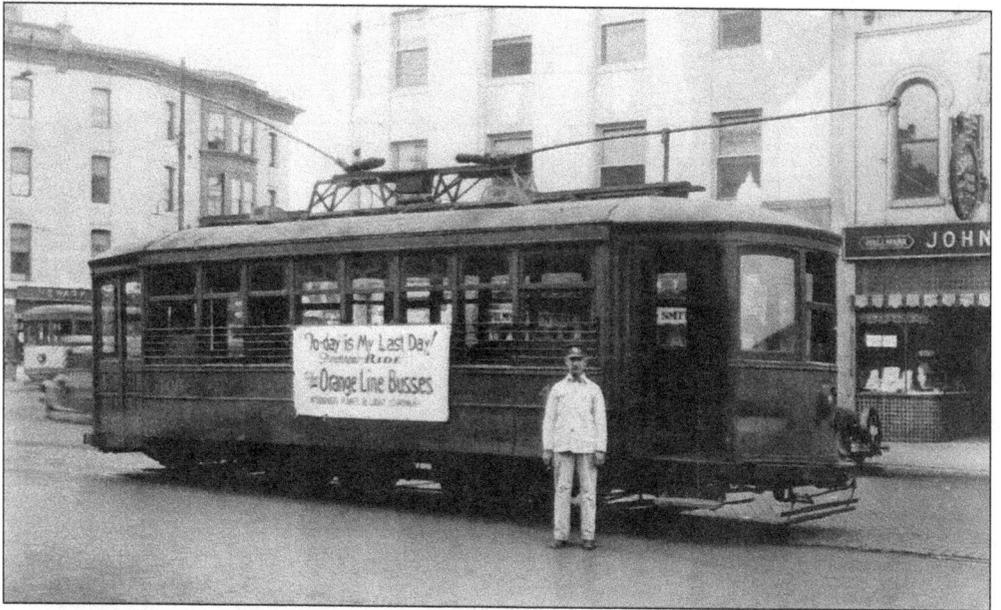

It seems that the whole network of interurbans and various streetcar systems in northern Illinois and southern Wisconsin collapsed at about the same time. Although Beloit's system, the Beloit Traction Company, was largely independent of the Rockford & Interurban, the two companies shared some of the management. BTC never developed quite to its full potential; in 1930, it was bought out by Wisconsin Power & Light. Shortly after, WP&L ended all rail transit service in Beloit, as witnessed by BTC car No. 406 making its last trips on Grand Boulevard and State Street. (BLc.)

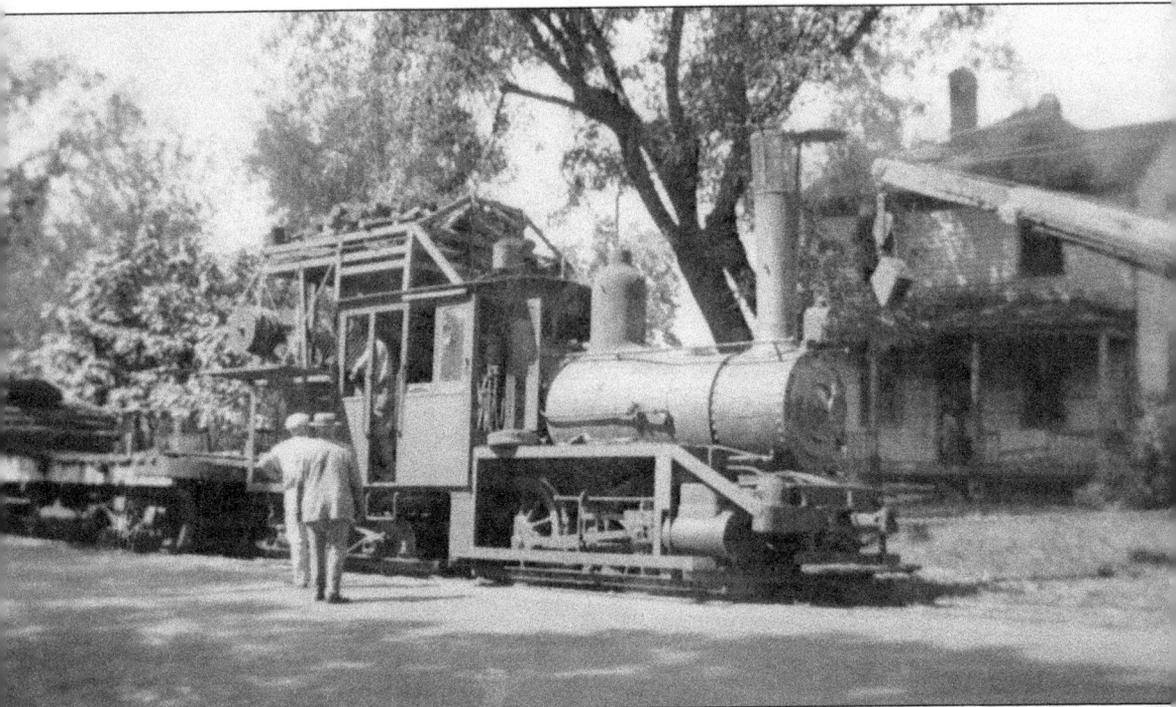

Following the abandonment of the R&I, B.J. Arnold, owner of Arnold Engineering in Marengo, bought the Rockford–Belvidere segment of the R&I and scrapped it out. He did so by purchasing two old Forney steam locomotives that had been used in early New York City elevated train operations before electrification. He brought them to the Midwest and, together with a steam crane built by his company, pulled up the R&I's track, ties, and trolley poles between Rockford and Belvidere. In this scene at West Pleasant and Pearl Streets on Belvidere's west side in August 1932, former Manhattan Railway locomotive No. 64 pulls up track as B.J. Arnold (in straw hat) supervises. (Photograph by Roy Peterson, Gordon H. Geddes collection.)

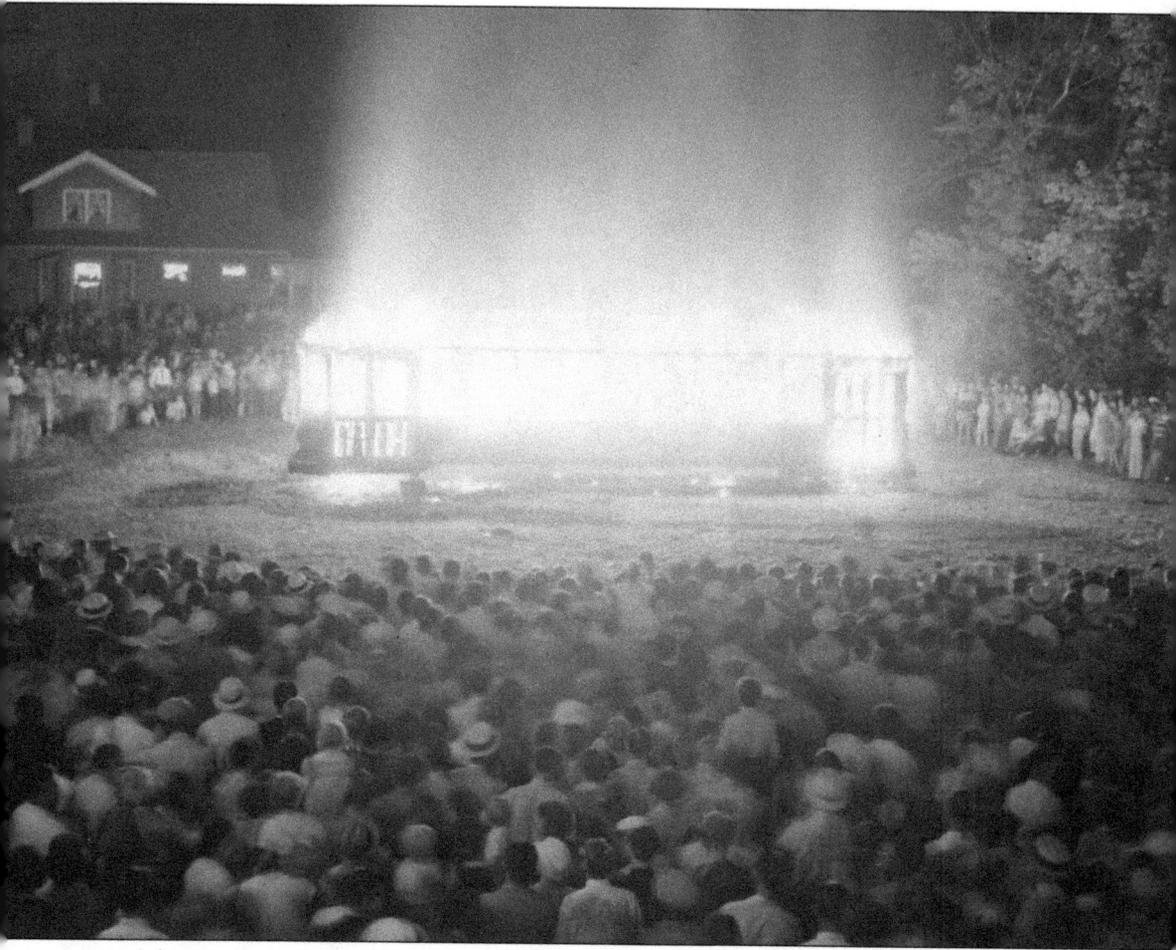

A huge crowd has gathered at an empty lot on Broadway near Turner School on the evening of July 3, 1936, to witness the ceremonial burning of streetcar No. 805, marking the abandonment of electric streetcar service in favor of buses in Rockford. That day was the last for streetcar operation, and the public was able to ride free all day. Shortly after midnight on July 3, Rockford dignitaries and public transit officials made a final trip over part of the system, thus marking the actual end of streetcar operation on July 4. This chilling scene shows the mind-set of some people earlier in the 20th century. The historical aspect of streetcars was negligible, simply regarded as another step in progress. Only in recent years have many city fathers realized the true value of electric trolley/streetcar systems, hence their revival throughout North America. Perhaps some day, even Rockford will witness the return of real streetcars. (Photograph by ACME, BLc.)

Five

FRAGMENTS OF HISTORY

The building of the new State Street bridge over the Rock River in 1949 provided an opportunity for the city of Rockford to remove the ties from the streetcar tracks that had remained under the pavement of State Street following the 1936 abandonment of streetcar operations. The rails probably had already been removed during World War II for the war effort, and the ties simply paved over. This photograph looks east from Wyman Street. The Rockford & Interurban station had once been located in a building, just out of the photograph to the right, that, during this time, housed Florsheim Shoes. (BLc.)

Despite the R&I's early passing, remnants survive at several locations it served. Facing south on Twelfth Street toward the intersection of Seventh Avenue in Rockford in 2006, the view in this photograph shows that the R&I main line has been resurfaced on the Keith Creek overpass. This was the main line out of Rockford to Belvidere on the city's southeast side. Coauthor Schafer's maternal grandfather, Robert Magnuson, lived in the house with the porch on the corner of Twelfth Street and Seventh Avenue around 1910 and likely used the R&I to get downtown. (Mike Schafer collection.)

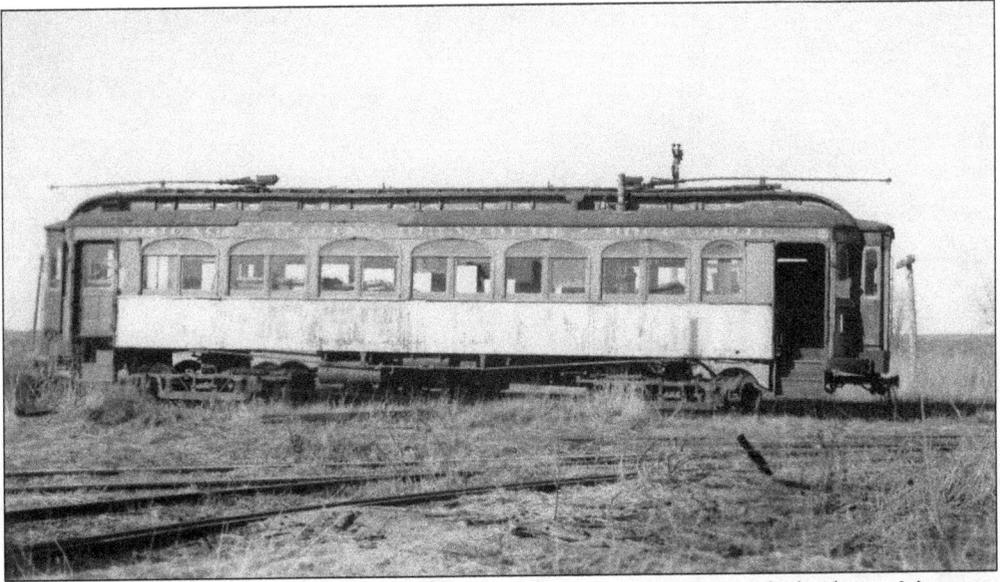

Elgin & Belvidere car No. 208, built by Niles Car Company in 1907, stands derelict in Marengo, Illinois, around 1935. The faded "Chicago-Elgin-Belvidere-Rockford" lettering above the windows is a sad reminder of the heady days of the interurbans, when this now-sagging wooden car flashed along the Illinois prairies that lapped at the E&B and Rockford & Interurban right-of-way between Elgin and Rockford. (Gordon H. Geddes collection.)

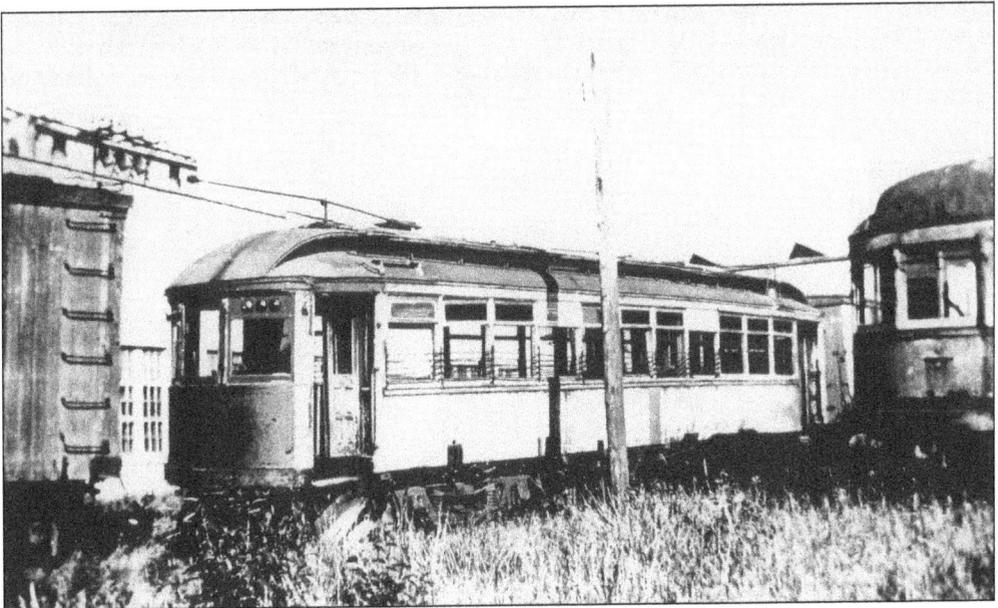

Many Rockford & Interurban cars wound up being scrapped at Marengo, along with Elgin & Belvidere equipment. An R&I city car of an unidentified number awaits disposition at Marengo in the early 1930s. (BLc.)

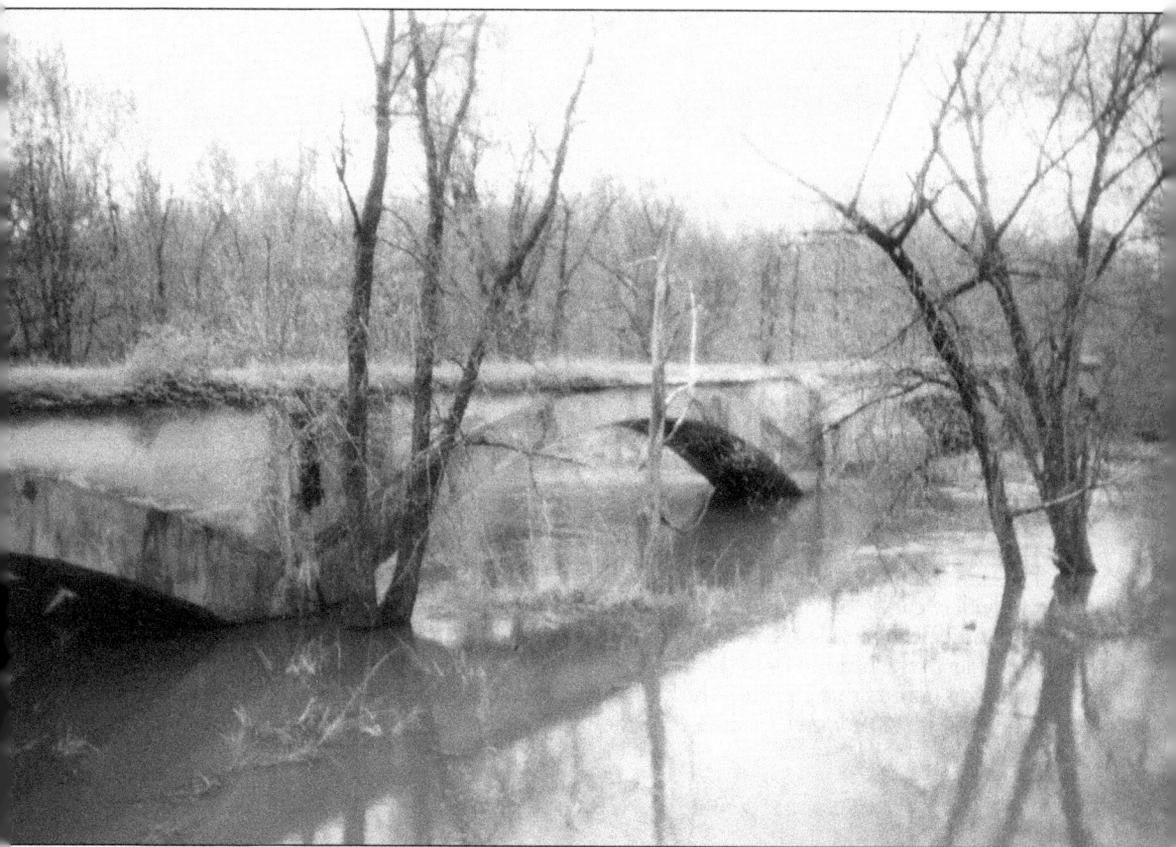

The stone arch bridge over Coon Creek east of Belvidere (see page 32) on the old Elgin & Belvidere right-of-way, shown here in 1996, remains intact. If the planned Amtrak service between Chicago, Belvidere, and Rockford comes to pass, passengers will be able to see the bridge from the south side of their train. (BLc.)

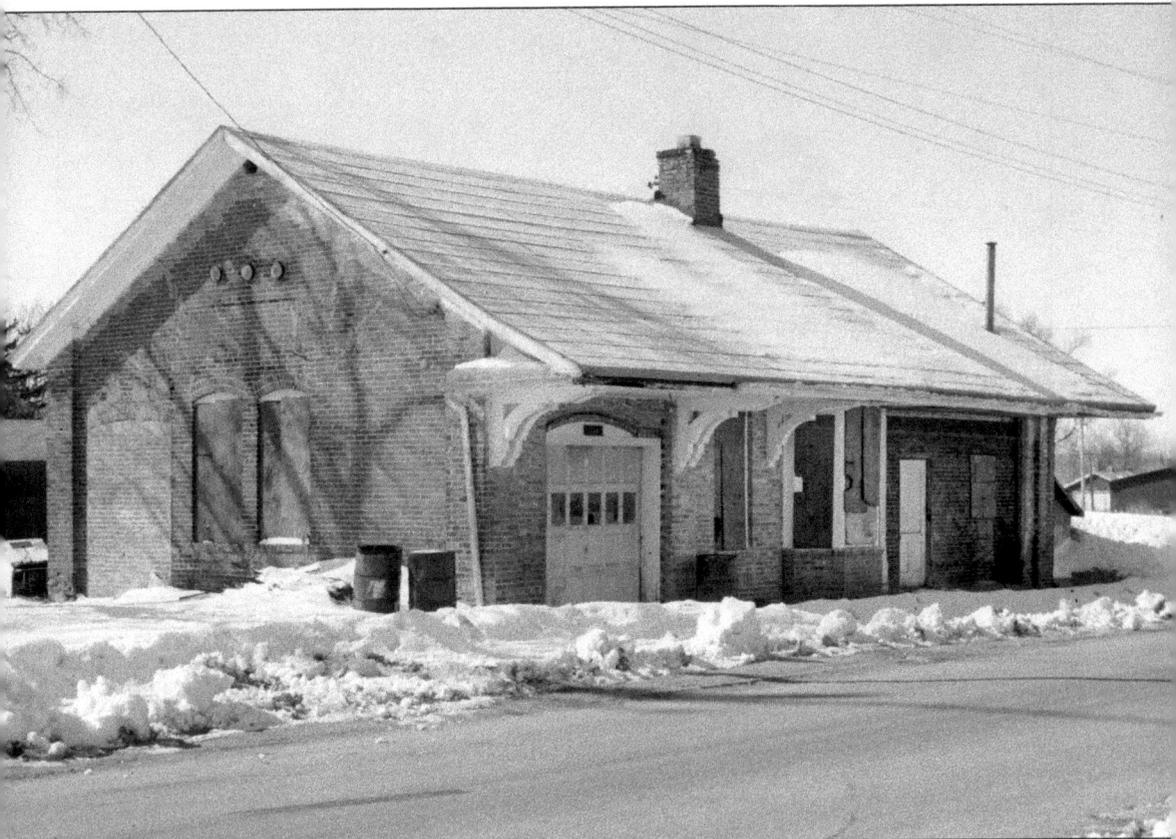

When photographed during the winter of 1974–1975, the former Rockford & Interurban depot at Winnebago was, on the outside, largely intact and unchanged from its interurban days. The principal depots along the old Rockford & Freeport Electric were substantially built and thus have survived the ages. (Mike Schafer collection.)

Since the 1970s, the R&I depot in Pecatonica has undergone extensive cosmetic changes, as shown here in 2013, well over 100 years after it was built. As of the time of this photograph, it was serving as the headquarters for Bennett Construction, Inc. (BLc.)

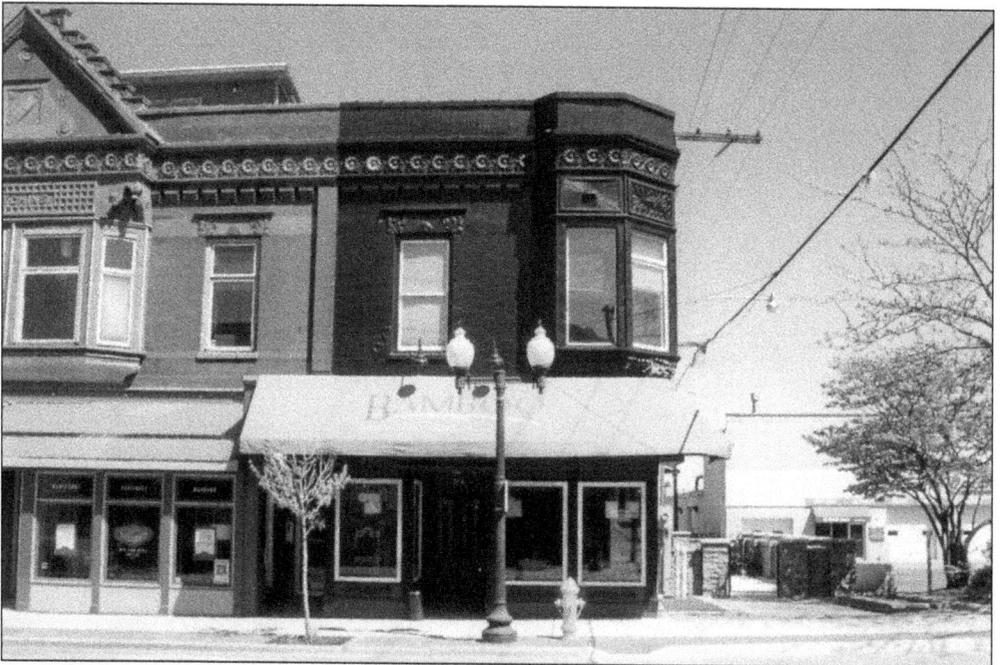

The R&I had an uptown station in a storefront on the north side of East State Street near Kishwaukee Street. The building still stands and is shown here in 2010, when it housed an Asian restaurant and bar. (BLc.)

One of the most extraordinarily rare surviving R&I artifacts is this red globe lantern, used by trainmen at night for signaling the motorman during backup moves or to protect a stopped car from other trains. The metal holder at the bottom indicates that the lantern could also be mounted on the outside car ends for use as a "marker" light denoting the back end of a train. (Mike McBride collection.)

The wooden shelter that served as the Lincoln Park depot on West State/US 20 near Springfield Road was salvaged several years ago (above) by volunteers associated with the Illinois Railway Museum. Today, its serves in its as-built purpose as a streetcar stop (below) on IRM's trolley loop. (Above, Gordon H. Geddes collection; below, BLc.)

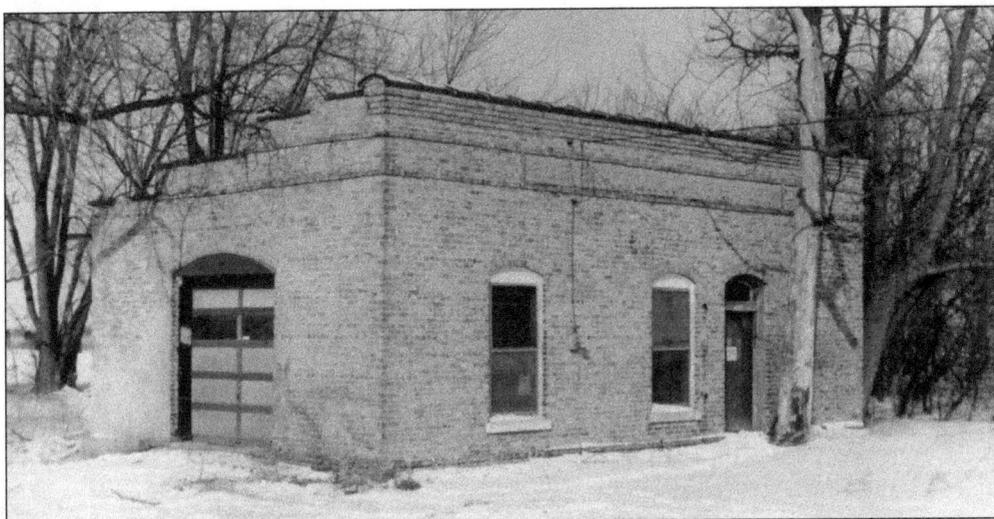

Rockford, Beloit & Janesville interurban substation No. 3, on the northwest corner of Avalon Road and Prairie Road/Beloit Road south of Janesville, survived quite late. Seen here in 1976, it was torn down to make way for a new highway interchange off nearby I-90. The lintel, however, was saved. (BLc.)

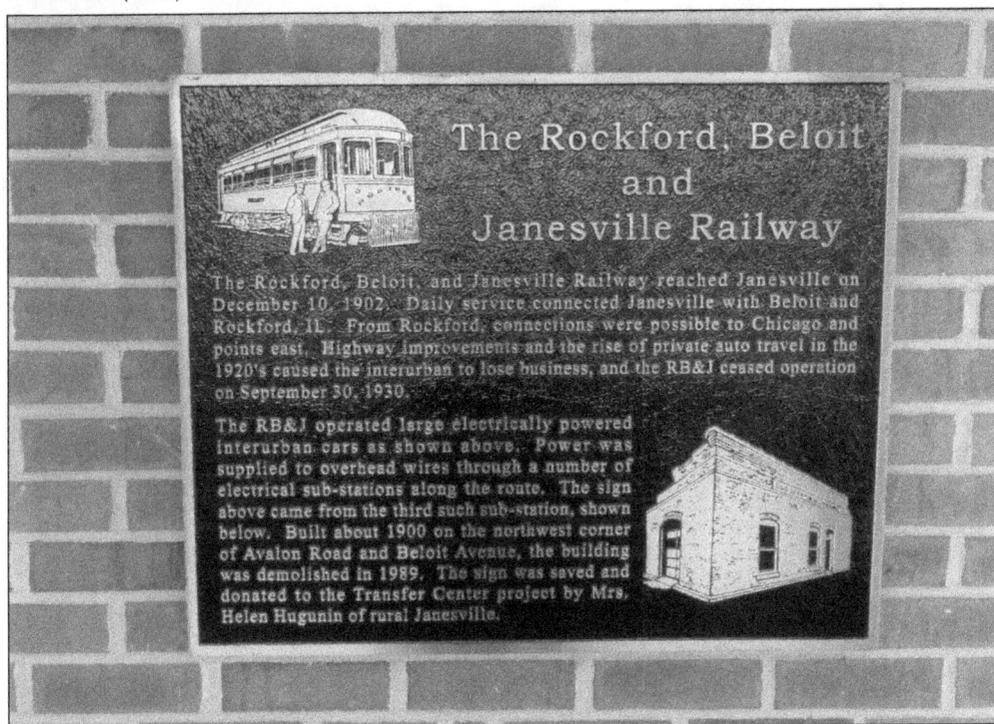

Despite its short history before being absorbed by the Rockford & Interurban, the Rockford, Beloit & Janesville Railway has been commemorated on this brass plaque adorning the new Janesville Transit bus station in downtown Janesville, Wisconsin. The plaque shows one of the RB&J interurban cars that wound up on the R&I, as well as the substation that stood on Prairie Avenue south of Janesville until the 1990s. The substation's lintel has also been incorporated into the new transit building. (BLc.)

Rockford's nod to remembering the Rockford & Interurban is in the form of the Rockford Park District's Riverside Trolley ride. The custom-built "trolley"—actually a propane-powered tram—operates over Union Pacific's former Chicago & North Western "KD Line" branch, from this replica depot beneath the Jefferson Street bridge, north to Sinnissippi Gardens along the Rock River. (BLc.)

NORTH WESTERN ILLINOIS CHAPTER–NRHS

Organized by former Rockford residents Jim Boyd and Mike Schafer, the North Western Illinois Chapter of the National Railway Historical Society (www.nwinrhs.com) was chartered in 1969 to research, document, and otherwise preserve the history of railroading in northern Illinois—including Chicago—and southern Wisconsin, but especially Rockford-area railroads. The group has operated continuously since 1969 and holds monthly meetings that feature slide presentations and guest speakers. Meetings generally are held on the fourth Saturday of the month at 7:00 p.m. at St. Marks Lutheran Church, north entrance, 675 North Mulford Road, in Rockford. NWI publishes a monthly newsletter, the *Northwestern Limited*. Membership is open to anyone interested in railroading. For membership information, check the website or write to NWI at PO Box 5632, Rockford, IL 61125-0632. NWI is an invaluable resource for historians like Brian Landis (left), who served as coauthor on this book. He is shown aboard the Rockford Park District's Riverside trolley. Landis was one of the first to apply for the job of trolley motorman. In 2014, author, photographer, and historian Mike Schafer (right) celebrated the 50th anniversary of his career documenting the US railroad scene. (Left, BLc; right, photograph by Tom Hooper.)

www.ingramcontent.com/pod-product-compliance
Lightning Source LLC
Chambersburg PA
CBHW050546110426
42813CB00008B/2269